The Tuareg

or Kel Tamasheq

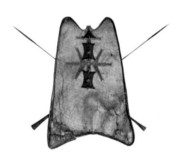

Targhai Tamut. Kilegeuk. (I)shegetan.

Tahbanat. (I)f(o)ghas. Ten gr(e)g(e)desh

K(e)lt(e)g(i)lalet. Tezg(o)gamet. (I)sh(a)dh(e)nharen.

(I)m(e)d(i)deghen. Uragyragen.

Above:
Parchment found in 2014 in Heinrich Barth's archives (now in the
Bibliothèque nationale de France). The words are names of either
Tuareg tribes or regions

Half-title page:
Tuareg shield & spears collected by Marceau Gast in Ahaggar, 1950s

The Tuareg

or Kel Tamasheq
the people who speak Tamasheq

and a history of the Sahara

Edited by

HENRIETTA BUTLER

Introduction by Robin Hanbury-Tenison
Preface by Justin Marozzi

Tuareg /ˈtwɑːrɛɡ/ or Kel Tamasheq /ˈtæməʃɛk/

noun

1. a member of a Berber people of the western and central Sahara, living mainly in Algeria, Mali, Niger, and western Libya, traditionally as nomadic pastoralists. "Proposed by Benhazera (1908) and adopted by Foucauld, Twareg (westernised to Tuareg), is a Beduin Arabic plural derived from Targa, the Berber name of the northern Fezzan – anciently, also the population of Targa. A man of

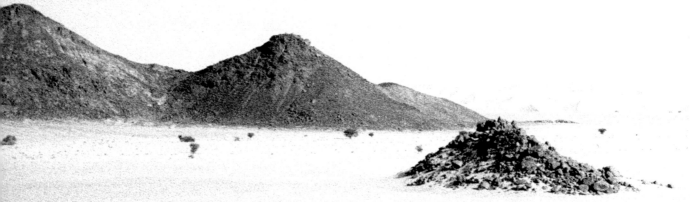

History /ˈhɪst(ə)ri/

noun

1. the study of past events, particularly in human affairs.
2. former times, historical events, days of old, the old days, the good old days, time gone by, bygone days, yesterday, antiquity

Sahara /ˈsəˈhɑːrə/

noun

a desert in N Africa, extending from the Atlantic to the Red Sea and from the Mediterranean to central Mali, Niger, Chad, and the Sudan: the largest desert in the world, occupying over a quarter of Africa; rises to over 3300 m (11 000 ft) in the central mountain system of the Ahaggar

Targa is a Targi. If the word Targi is instead derived from the Arabic verb taraq, Targi could mean "nocturnal visitor, itinerant, outlawed" and so "a man abandoned [by God]". Overall, Tuareg call themselves Kel Tâmâsheq - or Tâmâhâq, Tâmâjâq, or Tâmâshâq, depending on their region - the people, Kel, who speak Tâmâsheq - or Tâmâhâq, Tâmâjâq, or Tâmâshâq". Karl-G. Prasse

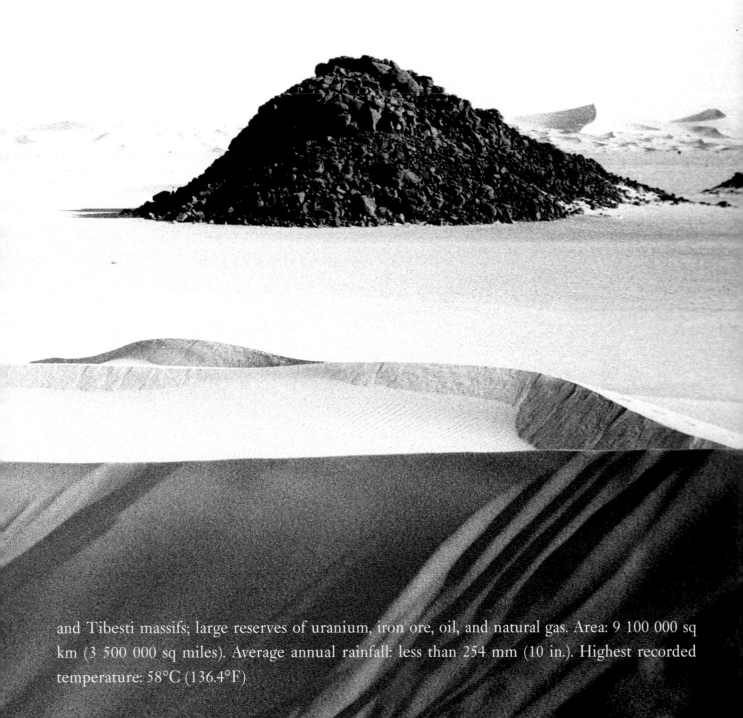

and Tibesti massifs; large reserves of uranium, iron ore, oil, and natural gas. Area: 9 100 000 sq km (3 500 000 sq miles). Average annual rainfall: less than 254 mm (10 in.). Highest recorded temperature: 58°C (136.4°F)

Spellings

Certain inconsistencies in the spelling of Saharan or Tuareg names or words will soon be noticed in the texts throughout this book. Many Tuareg words or names are both spelt differently by Tuareg in their different Saharan regions, and by Europeans, whether being French or English, for instance. Tuareg are of course Touareg in French. Texts have been left with the spellings used by each writer; words or names have not been standardised to be the same throughout the book. The word Tuareg is in fact the singular of the noun although many use it for the plural. More correctly, a group of Tuareg are Tuaregs (in English).

Other key differences here include for the mountaineous region of Algeria called Ahaggar by the Tuareg or Hoggar by the French. And words which may be spelt with an 'r' in place of what was is correctly 'gh' - such as Ghat or Ifoghas or Tamanghasset, as the 'gh' lettering represents an 'r' sound. The Dag Rali are of course the Dag Ghali. Agadez in English may be Agadès in French. Tamasheq is the English spelling of Tamacheq (in French). And of course Timbuktu has multiple variations.

Readers will see these differences - and others - and it is hoped they will not be cause for confusion.

My immeasurable thanks go to all of the following people who have given life to this book and the exhibition, both somewhat feats of endurance but hugely enjoyable ones - but which still only scratch the surface of the Tuareg's world. Perhaps the book will reach the eyes or ears of people that could be moved to speak up for the Tuareg and their astonishing way of life. Particular thanks are for the Bernus family, for their great kindness and enthusiasm in giving me carte blanche with their parents' archives, and to the contributors, who have given the book a depth and erudition far beyond my knowledge or capability.

Danto Acacusine
Mohamed Aghali-Zakara
Moussa ag Aleko
Moussa ag Keyna and Aminatou Goumar of Toumast
Hugh Alexander, of the National Archives, Kew
Tony Allen
Robin Bell
Jacques, Caroline and Cécile Bernus
Olivier Loiseaux and Frédérique Laval of the Département des Cartes et Plans, BnF
Edward, Will and Sally of A.Bliss, sponsors
Bombino
Juliet Boobbyer and Philip Boobbyer
Ed Buckley
Fabien Bordèles, formerly of IRD
Pierre Boilley
Nick Carter of Lots Road Auctions, sponsors
Dominique Casajus
Ged and Mary-Lou Clarke
Hélène Claudot-Hawad
Catriona Colledge
Jeremy Coote of Pitt Rivers Museum
Henri Delord
Francis Dunne
Jean-Marc Durou
Laurent Guillaut of the Musée Henri Martin, Cahors
Janine Gray
Hugh Gilbert
Justine Hancock
Robin Hanbury-Tenison
Rissa Ixa
Neil Johnson of Exib
Francis Richard and Yann Lévenez of BULAC
Alex Maitland
Galal Maktari
Sara di Marcello of Consiglio Nazionale Delle Ricerche
Dee McCourt of Borkowski
Brian Melican
Tony, Dave and Kate of Metro Imaging, sponsors
Justin Marozzi
Sandra Piesik
Marc Franconie, Pierre Touya and Yves Belleville of La Rahla
Adal Rhoubeid
Alasdair Macleod and Denise Prior of the Royal Geographical Society
Louis de Roys and Emmanuel Bonassi
Véronique de Touchet and Bernard Palmieri of of the Service Historique de la Défense
Jeremy Swift
Berny Sèbe
Thierry Tillet
Liz Thomson of Mountgrange Heritage, sponsors
Ali Wade

And to all in the archives and libraries where I have scurried to find what I was looking for, or lost, their tremendous help with the reproductions; for the painstaking work of Jesse Holborn, designing the book, Manish Patel, reviving my photographs, Hugh Tempest-Radford, saving the day, and the loveliest sponsors, the estate agents Mountgrange Heritage. A special acknowledgement must go to Karl-G.Prasse. Finally, to the numerous Tuareg who have helped, guided or welcomed me, notably Mohamed Ixa, Rhissa Feltou, Rhissa ag Boula, Akoli Daouel, Akli Joulia, Balal Attoubane, Almoustapha Iambo, Almoustapha Aima, Moussa Ilandi, and the delightful poet, Atano Handi
For the Tuareg in general, whose guardianship of their Saharan land would help make the Sahara a safer place for us all, may their dreams become a reality.

*In this desert where everything is fierce, where life is tough,
to complain is a weakness which dishonours men*
Mano Dayak

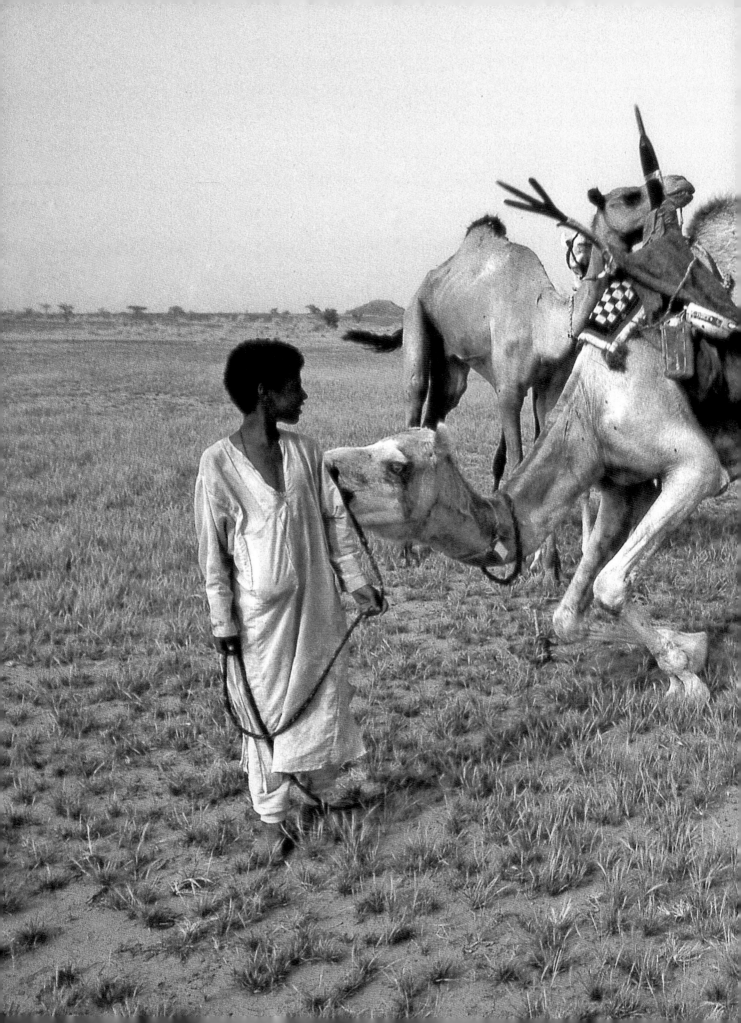

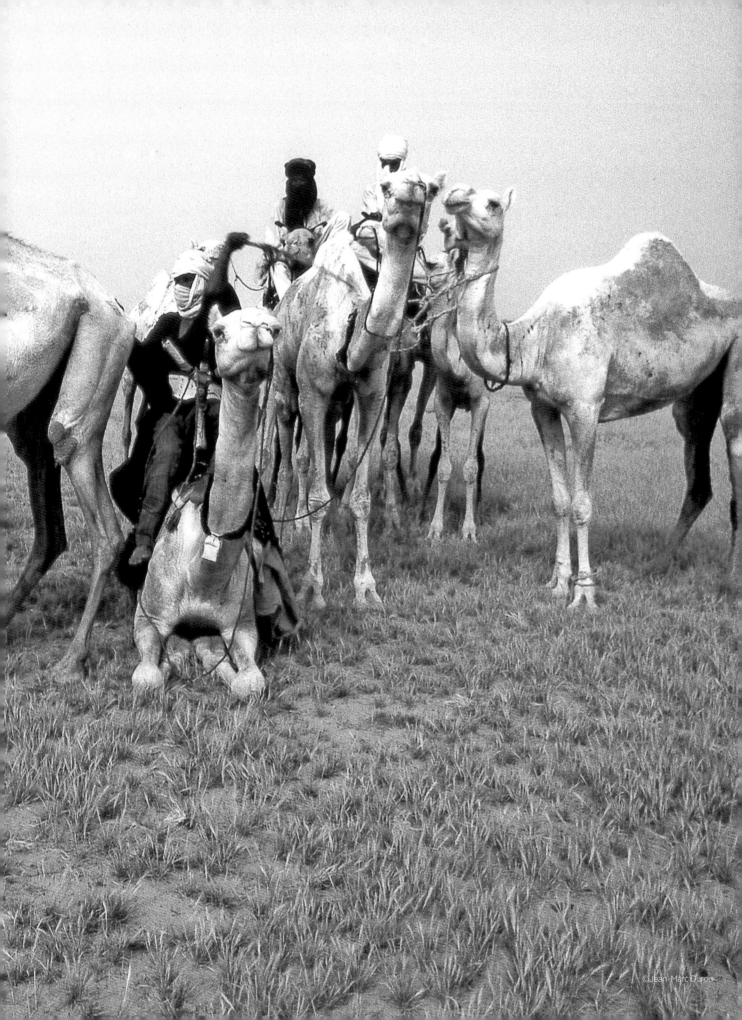

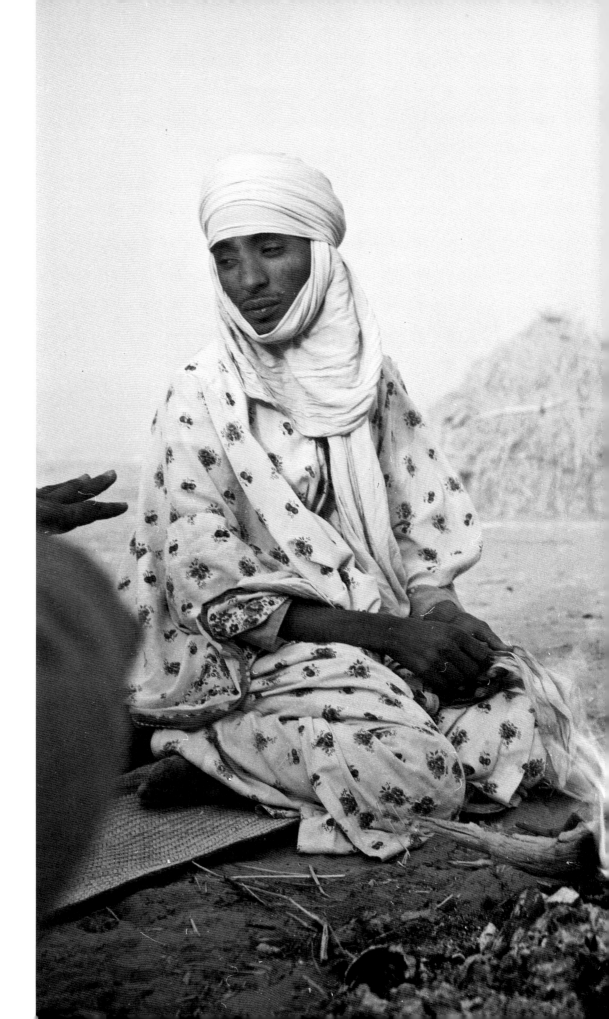

A Tuareg man and his
greyhound at home. The
greyhound is often present
in Tuareg camps - it is a
pet dog
©Bernus 1967/ The Bernus
Estate

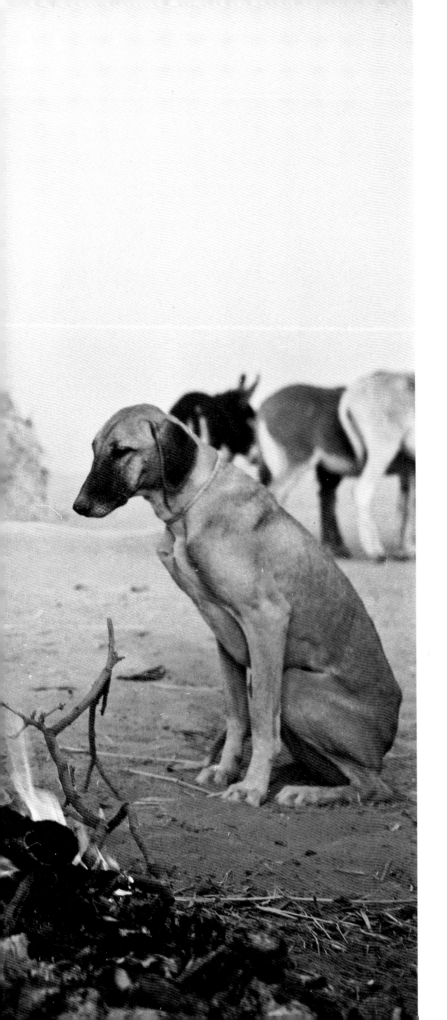

Introduction
Robin Hanbury-Tenison

I first travelled by camel with the Tuareg through the Tassili n'Ajjer mountains in 1962 just as Algeria became independent, and I was bewitched. Their world is profoundly silent. One becomes acutely aware of the slightest sound: the whisper of sand the murmur of the breeze. The Tuareg are at home there; they seem to delight in the sparseness and aridity, somehow making it rich and wonderful.

My two first Tuareg companions Mahommet and Hamouk, taught me to relish the pace of desert travel, as we covered mile after mile, mostly walking, sometimes riding on our camels. We drank only thimblefuls of sweet green tea and occasional sips of putrid water from our goatskins, but I have never felt healthier and more alive in my life than when on that and subsequent Saharan travels.

During the nineteen sixties I was able to make two more long desert journeys: to the Tibesti Mountains in northern Chad, inhabited by the Berber-related Toubou, and to the Aïr Mountains in Niger. After a long hiatus during the great drought which ravaged the region during the seventies and eighties, I was able to return to the Aïr and the Hoggar in the late nineties, renew my friendship with the Tuareg and make more journeys by camel.

Shortly before that region became impossible to visit due to the troubles following the fall of Gaddafi, I made my last long camel ride with a group of four Tuareg and nine camels through the heart of the Aïr Mountains from Iferouane to In Guezzam on the Algerian border. For forty days I was alone with people completely at home in one of the most hostile terrains on earth and yet completely at ease there- indeed revelling in every moment. With my old friend Kelakua, perhaps the finest *chamelier* in the Sahara, I was privileged to experience a minute part of their extraordinarily rich and varied culture.

When that is under greater threat than perhaps ever before – Kelakua was later killed by the Mali army because his son was a suspected 'terrorist' – it is vitally important that the full illustrated story of the Tuareg is told in this timely and inspiring book. The photographs capture the grandeur of the Sahara and its graceful, elegant, proud people. The text tells the real story of what has happened and is happening there today, a story constantly misunderstood and misrepresented by the media, but here revealed and described with absolute authority and sympathy.

Taoudenni

T A N E Z R O U F
DESERT

IFO
MOUN

MALI

KEL

8

Timbuktu

TUAREG OF THE
NIGER RIVER BEND
AND THE GOURMA

Gao

Niger River

OUDALAN

Ay

**BURKINA
FASO**

Edmond Bernus' acclaimed map of the 1970s shows the different Tuareg regions and their respective 'Kel' - or other *Imuhagh* groups, and the Tuareg's historic, un-monitored area of the Sahara, of when they were "free people". It also shows today's borders of the Tuareg's new, five nation states within this area. These borders are about sixty-five years old

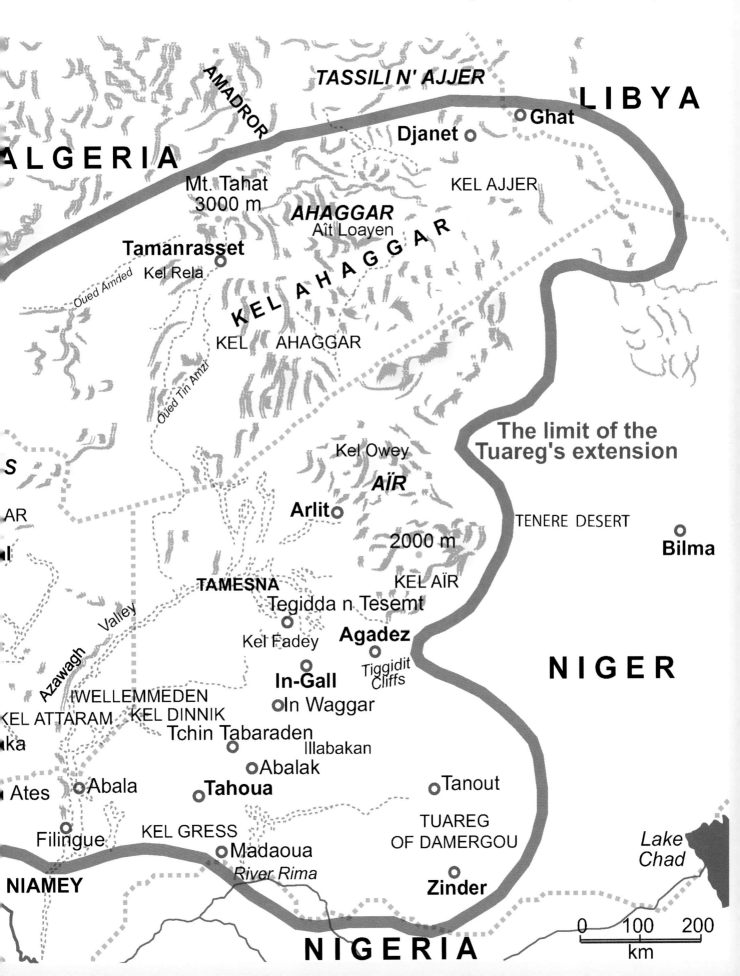

J. BERNUS after Berger-Levrault map *Les Touaregs*, 1984

LIBYA

TASSILI N' AJJER

AMADROR

○ **Ghat**

Djanet ○

ALGERIA

KEL AJJER

Mt. Tahat
3000 m

AHAGGAR
Aît Loayen

Tamanrasset

Kel Rela

Oued Amded

K E L A H A G G A R

KEL AHAGGAR

Oued Tîn Amzi

Kel Owey

AÏR

**The limit of the
Tuareg's extension**

S

AR

Arlit ○

2000 m

TENERE DESERT

○
Bilma

Tamesna

TAMESNA

Tegidda n Tesemt
○

KEL AÏR

Agadez
○

Kel Fadey

Tiggidit
Cliffs

NIGER

○
In-Gall

In Waggar
○

IWELLEMMEDEN

Azawagh

Valley

KEL ATTARAM

KEL DINNIK

ka

Tchin Tabaraden
○

Illabakan

○**Abalak**

○**Abala**

Ates

Tahoua

○ **Tanout**

Filingue
○

KEL GRESS

TUAREG
OF DAMERGOU

*Lake
Chad*

NIAMEY

○**Madaoua**

River Rima

Zinder
○

0 100 200
km

NIGERIA

Preface
Justin Marozzi

The Tuareg are arguably the least understood and most misunderstood people of the Sahara. On one level they have long been romanticised by Western explorers as the mysterious "People of the Veil", magnificently robed and veiled in blue astride their handsome white mehari camels, dashing across the dunes. This is the exoticism of the Orientalist. From this rose-tinted caricature it is just a small step to the parallel stereotype of the rapacious, raiding primitive, master of a dread world of treachery and brutality. This latter view is by no means limited to Western visitors. For centuries the Arabs living on the borders of the Sahara have referred to the desert as the *bilad al khaf,* or land of fear.

The Tuareg, a rich, startling and important book, illuminated by sumptuous photography, seeks to present a more multi-layered picture of a complex people who have mastered the challenges of living in what is commonly regarded as the world's most pitiless and inhospitable environment.

The Tuareg stretch across a vast and varied landscape encompassing the arid mountain chains and desert plains of the central and southern Sahara, from the Ahaggar and Tassili ranges of southern Algeria to the Aïr mountains in western Niger and the Ifoghas in eastern Mali. From these mountain heartlands, generations of Tuareg expanded across both the banks of the Niger river, and east into the southwestern fringes of Libya. Born into a world of limited resources and apparently limitless horizons, they are nomadic pastoralists par excellence, combining livestock herding with trading, raiding and agriculture, not to mention smuggling across the dangerous maelstrom that is the contemporary Sahara.

Henrietta Butler, mastermind and editor of this volume, has assembled an expert team of contributors. If there is a common theme in this book, it is surely the passionate interest of the authors in a marginalised people who once again are facing systemic challenges to their ancient way of life.

One of the most remarkable aspects of the Tuareg is their extraordinary affinity for the environment in which they live. As Jeremy Swift observes, in the early years of the twentieth century, some of the greatest

Saharan guides were blind and navigated by smell, wind and the taste of the soil.

Foreigners who have lived with and studied the Tuareg have frequently formed the strongest bonds of friendship with them. In a portrait of Edmond Bernus, the eminent Tuareg anthropologist, his daughter Caroline Bernus writes of how in 1968, when rioting students were running amok in Paris, Edmond was worrying about the seasonal rains of In Waggar. "I missed a moment in history, more concerned in whether there was fresh pasture" in Niger, he confessed. Edmond was a devoted student of Tuareg culture at its broadest level, from the Tamasheq language and literature and the Tifinagh script to the ancient traditions of wordplay, riddles, proverbs, poetry and songs. What he called his "happy research" - during a more peaceful time in Saharan history - also investigated behavioural codes and notions of time,

Bottom left:
Henri Duveyrier's 1861
sketch of his host,
Ikhenoukhen, the chief
of the Kel Ajjer, on his
dromadaire. Ikhenoukhen
saved the young explorer's
life from fanatical Muslims

Right:
The first depictions of
Tuareg, drawn by Captain
George Francis Lyon after
the journey with Joseph
Ritchie in Libya's Fezzan in
1818 - 1821. Unusually for a
European explorer at this
time, Lyon learnt Arabic
and went slightly 'native';
he had a great affinity
for the Tuareg. "They are
the finest race of men I
ever saw", he wrote, "tall,
straight, and handsome,
with a certain air of
independence and pride,
which is very imposing"

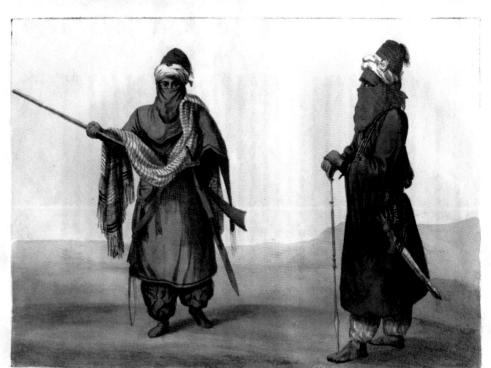

Drawn from Nature by G.F.Lyon. On Stone by M. Gauci.

TUARICKS OF GHRAAT.

Drawn from Life by G.F.Lyon. On Stone by D. Dighton.

A TUARICK ON HIS MAHERRIE.

space, and geography. If anyone doubts the richness of Tuareg culture, Mohamed Aghali-Zakara's essay is required reading and a testament to its enduring sophistication.

History suggests that for all their demonization by nation states, be they European or African, the Tuareg have more often than not been on the receiving end of aggression rather than meting it out themselves. Beginning in the late eighteenth century, then accelerating in the early nineteenth under the auspices of the Royal Geographical Society and its French counterpart the Société de géographie, foreign penetration of Africa increasingly spelt problems for the Tuareg and their homelands.

Henrietta Butler examines the extraordinary impact of these explorers. Men – and it was invariably men – such as Major Alexander Gordon Laing, the first European since the Andalusian Berber Leo Africanus arrived in around 1510 to "discover" Timbuktu in 1826, shortly before being killed by his guide; Frenchman René Caillié, showered in glory after going one better than Laing and returning alive; the irascible James Richardson, a fierce campaigner against the Saharan slave trade; most interesting of all, Dr Heinrich Barth, a generous-spirited, endlessly curious and humane linguist and anthropologist. Barth's prodigious work *Travels and Discoveries in North and Central Africa*, published in 1857, stands as a monument to the possibilities of open-hearted exploration. He dedicated himself to providing a radically different view of "apparently savage and degraded tribes", including the Tuareg, connecting them "more intimately with the history of races placed on a higher level of civilisation". Anthropologists still benefit from his research exactly 150 years after his death.

Against the backdrop of what foreigners have made of the Tuareg, it is refreshing to hear what the Tuareg think about us. Having had the benefits of a Saharan upbringing, Berny Sèbe, a specialist in colonial and post-colonial studies, is well placed to explain. He tells the splendid story of the Tuareg leader, *amenokal* Moussa ag Amastan, being resolutely unimpressed by his visit to Paris. "True, you French people have the Eiffel Tower, but we have Ilaman," he said, comparing the iconic Parisian landmark unfavourably with the volcanic peak of Ilaman, close to the Algerian town of Tamanrasset. As the Tuareg enjoy remarking to visitors, "Westerners have watches, but we have time." The Sahara moulds – and fortifies - the people who live here. "There is probably no better mirror to the vanity of human life than these vast expanses where human beings are crushed between rocks and skies whilst, paradoxically, their horizon widens up to well beyond infinity," Sèbe writes.

The modern political world has not been kind to the Tuareg. Colonial rule, the rise of nation states with rigid borders, the discovery of oil, post-colonial independence and attempts to curb Tuareg nomadism and settle populations in fixed areas have been bitter pills to swallow. Pierre Boilley, an historian of the Sahara, chronicles the narrowing freedom of the Tuareg at the hands of French colonial authority. Once the six principal political formations of the Kel Ahaggar, Kel Ajjer, Kel Aïr, Iwillimiden, Kel Antsar, and Kel Adadgh proved unable to unite against the conquest, they found their lands completely dominated by the dawn of the twentieth century.

The rise of political Islam, rebellion, revolution and jihadism have brought renewed scrutiny and pressures on the Tuareg. I have travelled with the Tuareg twice, once entirely peacefully during an expedition by camel across the Libyan Sahara, the second time less voluntarily during the Libyan revolution of 2011 when the Tuareg found themselves caught up in violent reprisals after Gaddafi's overthrow. After the initial scare of an armed hold-up and kidnapping, and once we had established they weren't going to kill us, it was one of the most remarkable experiences of my life. I can only thank the Tuareg for it. There was something reassuringly traditional about the whole episode. Even at a time of severe stress for the community, the youthful rogues and adventurers were unfailingly hospitable.

If there is any fear about the Tuareg today, it must be for their ability to withstand the latest wave of assaults from the outside world. They will require all their stores of courage, adaptability and ingenuity, forged in the furnace of the Sahara, to prevail.

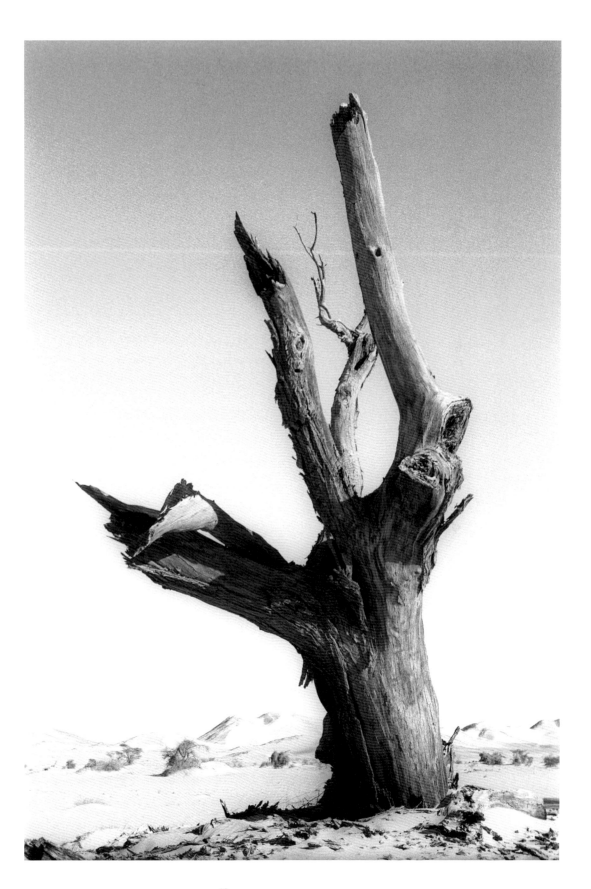

Right:
Zagado, 2002. On the
edge of the Ténéré desert.
The tree is the height of
about six or seven men

Page 20:
Tiguidit, 2005

*You will taste the honey
[of foreign riches], but
never leave the desert.
The desert purifies your
soul; away from it, you are
deaf and blind*

Mano Dayak's mother
to Mano

Pages 22-23:
Taguedoufat, 2005.
Tuareg take time greeting
each other, exchanging
standardised questions
asking about each other's
health and asking after
their families, particularly
if they are surviving the
heat, and if all is well.
The questions, and the
handshakes, the two
partly stroking the other's
palm then drawing their
hands away, then stroking
the palms again, may
take a good minute. They
are equally assessing
the person they are
meeting, if he might be
friend or foe, and what
the consequences of the
meeting might be

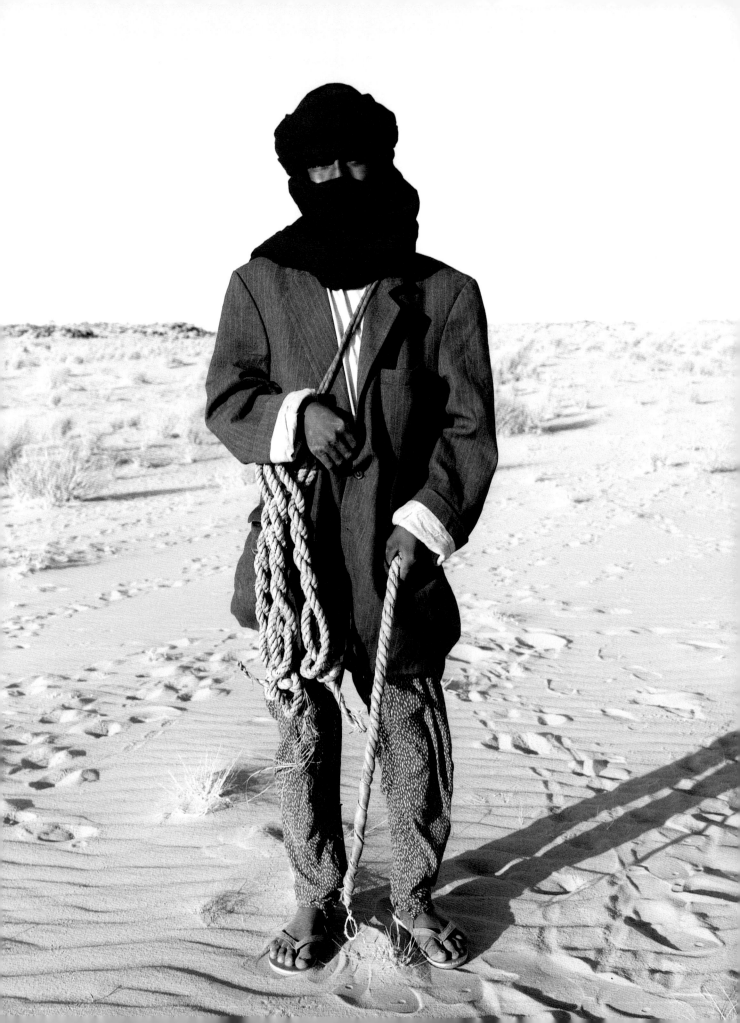

The Tuareg and a history of the Sahara

with photographs by Henrietta Butler, Jean-Marc Durou, and Edmond Bernus

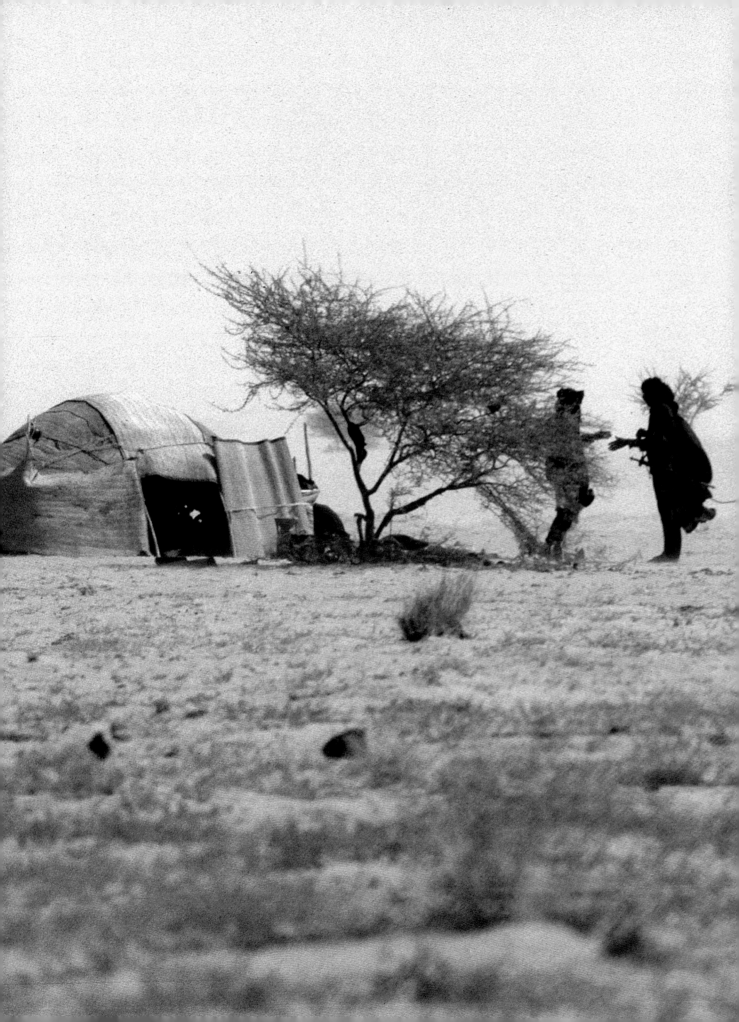

Indigo, the world's only natural blue dye, has been in continuous use for over five thousand years. The most widely used of all dyes, and among the oldest and best-loved, it is found on archaeological textiles of all the great civilizations. Extracted from various indigo-bearing plant species, its unique manufacture and dye processes led to its use for both everyday and prestige textiles and bestowed upon it special symbolic and cultural meanings. Its story spans many aspects of life and in the modern world indigo, available in synthetic form since 1900, is the hallmark of denim jeans, the longest-running and most universal fashion item ever known

West Africa is closely associated with indigo and the Tuareg are famed for wearing dramatic robes and turbans made from indigo-dyed cloth beaten to a high sheen. The turbans are worn with pride as a mark of status, for protection and for celebrations

Jenny Balfour-Paul, author of *Indigo*

Chapter I
Who are
the Tuareg?

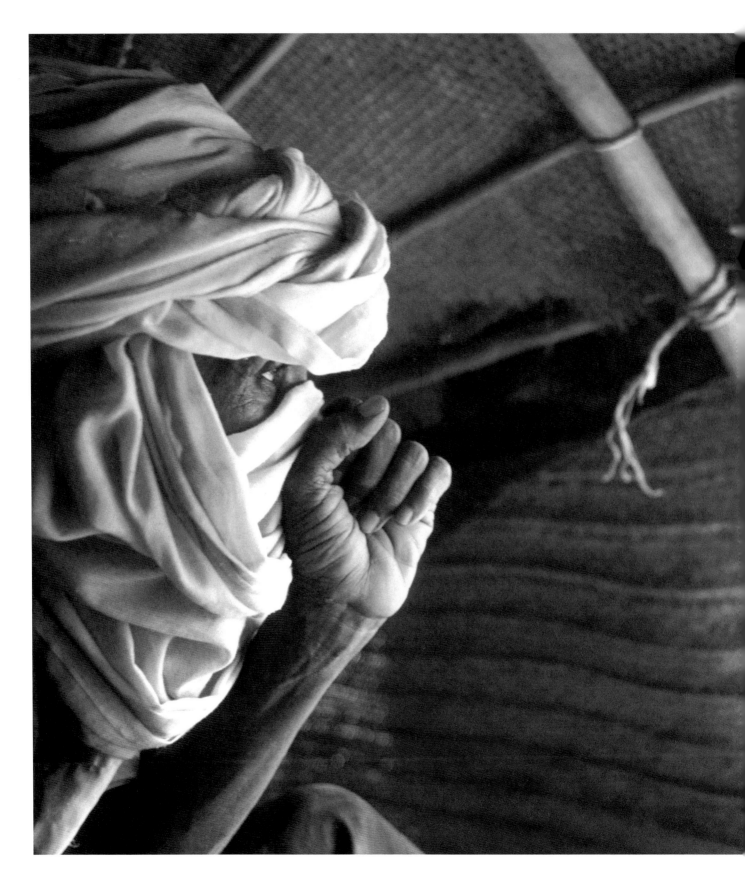

FROM THE SEA-SHORES TO THE DESERT: ORIGINS OF THE KEL TAMASHEQ

Much about the Tuareg is mystery: where they are specifically from is still vigourously debated; their writing is a system of codes; their language is full of metaphor, indirect and couched in symbolism, and the notion of trust is widely mistrusted. The Tuareg call themselves "free people" but the class structure that orders their society is more rigid than the rocky landscapes that some of them inhabit. They are Muslim but the society is matrilineal, and it's the men who are veiled, women are unveiled.

Many Tuareg descend from groups of people with roots all along the Mediterranean shores. As proof of an original territory, the earliest examples of the Tuareg's hieroglypic script (Tifinagh), are found as rock-carvings in Dougga in Tunisia, formerly in a region called Targa. Karl-G.Prasse is a current authority who marks Targa as a precise area of Tuareg origin, and from where the name "Tuareg" derives. The Tifinagh characters have a Phoenician character which could however place some Tuareg ancestors further east in Syria, Lebanon and Israel. Some Tuareg perhaps descend from the Garamentes, fierce defenders of their territories during the Roman invasions of Africa in whose regions live the Kel Ajjer (which means the people, *Kel*, of Ajjer). Others, the noble Kel Ghela of the Kel Ahaggar (or "the people of Ahaggar"), of south-eastern regions of Algeria descend from Tin-Hinan, the Tuareg's 4th century Queen whose tomb at Abalessa, southern Algeria, was excavated in the 1920s. Some, a servile class, notably the Dag Ghali of the Kel Ahaggar descend from Takama, Tin-Hinan's servant-companion. However, as Paul Pandolphi, a specialist in Tuareg history and culture says "there remain numerous versions of this historical myth". Some say that some Tuareg were indeed originally Jewish, hence the conundrum of blue-eyed Tuareg - or perhaps this is a genetic throw-back from more ancient Caucasian roots that others state. Francis Rodd even hypothesises on possible Viking links.

Now, all Tuareg live deep in the Sahara desert. The major six or seven mostly "Kel" groups are categorised by Europeans as "confederations"; each confederation

If you decide to go into the desert
Learn first humility
For there when you place your feet
No noise will be made
Know that in the immense silence
You will hear only the beats of your heart . . .

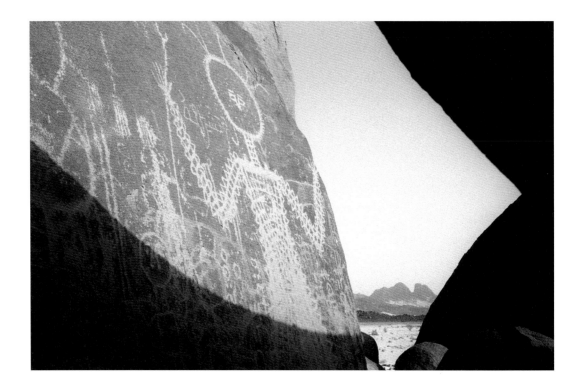

may have hundreds of smaller "Kel" or other groups; this Kel name may also relate to the region they live in, or indeed historically lived in. It can be muddling to understand that the Kel Ferwan from Iferouane, for instance, actually no longer live anywhere near Iferouane. The single confederation is a political unity or "*tobol*", taken from the name of a drum. The confederations are therefore "drum" groups and the drum, the property of the Amenokhal, or King (to whom each smaller group traditionally paid taxes or levies for protection), is used to gather people at important political meetings.

Descending from all the different areas - or peoples - as they did, and (what is easy to forget), with the groups living hundreds if not thousands of miles apart, the key to understanding complicated inter-Tuareg politics (politics being at the root of much about the Tuareg and their social unity or disunity), is appreciating that the drum groups were never united - foreigners who know little about the Tuareg often assume otherwise. They may inter-marry - and traditionally they may have found themselves fighting their relatives in one of the frequent raids or *razzias* that the Tuareg traditionally survived by economically - but the groups always had different political motives; any alliance might last for just a short period.

With the drum groups based in often vastly different physical terrains, specific ways of economic or daily life are furthermore different in most Tuareg regions. Some may practise nomadism - or, more correctly, transhumance, as the Tuareg are semi-nomadic pastoralists - with camels, if they live in the desert, while others, such as the Dag Ghali of Ahaggar who live in brutal rocky terrain, have goats - camels could not survive here as there is not enough pasture. But - to complicate things again - before the birth of the current states of Algeria, Libya, Mali and Niger, the Dag Ghali traditionally kept camels in Tamesna, northern Niger. The groups were politically distinct but they would still unite (if not at a time of hostilty), such that all and any groups mingled and meandered here and there according to pastures for the livestock. Culturally, they were all Tuareg.

Pasture-land always dictates groups' movements, not, as could be thought, the presence of wells or water. And people follow the camels, or goats, in their search for pasture, not vice-versa. Water can be found more easily than pasture, even when it is not visible - holes can be dug, for instance. But not of course deep in the deserts of scorching dunes - but the Tuareg don't live in the dunes, which can also be mis-understood. They live near oeuds, dried up river beds, large valleys that may even flood during the sometimes torrential downpours (one should never camp down in a oeud, it is not uncommon to hear

Below:
Agadez street, 2005

Pages 30-31:
Such a mother; such a
daughter
Everything comes to you
from your mother
Souéloum Diagho

stories of people being swept away in the middle of the night). Or Tuareg live by or in mountains where there are gueltas or sometimes ponds. Some live in small villages with plentiful irrigated gardens. Gardeners are settled - the warriors or nobles slightly look down on them for this but equally they depend on them. There are also beautiful oases with long valleys of date palm trees that look up to a hundred feet tall.

As in any culture, mysterious myths explain the unknown. Rock-carvings of alien-like people and tifinagh writing and animals that lived in the Sahara when it was a lush, forested landscape are strewn all over the desert. For the Tuareg, the alien-like people are the "people from before". Indeed, no-one knows who these figures represent; they are uncannily like the supposed visitors to Roswell in New Mexico in 1947. The most significant mythical hero is Aligurran, the creator of Tifinagh and poetry. Poetry, sometimes sung to the revered *imzad* (best described as a one-stringed violin), is the most treasured cultural art.

The Tuareg use the cross symbol widely - on their shields for one, and as highly worked crosses - notably the Agadez cross and its now 21 variants - worn around the neck. As an oral culture, visual signs, or symbols take on great meaning. The Agadez cross is a powerful Tuareg emblem, the variants are named after the different regions of Aïr and given by men to women as tokens of love, or from fathers to sons as protective charms. The 22nd variant was made in the late 1990s in memory of Mano Dayak, the rebel leader of the Tuareg of Niger's first rebellion. The influence of the cross could be Christian

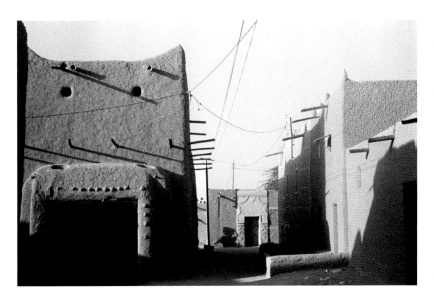

or after the Southern Cross. The Tuareg import whatever pleases or is useful to them into their culture - besides warriors they are significantly also traders. The oldest swords come from Spain; all swords, or *takuba*, are similar to the swords of the Crusaders. The merchants travel in every direction across the deserts - Lyon, for instance drew a picture of a Tuareg man from Agadez (similar to those of page 19), in Libya: goods come to the Tuareg from far and wide. (Barth even found cloth from Manchester during his travels). The key item in the Tuareg wardrobe comes from Nigeria: the rich indigo cloth which is used as a veil on special occasions.

The origin of the Tuareg's veil for which Tuareg are universally known is a complete mystery. Whether to keep bad spirits from entering otherwise normally exposed orifices or merely as a protection of these from the dust of desert winds, the veil has become a fundamental distinction of what it is to be a Tuareg. It is worn the whole time - even these days it is rare to see someone one doesn't know well unveiled. It is most respectfully worn high above the nose - in front of a mother-in-law or a prominent elder for instance - but it will be raised or lowered according to the status of the company a man is in. If amongst equals it will be loosened and lowered, but the moment a man of a higher class appears, or a stranger, or a woman, all will hurriedly whip it up above the nose. The most senior man of the group however doesn't need to wear the veil at all, if amongst men. As Rodd says of the veil, "only when the riddle of [Tuareg] origin is solved will an explanation probably be forthcoming".

The town of Agadez, left, is an ancient trading crossroads, marked along with Timbuktu on the oldest maps of the Sahara, and historically inhabited by people of other African groups to Tuareg - but it was still controlled by Tuareg from the desert. Its decorative architecture is Sudanese (not Tuareg), and it is otherwise notable for its mosque and curious Sultanate. Popular history tells how the constantly warring Tuareg realised they needed an overlord - a referee for their disputes or a judge to help resolve contentious issues. With Constantinople the most powerful city of the Muslim world then, they sent an envoy to the Sultan there asking him for a suitable candidate. The Sultan of Constantinople sent a son of one of his concubines - the current Sultan of Agadez is the direct descendant of this man. Importantly, the Sultan of Agadez is not a Tuareg and he may never marry a Tuareg woman; he is impartial to all Tuareg groups.

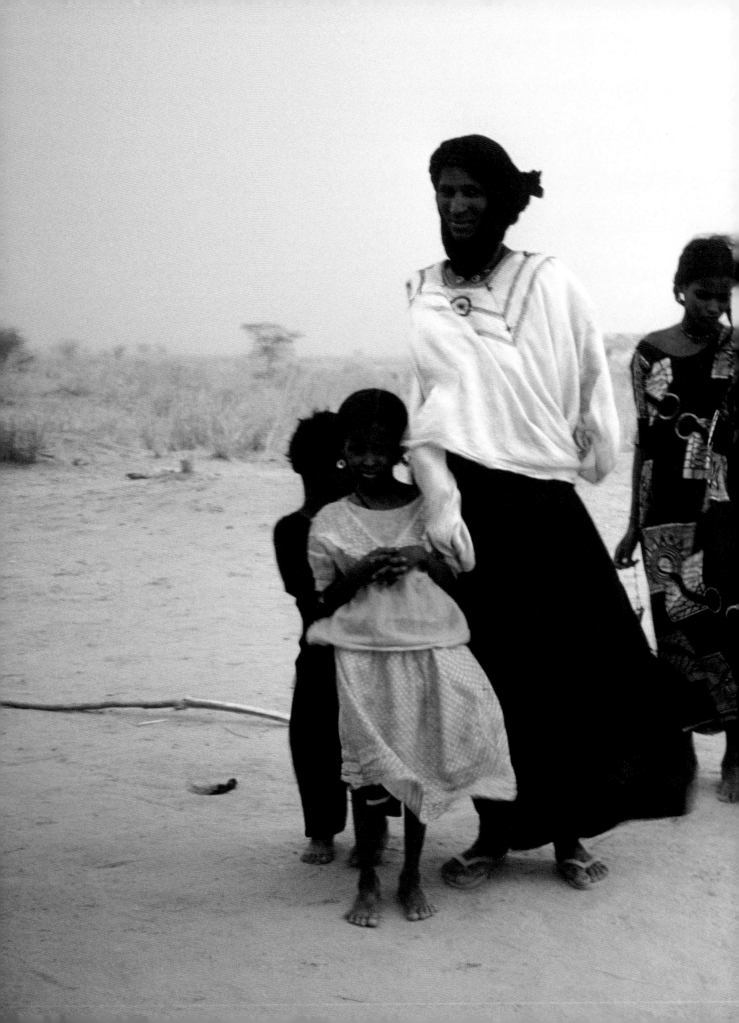

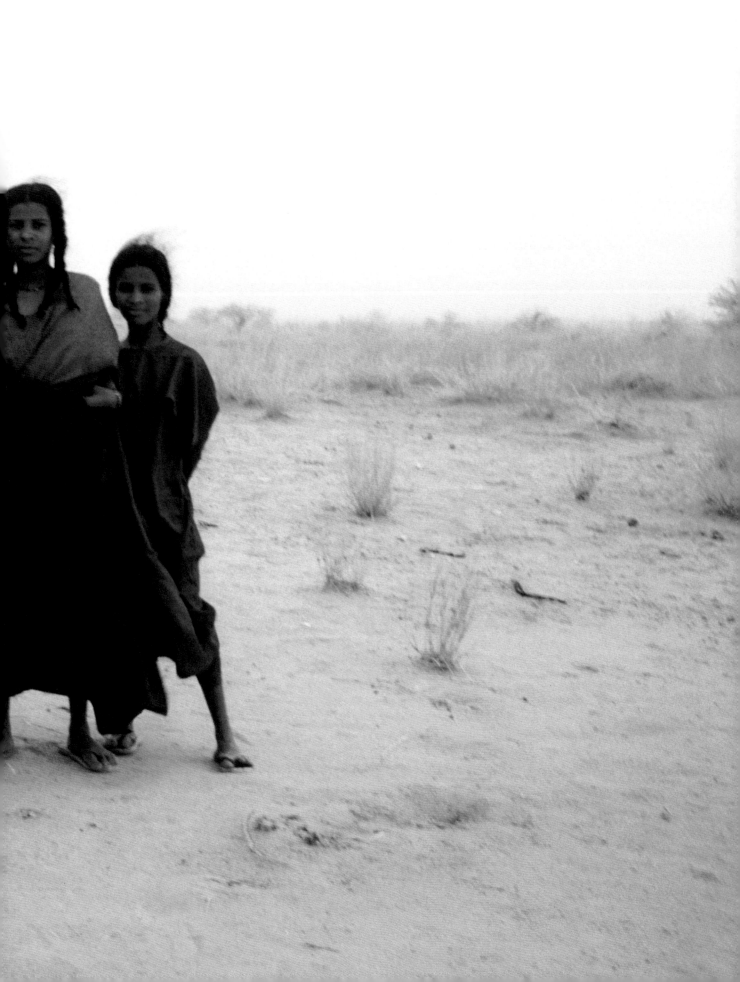

*There is not a Tuareg who doesn't exalt their mother. She is
the soul and the heart of the desert. She does the hardest work
when the caravans leave. She looks after the animals, grinds
the corn . . . and educates the children. She is gay and happy.
In the evening she sings, dances, recites poetry, and plays the
Imzad, with melodies that calm or exalt women and men*

Mano Dayak

IT'S A WOMAN'S WORLD

At the start of the 20th century, Tuareg women were freer than women of any European or westernised country. Tuareg men see women as equals, for Tuareg neither men nor women are dominant. Men and women do do things separately - notably, they eat apart (it is indeed shameful for a man to eat in front of his mother-in-law), but legally, women have powerful rights, and what we would consider extraordinary liberties.

As young teenagers women can experiment sexually with no thoughts of improper behaviour. The *ahal* (or poetry *soirée*), is the venue for courting and young Tuareg flirt freely. There are particular ways however that a young men must approach his lover's tent, now in the dead of night - totally silently, from the side and not the entrance, and remembering that his lover's mother and siblings sleep there too, but the couple may amuse themselves however they like, for as long as they like, so long as the young man creeps away, equally silently, before dawn. Co-occupants of the tent will feign ignorance with great discretion. The next night, if she likes, the girl may entertain herself with another boy. Until she is married, the Tuareg girl may have as many boyfriends as she pleases and, perhaps because of this freedom, she may not actually get married until about twenty. Even when married, women may maintain close platonic male friendships. Ibn Battuta, travelling through Aïr in 1353, was famously shocked when he stumbled on a married woman with a man alone togther - though they were not up to mischief he thought the whole idea was quite inappropriate.

On marriage women receive dowries from their mothers - notably a tent, her new home. She will also be given animals - whether camels or goats, whatever the family can afford. Both the tent and the animals remain the woman's property during the marriage, and her husband comes to live in her family's camp. And children will belong to the mother's Kel group.

Traditionally, many Tuareg men inherited status - a title for instance, or wealth - from their mother's brother, the society being matrilineal. (A man's son will not necessarily inherit an important political role from his father). Although the society is not matriarchal, where women hold the political reins, it is usual to see women sitting a short distance from men involved in political discussion. They'll not add to the conversation but after the meeting, behind the scenes, men will discuss the issues with their wives, or indeed their mothers.

Divorce is considered quite normal, if not usual: the Tuareg are "serial monogamists", as Jeremy Keenan says, and Tuareg men expect to have at least two wives, crucially, considering they are Muslims, at different times. On divorce, women will automatically keep all the couples' possessions. Sometimes the man will find himself walking away with just his camel, and he'll return to live at his mother's camp, which will also be his sister's camp, if his mother may have died. (Today, sadly, with the influence of greater contact with Muslims of other African groups, some Tuareg men eye the supposed pleasure of more than one wife at the same time with envy, but they know the unhappiness this would bring. Some pursue this Muslim right but it is unlikely that the trend will take off in Tuareg society, where women and their well-being is so treasured).

Arriving at any campsite, the first person that a Tuareg man will go to greet is often his grandmother, or the most senior woman elder. Women can live up to exceptional ages in the desert - one will often meet women over a hundred years old. Perhaps it's because their diet is healthy but, although they work hard, doing everything at the campsite - cooking, bringing up the children, helping the children learn to write (when they can), and looking after the animals (young or unmarried boys and girls will take the herd the kilometre or two or three, or sometimes ten kilometres to the well), women are equally revered, and looked after. "Everything comes to you from your mother", Tuareg men say.

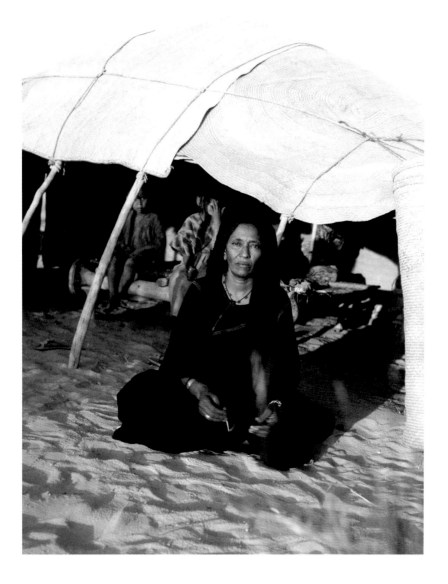

As the Tuareg's traditional structure has been turned on its head, few Tuareg now understand Tifinagh, which they will have learnt to write in the sand. Previously they were all literate, as Captain Bissuel remarked of Kel Ajjer groups in the 1880s, "Apart from rare exceptions, nearly all the Tuaregs of the west, men and women, know how to write".

Of course noble women don't work (like noble men). They are literary, and besides bringing up their children, they might compose poetry or play the *imzad*. They might also spend hours tressing their long hair into tiny neat plaits and generally making themselves beautiful - which Tuareg women really are. Like the women of our upper- or rich classes, they might largely spend their time involved in hobbies.

Despite their love of music, Tuareg women don't dance, this would be undignified - and for this same reason noble men don't dance. The dance itself, by other Tuareg men, is a furious stomping knees-up, so strenous in the heavy sand that each man will only dance - with the odd lance or sword as a prop - for barely half a minute. Like much in Tuareg society, it's a great show of display, here for the women, who are singing and playing a *téinde*, or drum. But there is nothing that brings Tuareg men to their knees more than hearing a beautiful woman play the *imzad* and sing poetry.

Right:
The talking tree. *L'arbre qui parle* is how Edmond Bernus captioned this photograph. The tree shows messages in Tifinagh to passers by, whether short odes of love between lovers, as much of our graffiti does, or specific messages with regard to local circumstances - where the nearest well may be, or where such and such a group may be camped

The tree is an Agar (*Maerva Crassifolia*), a species considered by Tuareg to be inhabited by spirits. Its thick, thorny vegetation also offers lush food for camels and superb shade for people

NOMADIC LITERATURE

LANGUAGE, POETRY, PROVERBS, AND SAND (OR ROCK) SCRIPT: THE ORIGINAL GRAFFITI
by Mohamed Aghali-Zakara

The word Tuareg is applied to a Berber people who the Arabs call *Targui* (in the masculine) and *Targuia* (in the feminine). The etymology of the word Tuareg is therefore Arabic, coming from the name for the province in the Libyan Fezzan called Targa, where the first people who were called the "people of Targa" settled.

The Tuaregs are one of the Berber peoples referred to as Imazighen (or *Amazigh* in the singular), a term used across the Maghreb. Like all Berber speakers, the Tuareg refer to themselves in their own language, whether this is Tamahaq or Tamasheq or Tamajaq. The Tuareg use the prefix Kel, which means 'the people of', followed by the name of one of the numerous population groups. The combination of the group name with that of the place name allows one to easily locate and identify the *tawsétén* or the "confederations" - the large Tuareg groups.

Kel-Ahaggar and *Kel-Ajjer*, of the Ahaggar and the Ajjer in Algeria and Libya respectively.
Kel-Denneg and *Kel-Ataram* or *Iwellemmeden* of east and west of the great central plain of Azawagh of Niger and Mali.
Kel-Ayar of Ayar in Niger.
Kel-Adagh of the *Adghagh* of the *Ifoghas* in Mali.
Kel-Gurma in the bend of the Niger River.
The Udalan in Burkina Faso (an eponym without the *Kel* prefix).

The language variations are principally phonetic, influenced by other languages spoken in the various regions but the differences do not affect comprehension between the groups, despite the vast distances which separate them. The main variants of the Tuareg language are *Tahaggart, Tayart, Tadghaq*, and *Tawellemmet*, followed by a range of peripheral dialects which remain under-researched or have very small numbers of speakers (*Tajjert, Tamesgrest, Tafaghist, Tadabbakart*). Currently, all of these speakers are regarded as a unity designated by the term "Tuareg" who talk "theTuareg language". This generic term is useful as it states implicitly the unity of this Berber sub-group linguistically, which comes from the large family of hamito-semitic or afro-asian languages.

Culturally close, Tuareg societies have conserved certain particularities despite changes to their way of life today. In fact the move from a nomadic way of life to agricultural or, for some, urban life, and contact with other communities – Arab society in the Sahara and various African societies in the Sahel – has led to the formation of new words as a consequence of interaction with these heterogeneous languages.

Nevertheless, the principal socio-cultural elements remain, and underline the continuity of the elementary aspects of identity - notably the richness of the language, the attachment to the Tifinagh script, and the diversity of literature in prose and verse.

The Tifinagh Script

In Africa, outside of Ethiopian and Arab scripts, only the Tuaregs have their own script: Tifinagh. It is the continuation of Libyan writing which dates back further than 2,500 years. The most reliable source of the origin of this Libyan script is a bilingual Punic-Libyan stele discovered by Thomas d'Arcos in 1631 at Dougga of antiquity, Thougga, in north-western Tunisia. Thanks to knowledge of the Punic, almost all the Libyan characters have been identified. On this stele, the inscription known as RIL 1 is the first in the *Series of Libyan Inscriptions*, a corpus reconstituted by Abbé Chabot in 1940. However it is the inscription RIL 2 of this corpus which, dedicated to Micipsa, son of the Numidian king Masinissa, allows historians to date the writing to his reign – 149 BC.

There are numerous oral accounts, or historical legends, in all Tuareg regions of the Sahara and Sahel concerning the origins of *Tifinagh* (a feminine word in the plural); many versions converge on common elements that Tifinagh was created by two mythical characters, Amerolqis and Aligurran.

Amerolqis was a libertine giant of a far-gone age when the rocks were still soft, or not set; on these he traced the signs one finds today. He was a cultural hero, the inventor of poetry, music, and writing; he would have stolen the Tifinagh script from a higher power before the arrival of Islam. Tifinagh is considered the devil's script by religious Arabists, devout Tuareg and other Muslim believers, the script of reference being the sacred writing of the Quran: only Arabic characters are considered to be true script by these religious groups.

Aligurran, or Anigurran depending on regional

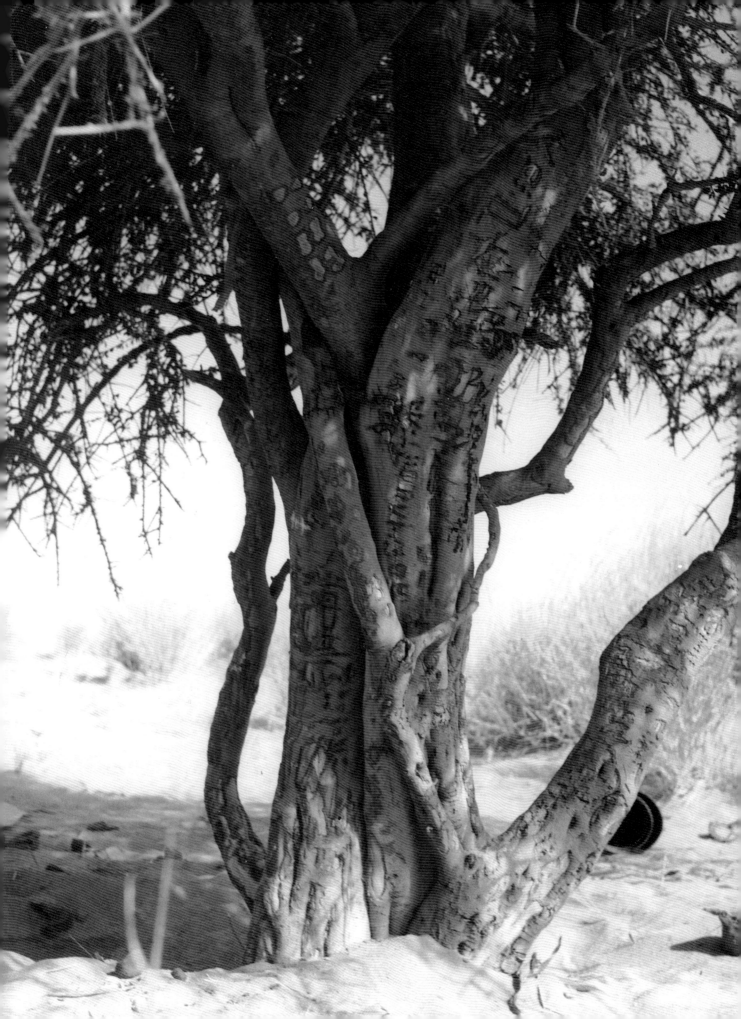

	Ahaggar *Algérie*	Ghat *Libye*	Aïr *Niger*	Azawagh *Niger*	Adghagh *Mali*
a	·	·	·	·	
b	ⴱ	ⴱ	ⴱ	ⴱ	ⴱ
ḍ	Ɛ	Ɛ			Ɛ
d	⊔ ∨	⊔	Ɛ	Ɛ	∨
f	ⵀ	ⵀ	ⵏ	ⵀ	Ɪ
g	ⵛ	Ⲧ	Ⲧ	Ⲧ	Ⲧ
gʸ	Ⲧ	Ɪ			××
$/gh	⋮	⋮	×	⋮	⋮
h	ⵛ	Ɪ	ⵥ	ⵥ	Ɪ
j	ⵛ	Ɪ	ⵥ	ⵥ	Ɪ
k	∴	∴	∴	∴	∴
l	‖	‖	‖	‖	‖
m	⊏	⊏	⊏	⊏	⊏
n	ᛁ	ᛁ	ᛁ	ᛁ	ᛁ
nʸ	≠				
q	⋯	⋯	⋮	∷	⋯
r	○	○	○	○	○
s	⊙	⊙	⊙	⊙	⊙
š/ch	₢	₢	₢	₢	₿
t	+	+	+	+	+
ṭ	Ɛ				
w	⋮		⋮	⋮	⋮
x/kh	∷	∷	∷	⋯	∷
y	ⵏ	ⵎ	ⵎ	ⵏ	ⵎ
z	ⵥ	ⵥ	ⵥ	ⵏⵁ	ⵥ
ẓ	ⵁ	ⵥ		ⵏⵁ	ⵁ

variations, is a charismatic leader, a genuine social role-model blessed with superior intelligence and able to solve all the problems of daily life faced by the nomadic pastoralists. His tomb would be close to the cave where he would have lived and which carries his name. Both inside the cave and in its immediate vicinity there are numerous Tifinagh inscriptions on all rock surfaces. Aligurran is the author of these say indigenous Tuaregs.

The Characteristics Of Tifinagh

Traditional Tifinagh characters (or *tifinagh ti n ersel*, the original set of characters), are graphic, composed of geometrical signs such as lines, circles, and dots; and the script is consonantic. The dot – *tereqqémt* – is only written at the end of a sequence of characters or the end of a message. Most ordinary messages begin with the words *awa näk*, or 'it is I', followed by the name of the writer. There are many alphabetical series which have between 22 and 27 single characters according to the region. The characters have a range of variants and fixed signs as one can see in the principal alphabets. There are also bi-consonantal characters which result from the combination of two characters or the shortening of a single sign, but also from the change of orientation of the same sign.

Learning And Using Tifinagh

In traditional writing, the signs can be written in all four directions, dependent on the space available (vertically from bottom to top or top to bottom, or horizontally from left to right or right to left). One can also write in boustrophedon [bi-directional script], notably in games or riddles.

Tifinagh is learnt informally by young Tuareg during play with each other, although some may learn it from their parents or relations. In the majority of cases however, it is during games that Tifinagh is learnt. When exchanging riddles, the young girls and boys amuse each other writing the alphabet's signs on the [sandy] ground. Acquisition is based on the the common method of focusing on familiar points of interest - writing ones name, for instance, or the names of friends, relatives or objects of daily life. Most of these exercises are done on sand, the obvious medium of choice: one writes, then rubs it out, it's a child's game…one begins again until having mastered the simple signs. Progress is rapid due to this didactic technique based on play.

Besides these traditional methods used by all Tuareg communities, there is a small, well-known mnemonic formula - with regional variants - which contains nearly all the signs (those not in the mnemonic are learned separately). This technique is not particularly abstract as the content corresponds to social practices common in several Tuareg regions:

ⵀ Ɛ ⊏ + ⫶ ‖ + ⫶ Ɛ ⊙
Fademata wəlat Awadis | Fademata daughter of Awadis
‖ ⊏ ᛁ ⊙ ⫶ ○ + + ⫶ Ɛ ⊙
elam-nes wər itətwədis | her skin is not to be touched
+ Ⲧ ‖ + ᛁ ⊙ ⊏ ○ ⫶ ⵎ ⊙ ᛁ Ɛ ⊙ Ɛ ⊙
taggalt-nes mərăw yəsăn əd səḍis | she has a dowry of sixteen horses

Young Tuareg play other linguistic games, notably for conveying intimate messages; these have private signs or codes to avoid any temptation of unwanted reading. Equally, there are competitive games where pictographic riddles, logograms, palindromes in graphics and line-ups of similar signs must be guessed. This could be a word, an expression, or a phrase. A palindrome, below, is a series of characters which can be read two ways, both left to right and right to left:

⊙ ⊙ ⊙ ⊙ ⊙ ⊙ ⊙ ⊙

asu sa s osäs essa susas | Go over to where he has hung
up seven straps

‖ ‖ ‖ ‖ ‖

ilelli ila elil | The nobleman has a bag

Elsewhere, one finds examples of Tifinagh as
engravings on rocky walls, trees, on certain everyday
objects and, more recently, on paper - as records of
taxes levied by chiefs, for instance, or as private letters.
As records of taxes levied by chiefs, for instance, or
as private letters. (Most of these older examples don't
exist any more; a few are held by the military or in the
archives of the Père de Foucauld). Artists and craftsmen
often use Tifinagh to sign their work, implicitly
stressing their original identity as that which drives
literary production.

Literature

The diverse range of literary genres shows how very
rich and varied Tuareg literature is. The categories
of literary production both help us gain a better
understanding of Tuareg society, and reveal its essence.
The different literary forms are intimately linked
with the concrete realities of this society. There are
three major classic genres: prose, poetry, and a hybrid
rythmic form of short phrases such as proverbs, riddles,
and aphorisms.

The lexical field of the names designating literary
forms is diverse, not only in terms of the form and the
content but also according to local usage and the varying
dialects. A comparative study shows the instability of
the domaine covered by certain denominations. The
term *tanəqqist* in Ahaggar, for example, covers a vast and
semantically varied range of forms, including stories,
factual accounts and tales. In Azawagh, however, each
of these forms has a different name: *tanəqqist* for stories,
əlqissät and *tanəfust* for factual accounts, while longer,
historical accounts are called attarix and tales and fables
are called *emăy*. It is in fact the *tawəlləmmət* dialect in
Azawagh where one finds the largest number of terms
characterising specific literary forms which are founded
on precise concepts - such as the didactic delivery of a
lesson or that of veracity/authenticity as opposed to the
purely imaginary.

What is most important (*almaɣsud*) in a text is to
find the underlying meaning (*almaɣna*) to a collection

of *iggităn* which articulate the text – of a presentation
which shows a hidden meaning to decipher. L' iggi (pl.
iggităn) is the term for everything with an implicit,
hidden meaning - such as rhetorical devices, metaphors,
allegories and parables. This first concept of figurative
meaning develops *tarɣəmt* - advice, education, or
admonishment - which illustrates things that are
preferable [in society] - in other words, to not risk
consequences. It explains the norm, and the setbacks of
transgression from the norm, explaining faults and their
punishment. This dialectic is developed differently in
two categories of texts: those which are considered as
"untrue", and those considered "authentic" – *tidət a
imôs* or "this is the truth".

In the first category, tales and fables, *imayyăn*
(sg *emăy*), where the actors are animals and/or humans:
the narrative is not concerned about real facts and
everyone is aware of the reason for the substitution
of fictive actors for actors of normal life. The fable
permits a liberal represenatation of the society and its
surroundings showing what is significant for members
of the audience, a method that is well known by all
authors of fables. In any society, tales and fables must
evoke what is specific for everybody in a disguised
fashion, to be understood and reach their goal, which is
tarɣəmt. The animals talk and act like humans.

"The lion and his friends were walking along one
day when, meeting a herd of animals, they took one
and slit its throat, putting it under the embers to cook.
When the animal was cooked the lion said to his friends,
"How do you think we should share out the meat?".
The fox replied contrarily, "There will be no sharing.
You will take the best bits and leave us the toes". The
lion grabbed the fox and wrung his neck so violently
that his eyes popped out, and the lion let the corpse fall.
Turning to the jackal, he said: "So how are we going to
share out the meat?". The jackal, tamely, replied that
they would all wait for the scraps that he would leave
them. "Who taught you to share like that?", asked the
lion. "The fox's eye," replied the jackal".

The lesson is one of daily life: it is risky to contest
hierarchy in a structured society, and tameness can be
an opportunistic ruse – opportunism is the habitual
behaviour of jackals. Meanwhile, the practice of
slaughtering and cooking an animal under the embers
of a fire is common in the bush and corresponds well to
the habits of semi-pastoral nomads.

In the second category are texts considered as
authentic (*tidət*): principally *əlqissät* is the account of

facts considered as coming from reality. The point of departure is reality – or what is considered as such – which is the guarantee of authenticity, regardless of whether proceeding events are imaginary or not. What is important is *taryəmt*, the social or religious moral that is delivered, as in the story of Solomon: slander is poor counsel and Solomon, a sacred person in religious texts, legitimises its sanction. The function of the text is given in the title: *əlqissăt n ənnəbi Solayman taryəmt i təkijit fəl igat n awal*, or "The story of Solomon who taught the chicken a lesson about gossiping" (or literally, an abundance of words). Relating to the word *tidət*, or truth, shorter texts are called *tanəqqist*, sometimes *tanəfust*. It is characteristic that, for Ahaggar, Foucauld's dictionary gives multiple meanings for *tanəqqist*: "short story, tale, fable, apologue, parable, anecdote, account of adventures or events true or false", and, by extension, "back-and-forth, chat, insignificant talk".

Another "true" form is *attarix*, which is a long text, generally historical, telling the story of religious figures, or legendary historic heros. Whether authentic or apocryphal, it's their example which makes the *taryəmt* - associated with the history of the group it reinforces their identity. Such is the case with *L'Histoire des Kel-Denneg* (1975), for example, transcribed by Ghubeyd Ag Alojaly (*attarix ən Kəl-Dənnəg*), who mixes prose and verse material taken from several centuries.

One sees that, being at the interior of Tuareg society, the variety of denominations and the fields they cover must be examined extremely carefully. The limits of each "genre" need to be seen in relation to the form, which may be prose, poetry, rhythmic prose – or a combination of the three, as in sung fables. All the while, due attention must be paid to the concepts of classification and the varying degree of knowledge which the speakers have regarding the differing terminology. The theme also has a role in defining how the text is received and identified with.

The notion of *tidət*, truth, can include the marvellous and the supernatural, and the same can be said of religious stories which have become hagiographic legends about the lives of the saints and the Prophet. It becomes clear that these protagonists are very much alive in the prose, and in the special "genre" of poetry, especially in the long poems recounted in evenings of Muslim liturgy, called *təmmal*.

Poetry is the most appreciated form of literature in Tuareg society. Poets know how to construct it with humour and satire, as in prose texts, as a way of reminding people of the society's values of good behaviour, dignity, modesty and reserve – notions contained in the crucial Tuareg terms *esshak* and *moni*. The poem, *Ameruka, disette et dignité*, published by P. Galand-Pernet and myself in 1977, is a good example of this.

The old craftsman Khammani, outraged by the violence of the distribution of American sorgho (or millet), during the struggles of the 1974 drought, expresses the offence in a poem: dignity is on the side of the poor.

Mohamed Aghali-Zakara, Docteur d'État, former professor at INALCO of Tuareg language, literature and Tifinagh script, researcher l'Université Paris 3 Sorbonne Nouvelle

ur di za iggât kumanda	I will not be submitted to violence by the person in charge
fəl ăttələt n ăməruka	for a ration of sorgho from America.
kəttôγ aššăk harwada	I know how to keep my dignity.
os-i-ddu Iblis inn-ana	Satan came to me and said,
kăy z aləs-in təffwăta	Alas, my poor friend, you have been frustrated!
ənneγ-as i Iblis əssâna	I know I have, Satan, I replied,
fəl as moni ur t-illa	respect for the next man has fallen into the dark
əglăn meddăn win iha	Men who practised it have gone
as tăn-d-əkteγ ad əhâlla	and I cry when I remember them now

These concepts and values are integral to the identity of all Tuareg.

ashikəl əs təllit

Arət imoosan əlmaghiza, tebə
ddəy n-aləs təzzərət fəl təllit
əzəs wan sənatet təmərwen ən
Juillet ən 1969.

Aləs di əsəm net Neil
Armstrong ənta a imoosan kumanda
ən fiza n-Amerik apollo 12.
as iga təməzayt osəy-in əmidi net
Edwin Aldrin fəl təllit.

əmedran n-adigəd awedən dəgh
Jinnawan shilan n-əjədər, ghur
akhluk n-awedən att-inay dəgh etəs
elan əssayəy təmərwen n-awətay.

⊟꞉ǁ ⊙+ǁ+
⊙+ ⊏⊙ǀ ǁ⊏꞉ᒧ. ꞉⊙
ǀ꞉ǁǁǀ +ǁ+ ꞉⊙ ⊟ǀ
꞉⊙ǀ ϟǁ ⊐⊏ǁ +ǁ+
Ɛ⊙⊐⊏+ǀ ǀ ⊏Ɛǁ ꞉ǁ
꞉⊙⊙ ꞉ǀ ǀ#⊙ Ɛ꞉
꞉⊕+

The Moon Landing

Journey to the moon
A wonderful event
a plane landed twice on the moon
flags from all nations have been put there
even the flag of Niger

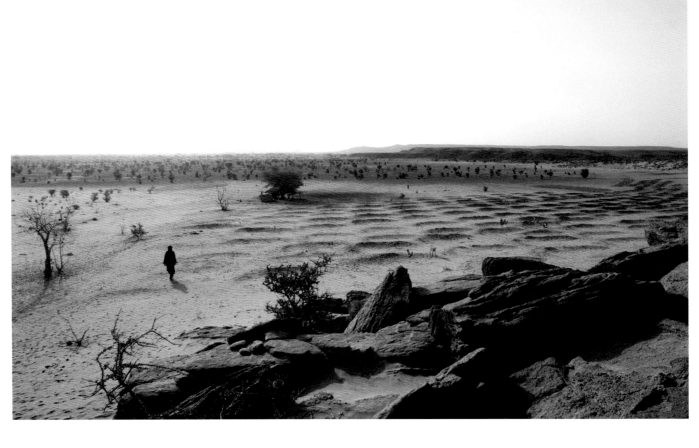

Above:
Tidene Valley, 2007

Right:
Short extracts from two
long poems by Kourman
who was one of greatest
poets of Air. Kourman
died in 1989. Translated by
Ghoubëid Alojaly
(Casajus, 1992)

ORAL DIARIES - the work of Ghoubëid Alojaly

Dans la vallée d'Abadrekum, là ou les pluies
Verdissaient l'an dernier les pousses *d'awajjagh*
J'ai erré tout le jour sur les aires désertes
Des camps abandonnés, et même l'ombre fraîche
Apparaissait brûlante à mon coeur désolé
J'avais cru rencontrer celle auprès de laquelle
J'avais eu si souvent de tendres entretiens
La fille qui aurait mêlé son rire au mien
Et dont j'aurais troublé les cheveux mis entresses
D'elle je me serais approché en silence
A l'heure où le sommeil gagne les campements

Mon chameau acajou me demande en bramant
"Penses-tu, compagnon, que nous serons à temps
À la fête joyeuse où l'on bat de tambour
Où les filles du chœur, ensuivant sa cadence,
Soutiennent la soliste et frappent dans leurs mains?"
Une est celle que j'aime et sa bouche est rieuse
Pareille à une liane entremêlée aux branches
Qu'on voit s'épanouir à la cime des arbres
Dieu l'a mise au-dessus de toutes ses compagnes

In the valley of Abadrekum, where the rains
Greened the shoots of *awajjagh* last year
I wandered all day through deserted lands
Of abandoned camps, and even the fresh shade
Felt like fire to my desolate heart
I had believed I would meet her with whom
I had had so many tender meetings
The girl who would have blended her laugh with mine
And whose tressed hair I would have disordered
To her I would have approached in silence
At the hour when sleep takes over the camps

With a roar, my mahogany camel asks
"Companion, do you think we will be on time
For the joyous festival where the drum will be beaten
And where the girls of the choir, following the rhythm,
Support the soloist clapping their hands?"
Among them is she whom I love and her mouth smiles
As a vine entwined in the branches
That one sees flourishing in the tree-tops
God has placed her above all of her companions

Ghoubeid Alojaly, c.1980s

Ghoubeyd Ag Alojali, was a Tuareg author, born near Abalak, Azawad, in northern Niger around 1932. His literary oeuvre was a huge contribution to the conservation of Tuareg identity and culture. One of his most important books is the *Histoire des Kel-Denneg*, 1975 (see page 108), the history of a group of the Oullimiden. He collaborated with Karl-G. Prasse on a Tamasheq-French dictionary (he corresponded with Karl on Tuareg language and literature for over thirty years), and with Gian Carlo Castelli Gattinara on *I Tuareg*, 1992. He did much research on the Tuareg's Tifinagh writing, proposing changes for its modernisation, or popularisation, such that he helped draft the first newspaper written entirely in Tifinagh in Niger with Mamane Abou. After a long illness, his death in June 2012 was perceived by Tuaregs and all lovers of Tuareg culture as similar to the loss of a great library.

Adal Rhoubeid, Niger, 2015

Yesterday, during my trip
I hummed my favourite songs,
I threw away my spear,
picked by my blacksmith.
I was very proud of my outfit,
and the indigo that covers my skin.
Suddenly, I looked up,
And I saw my enemies.
The first was a great hulk and totally agile,
the second was like a red horse,
rode by a proud teenager.
He screamed at me with surprise
I went to fight against him
While protecting myself against his sword, we both felt on our knees,
My teeth were tightly clenching,
My legs became like cotton [trembling],
And my hands were aching.
My spear, my sword and my shield
were pressed on my chest.
When I delivered a deadly blow to him,
it was as if thousands and thousands of stones felt on him
And that was the coup de grace to him.

By a Kel-Azawagh poet, 1870
Written into Tamasheq by Ghoubëid Alojaly; found in Alojaly's papers, Niamey 2013
Translated from the Tamasheq and then into English 2015

Yesterday in the middle of a very warm day
While I was experiencing a bumpy journey,
I asked my blacksmith in haste.
He said to me: walk with a stoop [bend your back] and choose loneliness.
Within a second, he was run through with arrows and spears,
Which flatten the dust and drove me to ride my camel.
I came in goose pimples and my liver said 'mataq' [onomatopoeia]
I drove my mount towards east,
When I clout it with my foot, it made a noise '*baraq*'.
Then I remembered the young girls, Bataq's mother in particular.
These young girls with whom I use to play every night until the morning star rises,
These young, I will never forget to my very last breath.

By a Kel-Gress poet, 1880
Written into Tamasheq by Ghoubëid Alojaly; found in Alojaly's papers, Niamey 2013
Translated from the Tamasheq and then into English 2015

A TUAREG IS NOTHING IF NOT A POET

Poetry relates the Tuareg's long history and reflects their soulful ideology. It furrows deep into their society's psyche, charting life in passionate, charming verse, idealising their culture or love affairs, and their life in the desert, as nomads or 'free' people. Through poetry, the Tuareg also recount (and remember) their history of war and significant political events. Ballads tell literal stories, relating a particular combat or defining moment. At celebrations, women sing praises of men's gallantry, beauty and bravery. Great romantics, Tuareg poets glorify their lovers with inexhaustible ardour - the emotional, solitary herdsman often composes poetry in conversation with his camel. And as the elders converse into the night, young Tuareg slip away from the campsites for Ahals, to flirt and sing poetry. The Ahal is the teenage Tuareg's night out.

Tuareg poetry has its origins in early Arabic poetry. Traditionally, it is passed down orally. First transcribed in 1905 by the curious missionary, the Père de Foucauld - translated from the Tuareg's Tamasheq language into French - poems can officially be dated to 1820 but many derive "from antiquity". Highly developed structurally, with specific rhymes and metres according to subject matter, it also varies according to who, or what class, the orator, or singer, is from. As with all Tuareg vocations, there are families of poets but nobles - the warrior-chiefs - were also acclaimed poets.

Poetry is always sung, occassionally with the revered Imzad, the Tuareg 'violin'. The poet is an important part of celebrations - marriages and baptisms for instance. Since the 1970s and the Tuareg's troubles with the modern world, poetry relates modern woes, in a new, angst-ridden verse. Here, removed from their old life they glorify and yearn for the desert, decrying the intrusions and their society's upheaval. The most recent poetry, sung to electric guitars, is Tuareg pop music, now acclaimed globally - Mali's Tinariwen were 2012 Grammy award-winners. Rooted in traditional forms these songs are equally influenced by Western icons such as, for Niger's fast-rising star, Bombino, Jimi Hendrix or Dire Straits.

My son, I give you the four directions of the world because one doesn't know where one will die

"The Agadez cross has a special role [in Tuareg society]. Given by fathers to sons on puberty, it represents masculinity, the pommel of the camel saddle and the four cardinal directions, with the top representing North"
Edmond Bernus

I am a lone traveller of the desert
Nothing is surprising
I tolerate the wind
I tolerate thirst
And the sun
I know how to walk until dusk
In the flat, empty desert, where nothing is given
Always alert
By the mountains where I was born
Which I have climbed up and down
I know where water hides
These concerns are my companions
Always familiar, the story of my life

From the song, *Amssakoul n'Ténéré* by Souéloum Diagho, for the band Tinariwen. Translated from the French version 2015

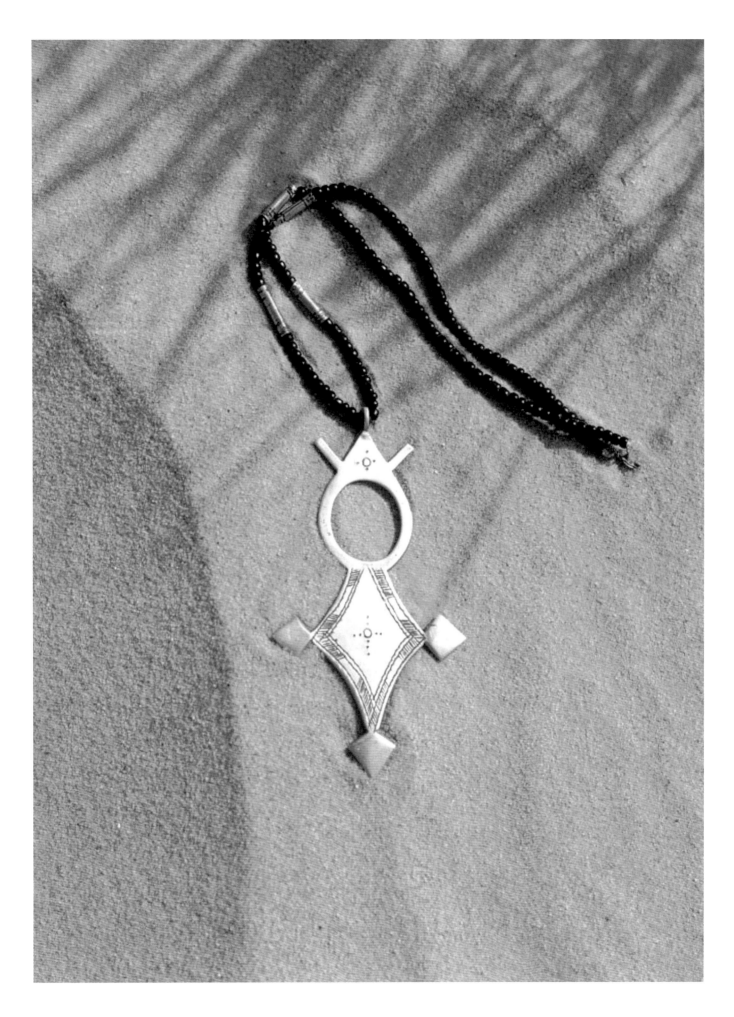

A hymn to Hadi

My darling girl eats porridge made of millet
From a calabash
Each mouthful precious like a bracelet of agate
As she does so every daybreak

So at special events
She is shining and so white
That she does not go unnoticed
It is as if she is sitting on a cloud
She is well-dressed in her sumptuous clothes
Made of cotton, and with her best shoes
Decorated with all kinds of patterns and precious pearls

When there is a celebration and she takes part
All the young men of the region
Waste their time coming to it in the hope of seeing her
With Yemma the beautiful, Alhom and Timina

For her, her fiancé is ready to do anything
To make her appearance the most beautiful of all
And he promises that even if she is locked up in a white man's house
Or in a fortress made of concrete
Surrounded by a barbed-wire fence
Guarded by the most dangerous soldier
Lighting cigarettes and smoking drugs
Disdaining ordinary fire as he is so wicked
I swear that I would go to her and devise with her

If I die for this audacious feat
I will be counted among the martyrs
Because to fight for a beautiful woman
God Himself is not against it

Hymn to my daughter Hadi
The tent she lives in
Is so big and wonderfully made
With blankets with jaguar motifs
And Moroccan carpets
For the benefit of two hearts that love each other
Living in a dwelling which is visited by a noble man every night
A noble rich in patience
Knowing how to converse at soirées
Which start just after dusk
And surrounded by a huge crowd
Until late in the middle of the night
They share the special tea called arragayga
Served on a tray from America

Right:
The poet Atano Handi and
her daughter Hadi
Agadez 2013

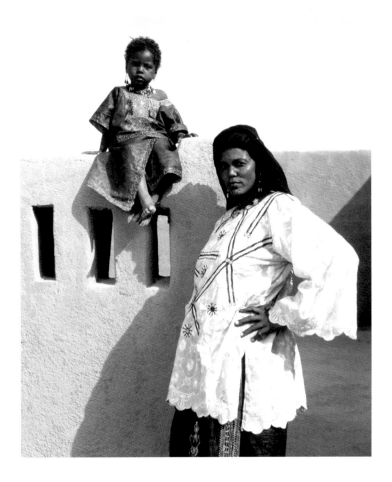

And not made in France
His utensils are brand new
He chose them well at Sebha's market

My wise darling, rich in education
Would sit next to these like a queen
Adorned in her best finery and jewellry
Two of them are stainless steel
Of which the bigger one
Is decorated with copper

All carried by a noble soul
Who goes back and forth during this happy time
Wearing her indigo litham of sixty of the most select bands
That she wears with great pleasure
It is with motifs designed by Ahanté the tailor
That one must compare it with
And not with those of low quality
That he knocks out by the dozen

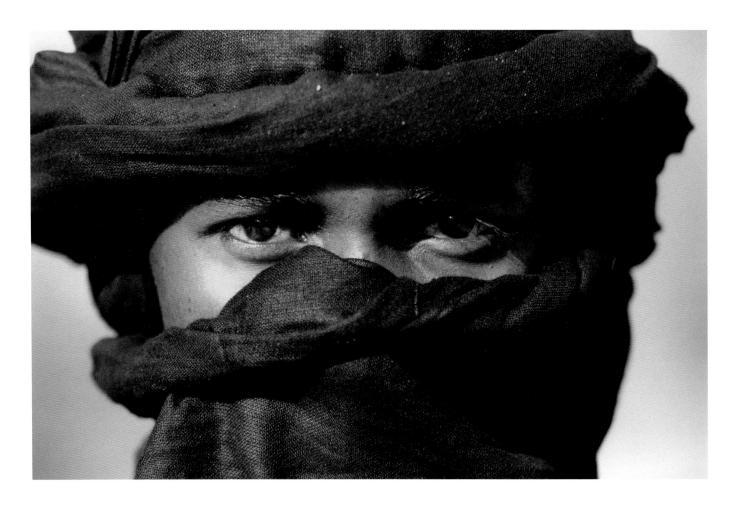

Malheur, sept fois malheur
a l'homme qui montre sa bouche,
sa bouche qui est un puits impur habité
par la démon de la langue,
sa bouche qui est sacrée habitée
par l'ange de la parole.
La loi du voile est mon guide
sur la route de sable et de pierres
où chacun passe avec sa caravane
La loi du voile sombre est pour moi
Plus clair que la lumière
La loi qui commande de cacher son visage
A la colère, à l'orgueil, à la suffrance
A l'amour et même à la mort.

Translated by the Père de Foucauld from
Tamasheq, c.1910

Unhappiness, seven times unhappiness
To the man who shows his mouth
His mouth which is an impure well inhabited
By the devil of language
His mouth which is the sacred home
Of the angel of words
The law of the dark veil is for me
Clearer than light
The law which commands one to hide one's face
To anger, to pride, to suffering
To love and even to death

Wearing an indigo cloth
veil or *allichu* at a wedding.
Soaked in expensive indigo
dye, men will spend small
fortunes - several hundred
pounds even - on new
allichu veils which are only
worn at special occasions.
The dye bleeds freely
onto the skin making it a
bluey-grey colour - how the
Tuareg acquired their exotic
title (from Europeans),
as "The Blue Men of the
Desert"

PROVERBIALLY SPEAKING

In the desert, when night draws in and stars clothe the sky, Tuareg men may sit and chat, for hours. Nightime is cool, the time for socialising. They chat animatedly, laugh a lot, drink tea and philosophise. Weaned to expect life-threatening circumstance or haphazard as the norm, they are pragmatists with little room for drama (self-pity is shameful). As for us, Tuareg proverbs explain cultural ways of being and instill general human values. These were published by Alhassane ag Solimane in 1996.

Azəl iyän da wər iggit afarag
A branch alone doesn't make an enclosure

Tuareg make enclosures for their animals from the thorny branches of the acacia trees - but one branch alone doesn't make the enclosure. The meaning is that as individuals we have our limits and must depend on others to achieve results.

Zənniməhazät iwällän näwän təsinnəməggəgäm enan näwän
Bring your hearts together; keep your tents apart

This translates fairly directly into "absence makes the heart grow fonder".

Ill-äy a khälalän jämbäg
There are things that are allowed in religion that are forbidden by tradition

This proverb underlines the fact that cultural identity exists independently of religion, with regard to adherence to Islam for the Tuareg.

Təhaannäy tämghart təganät a wər ihənnäy äbärad ibdädän
The old woman who is sitting down sees what the young man who is standing cannot see

Tuareg say this when someone has not taken into consideration the point of view of someone who he thinks is insignificant. This is not far from our saying, "Don't judge a book by its cover".

Ewet igän təgegh-as tagəst-net
To each song, its dance

"To each its own"

Imägarän as du-zäyän izenga, as d-əwädän ad əqqəlän imənokalän, as əsshäkälän əmoosän inädän
The stranger who arrives, enemy; the stranger who stays, King; the stranger who leaves, blacksmith

This saying semi-jokingly describes the Tuareg's view of their famed hospitality to strangers: they must treat guests as Kings, giving them the best of whatever food they may have, not doing so would be shameful. Even if the hospitality means killing a goat, for instance, that they have been saving for a special occasion, or which may be a child's pet. They watch the arrival of the stranger from afar with a certain annoyance, knowing they must welcome him properly - but once the stranger is with them they will treat him like royalty. When the stranger leaves he takes on the character of the blacksmith - mistrusted and respected at the same time. They fear the stranger's judgement of them: he will take his opinion of them into the wider world.

CLASS DIVIDES

**"When one doesn't understand the Tuareg social
system it appears like a negative hierarchy".**
In conversation with a Tuareg

For any ordered culture, the hierarchy of a social structure
ideally maintains the society's equilibrium and well-being.
The Tuareg, living in a fiercely challenging physical
environment, which is absurdly hot (the heat can severely
affect one's thinking), and where food and water for both
people or the animals on which they depend is an effort
to obtain, individuals - despite the ideological notion that
they are free - are traditionally intrinsically bound to a
rigid social system that ensures the good of everyone.
Tuareg may move up or down the social ladder but
traditionally they will adhere to the position they are born
into - and indeed the occupation or educational abilities
of this family. Each Tuareg plays a fixed role in the society

Nowadays, as Tuareg culture has had such radical
social change forced upon it, the circumstances of a
Tuareg's birth situation may have less relevance. It might
be the next generation of Tuareg, more influenced by
western ways, who will completely throw these concepts
out of the proverbial window but for now, wherever they
live - in the desert, or in France or Canada for instance
(where many largely refugee Tuareg live), the family and
the position into which they were born is engraved on
their psyche like the brands they mark their camels with
(such as those reproduced by Rodd shown on page 95).

Within the major eight Kel or other drum groups (the
tobol or "confederation"), classified by Mohamed Aghali on
page 34, are numerous sub-groups with their own names
and importantly, their own occupations or specific talents.
The key classes of each group begin with the nobles or
Imuhagh, who are the warriors, and the Amenokals or
Kings, and in Aïr, members of the Anastafidet's family,
the Anastafidet being the chief of several Kel groups in
Aïr that pay tribute to him instead of to the Sultan of
Agadez, pictured right. Then there are the *Inesleman*, the
marabouts or priests, then the *Imghad*, the vassals - like our
middle classes and similarly (now), these are the largest
class. The *Imghad* are warriors, or caravaneers - nomadic
merchants in other words - and the working pastoralists.
(The *Imuhagh* are of course pastoralists, or semi-nomadic,
but as nobles, they don't work). Then there are the
slightly feared blacksmiths or *Inaden*, feared for their
knowledge of fire and who may also be *griots* or confidants
- they know many "secrets" - but obviously they are also

artisans, creative people, making the swords and lances
or jewellery and the beautiful highly decorative green
and red leather goods - from the saddles to the wallets
hung around Tuareg's necks. Next come the sedentary
gardeners, the *Izeggaghen* (in Ahaggar), who don't live
or move with the nomads, living in villages tending the
gardens but they are affiliated to the larger Kel group or
to individual *Imuhagh*, who may own the land that they
cultivate. The land within villages is all owned, or bought
and sold as circumstance offers or dictates; in the desert, it
is the wells that are owned (by either the people who dug
them or those families or groups who have had control
of the well for generations), but most pasture land will be
recognised as belonging to specific groups.

The smallest sub-groups (of larger sub-groups), can
be single extended families; the name of the group may
be understood as a sort of surname. For example, on page
73, Caroline Bernus talks of how her family is called the
"Kel Bernus" by Tuareg, as a term of affection; no one
outside of her family would be Kel Bernus.

Finally, at the bottom of all classes are the *Iklan*, the
slaves. As often the case with former European servile
classes, the *Iklan* families might stay with their owner's

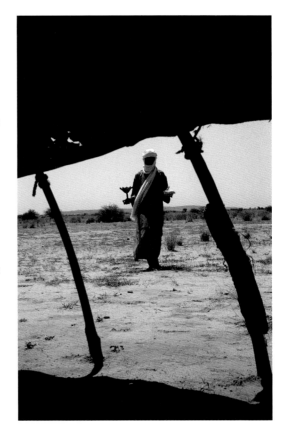

48

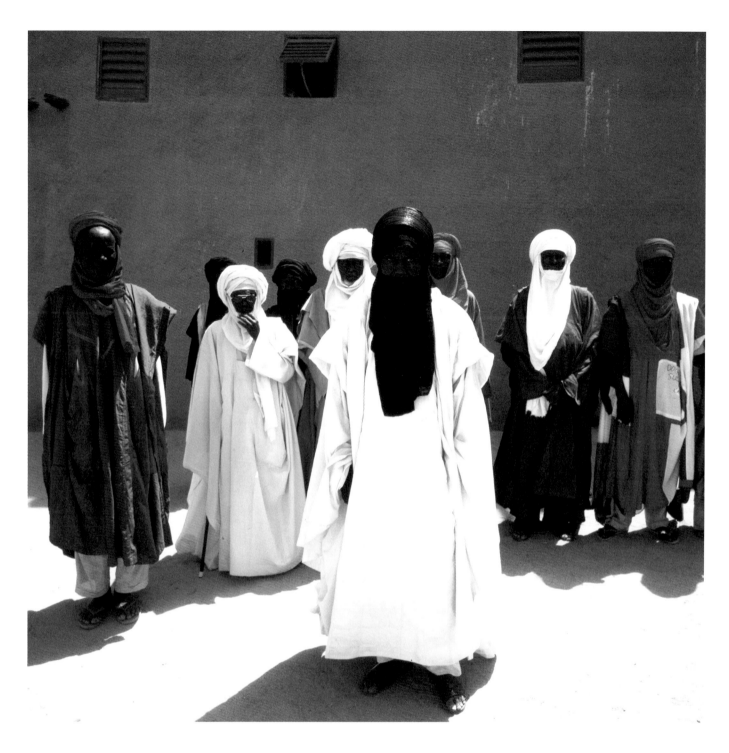

family for generations. They are as much a part of his family as his parents, siblings or children. When he clothes his children, he clothes his servant's children. They are uneducated and bound to him but he protects and cares for them. The *Iklan* are often Bella people, black people whose ancestors would have been captured by Tuareg. An *Ikli* (sg.) often acquires his or her freedom and would then become an *Iklan-n-Egif.*

These are very elementary distinctions of the Tuareg's complicated social structure and, as with the names of the different Tamasheq dialects, these names are differently pronounced or written by the different regional groups. To appreciate the complexity of the numerous sub-groups - which may also include families classified as warriors who write or who don't write, or who have slightly lighter or slightly darker skin, or even who are not allowed to play music, for instance, two authorities are Ghoubëid Alojaly and Joannes and Ida Nicholaisen, whose books are listed in the bibliography at the back of this book.

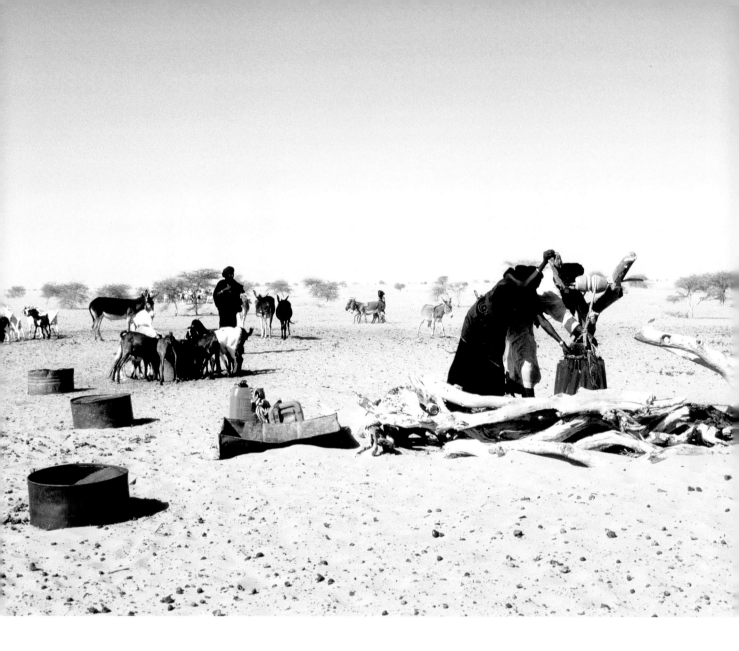

Tiguidit, 2007

Aman Iman, as the Tuareg say -
'Water is Life'

NOMADIC PASTORALISM
By Jeremy Swift

A desert civilisation sounds like a contradiction in terms, but the Tuareg of the Sahara have created such a civilisation. They live with the desert, not against it like the oases livelihoods found scattered precariously here and there in the same area, dependant on water and trade. The Tuareg accept the constraints the Sahara imposes and have created a way of living that turns the disadvantages of this extreme environment into advantages. It is an astonishing gamble, and it worked.

The Sahara shocks those who see it for the first time by its space and the simplicity of its landscapes. The size of the United States including Alaska, it is made up of simple combinations of sand, gravel and rock. Fashioned by wind, heat and cold, and water, these basic building blocks of landscape are worked into an infinite number of shapes and surfaces. There are gravel plains so flat that you can see the earth curve away from you. The Tanezrouft in the Central Sahara, one of the largest of these regs, is twice the size of the United Kingdom. There are eight or ten sand seas where the wind sculpts elegant and repetitive waves, curves and helixes, and moves the dunes gently down wind so that when you return after a year or two the landscape has changed. The two largest of these mobile sand seas cover the area of France and Germany together.

The simplicity of the landscape is reflected in the language used to describe them: the gravel plains are *reg* in Arabic, and the sand seas *erg*, the same three letters in a changed order suggesting the affinity of the landscapes they describe.

From a human point of view, the desert is rich for those who can see the riches. Water is hidden but present, especially after the intense storms that sweep across hundreds of miles, producing small tidal waves down the dried out river beds – or *wadis* - of a previous geological period. It is said that more people are drowned in the Sahara than die of thirst. After rain the desert briefly turns green, especially where rainwater collects in dune hollows and wadi beds.

Desert resources and those of its borders – the West African Sahel to the south and the Atlas mountain chain to the north - are highly variable in time and unevenly distributed on the ground. They provide a challenge, which the Tuareg have mastered.

Tuareg live in the middle of the desert and at its edges. The main Tuareg populations are based in the mountain chains of the central and southern Sahara: the Ahaggar and Tassili mountains of Algeria, the Ayr mountains in Niger and the Adrar n Iforas in Mali. From these mountains successive waves of Tuareg invaded the southern borders of the desert and occupied pastures and arable land on both banks of the Niger river.

The Ahaggar mountains in the central Sahara are the base for a small Tuareg confederation, which in many ways is the symbolic centre of the Tuareg world. They have a diversified economy, combining herding, raiding and trading. Sheep are their main animals, while their camels were pastured for months each year in the richer pastures south towards Mali and Niger. They used to trade across the desert bartering animals against cloth and dates in the north, and slabs of desert salt for millet in the south.

The Tuareg of the Ayr mountains of northern Niger also have a diversified economy. They cultivate wheat, barley, millet, vegetables and dates, and husband mixed herds of sheep, goats and many camels. They trade salt from the mines at Bilma; in the early 20th century the salt caravans from Bilma could be made up of twenty thousand camels.

The Adrar n Iforas mountains have their own Tuareg confederation. The mountains make cultivation difficult, but the pastures of the Adrar are richer than other Saharan mountain zones; this is not the centre but the edge of the desert. The Kel Adrar Tuareg also have mixed herds. They traded across the desert , north to Algeria and south to the Sahelian agricultural economies. Along the Sahelian border there are other Tuareg groups, especially around Timbuktu on the Niger.

Little rain falls in the Sahara, and that which does fall is widely scattered; the result is a chequer of grass and sand, a mosaic of *wadis* where rain has collected and flowed for sometimes hundreds of miles, and dry areas where there has been no rain at all. To live in such a place demands specialisation, flexibility, and above all mobility. Specialisation in livestock production and in managing the skills needed to make domestic animals perform at their best under difficult conditions. This is a joint enterprise between a herder and a group of animals, and the skills required by both sides are detailed and productive (the animas are skilled too). Specialisation has to be linked to flexibility, the ability to recognise future threats or

opportunities, and change course to meet them. A good herdsman scans the sky and the ground ceaselessly in search of clues to better conditions, sends out scouts to check on the ground, and decides based on this information and the accumulated understanding of generations of herders confronted by the same problems. The depth of knowledge of desert people about their environment is illustrated by the well-known fact that as late as the early 20th century several of the most skilled Saharan guides were blind: they navigated by smell, by the wind and the taste of the soil, their senses heightened by a lack of sight (and in any case in vast areas of the Sahara there was little to see that was different from many other places).

Mobility makes all this possible. Tuareg camps move regularly, not only in search of pasture and water, but also to trade, to escape a quarrel or to strengthen an alliance. Household goods are reduced to the minimum to make moving easier; the classic red leather tents that are home to most Tuareg households are the heaviest things to be transported. Camps generally move in search of the best quality of feed for the animals between places accepted by the whole social group as their priority pastures. This mobility is an essential part of the livelihood system of the Tuareg.

Mobility is equally important at moments of stress, when water and pasture are running low. Households must be able to move away from scarcity and danger, towards security and meeting the needs of the animals. Constraints on movement are among the most important threats to Tuareg life in the Sahara. Ominously that fact is not well understood by the governments of the countries where Tuareg live. The need for whole households to move is thought to be unnecessary, primitive, provocative.

The 20th century brought colonisation then independence to the countries where the Tuareg live. The Tuareg, secure as they thought in their desert landscapes, were not major actors at independence, although they earned a deserved reputation in resisting French colonisation in the Sahara. They have proved less lucky with the political events of the 21st century, and the Sahelian Tuareg in particular have been drawn into political violence by the various jihadist groups occupying parts of the Sahara and Sahel.

An intelligent political strategy to eliminate the jihadist threat should include bringing the Tuareg back into a secure and productive relationship with the urban markets and societies which surround them. The Tuareg occupy a potentially secure economic niche in a world where they produce goods and services in demand by a new generation of urban people: meat, milk and leather. To these products could be added valuable services such as protecting desert rock art and wildlife for a new tourist industry based on the iconic Sahara. Tuareg could also be formed into a mobile frontier guard to patrol desert borders against jihadist encroachment.

None of this will be possible without taking Tuareg nomadic pastoralism seriously, and equipping the people themselves to do what they do best: raising animals in the most beautiful desert in the world.

Dr. Jeremy Swift, author and researcher on the Tuareg, former professor at the Institute of Development Studies, University of Sussex

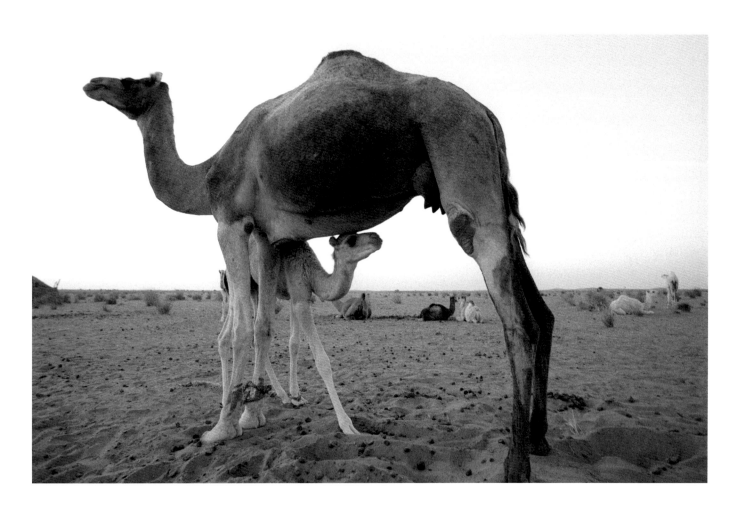

Above:
Tiguidit, 2007

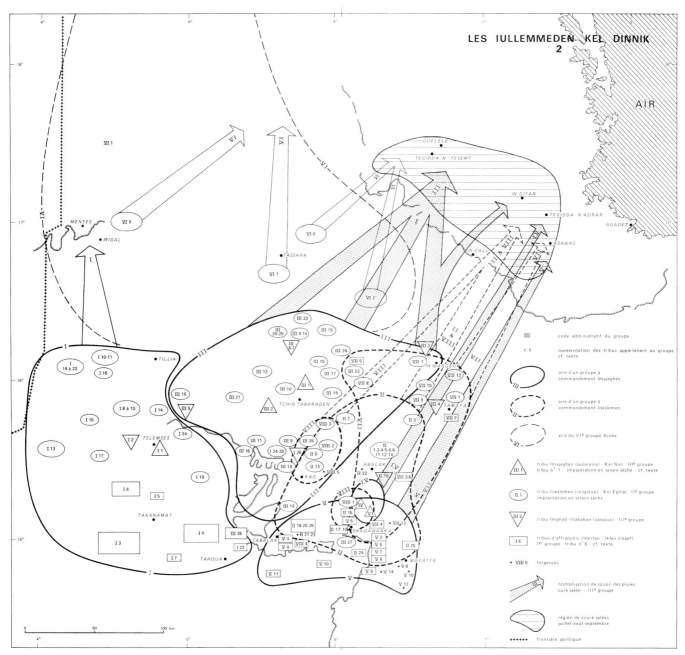

LES IULLEMMEDEN KEL DINNIK
2

Showing the seasonal movements, or transhumance of groups
of Iullemeden [or Iwellimeden], from just north of Tahoua up to
north west of Agadez, a good five hundred kilometres distant.
Movements that used to cross the new nations' frontiers are
now forbidden. The plan also illustrates how the different
classes of Tuareg live together - the Imajeghen, the suzerains,
the Ineslemen, the religious groups, the Imghad, or vassals, and
the forgerons, or blacksmiths: all are self-autonomous, with
independent camps and timetables, they are linked to but apart
from each other

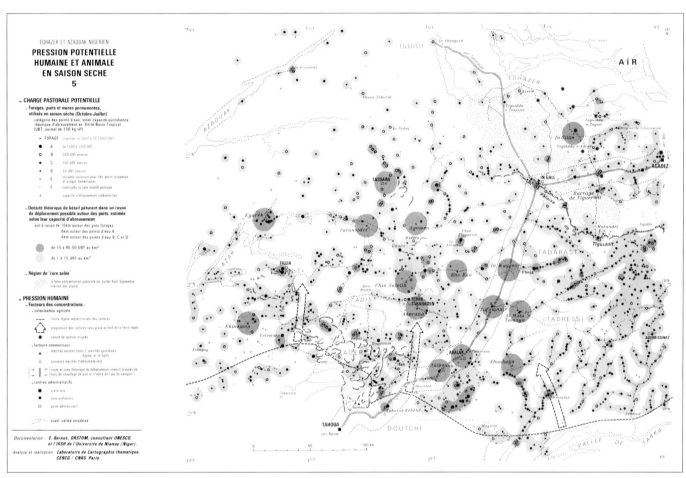

'Pression potentielle' shows the number of livestock and people the terrain in this area may sustain during the dry seasons of October to July, with good land management

A vast area west of the longitude of Agadez, and south to the latitude of Tahoua, current populations and livestock are now a small fraction of the life that is represented here

Pages 56-57:
Morning on the edge of the Ténéré desert; the men set off to look for some stray camels

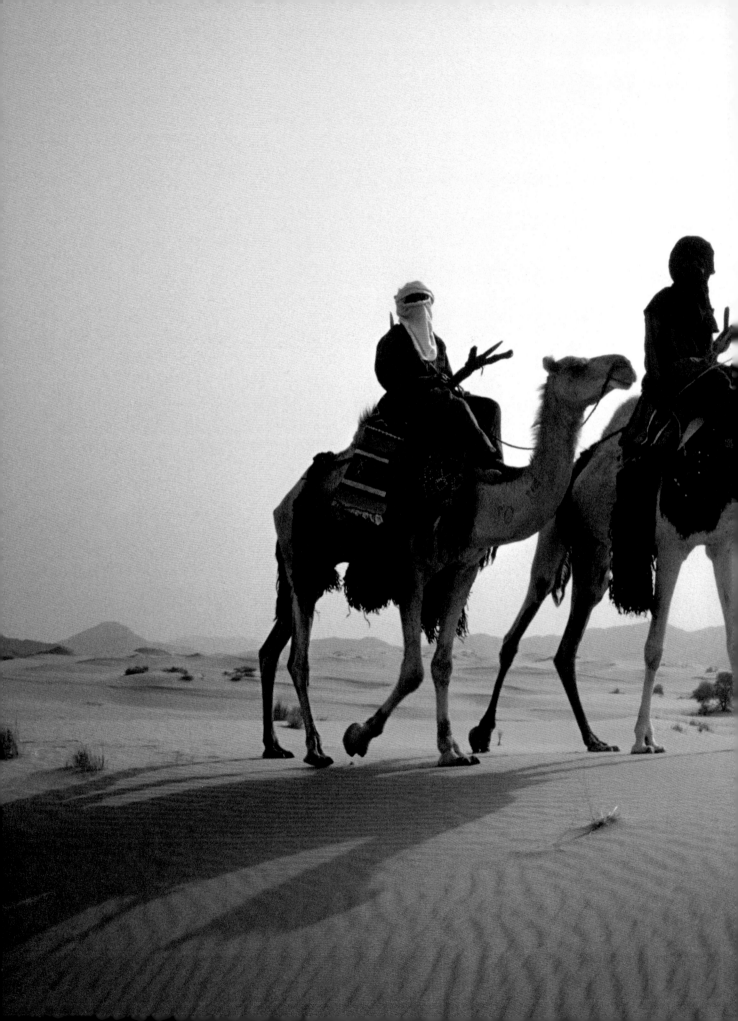

DAILY LIFE - through the eyes of Rissa Ixa and with the Illabakan

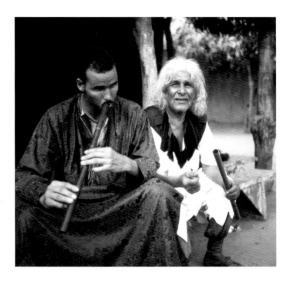

Agdud mebla idles am wemdam mebla iles
A people without a culture is like a man without words

While contemporary Tuareg musicians express their nostalgia for the life they mourn through song, Rissa Ixa, who was born in 1946, battles to preserve knowledge of Tuareg culture through his charming, poignant art. He made his first drawings in the sand when a nomadic boy of south-western Niger. However, he has now lived in Niamey, Niger's capital, for the best part of fifty years, moving to the city when hardship struck the family. The goal of his life is to keep Tuareg culture alive, or to stop it disappearing - for Tuareg traditions to be respected. His paintings hung in Niamey's Grand Hotel for decades; now they have been removed, his vision is no longer fashionable. With the tourists gone, Niamey's hotels are largely visited by hard-nosed businessmen; many will be involved in the rash of prospecting for underground resources in the lands of the people Rissa wants protected, so they may pursue their traditional culture. Abroad however, a painting which appeared at Bonhams in New York in 2010 sold for over $2,000.

Rissa's most popular œuvre is of his figurative scenes in oil of pastoral Tuareg life, like the painting opposite. Tranquil scenes, they brim with humour, all is a bit askew or out of proportion, heavy patches of strong primary colours fill elementary shapes of people and animals; there is barely any detail, all is clean, vivid to the point of being lurid, but they are not lurid, they are seductive and uplifting. For anyone who has been in the environments he depicts, they make one smile, one wants to be there. Which is exactly Rissa's intention.

Overleaf are some of Rissa's drawings that formed the illustrative base of Gian Carlo Castelli Gattinara's *I Tuareg*. They show scenes that would have been commonplace during his childhood. Forbidden for years, except of course the subject of the bottom drawing, the "tea ceremony", still a highlight of most Tuareg's day, the raiding or *razzias*, how Tuareg used to "make their living" have left an economic void that Tuareg were not able to fill until the advent of tourism in their lands; this too is now gone. Unpleasant or unfortunate to be on the losing side of a *razzia* - of

course - but such were the realities of the Tuareg's permanently challenging existence. At least the Tuareg were open, or honest about their thieving, or missions of revenge, primitive as they were - as opposed to western business worlds where, ironically, the poor or most vulnerable are subject to underhand whims of the rich without mercy, which even when discovered may be deemed unaccountable.

The Tuareg raids were always subject to well-respected rules. But the rules were not written down for them to be adhered to, or "legal" before they were conformed to, as we must - for us, it seems that only then is a way of being either obligatory or forbidden. Their society was, and still is governed internally, by the overriding notion of *ashak*, or honour. Children learn very young, often through proverbs, how one should or shouldn't behave. To diverge from what the elders or the culture may decree would be immensely shameful - and shame is something a Tuareg avoids at all cost. Tuareg would rather the ground swallowed them up than be shamed; they will suffer rather than appear shameful to others. Maintaining one's honour is key at all times. The power of these moral codes is hard to over-emphasise.

Patience is another Tuareg virtue - and why Tuareg persevere to attain their goals or accept natural hardship, whether or not the outcome is positive. They see the long view, as Rodd says. To be impatient is as if to complain, and that would be shameful. For Rodd the "ethical standards of right and wrong . . . codes of conduct for which there can be no legislation . . . seem to come from some older philosophy, some source

less obvious than their present religion . . .an ancient school to seek some goal which is [sic] no reward in the present material life".

As Rissa persists in his lifetime's quest to promote and uphold his culture, even when against the odds, so Tuareg rebels will persist in their quest for self-governance, theirs is a different culture to that of their governments. For them self-governance is a human right which most other cultures enjoy.

THE ILLABAKAN

The Illabakhan, studied by Edmond Bernus in 1967, numbered 1,200 people, of whom Najim was the chief.

of Azelik. There they can take advantage of their "salt cure". At that time the rains will have filled up the ponds that lie there and allowed new growth of grass.

The campsite consisted of 28 tents housing a population of 140 people, making an average of four inhabitants per tent. Four tents were in fact occupied by women who were alone (three widows and one divorcee). During a dry season, the camp is often placed hidden in a shaded valley. Families each have a tent for living in. Their tents are placed such that openings are not facing each other, thus preserving privacy. The animals are kept in collective areas. The tents are all put up in the same west-east alignment going up to the end of the tree cover.

"Najim's encampment is always laid out around a well and extends over more than one kilometre. From one place to another, the family tent emplacements are not kept the same. They live according to the rhythm of their seasonal travels. For nine months of the year, they move along the valleys etched down into the sandstone plateaux of the Tegama. Each summer, in the rainy season, the families move with their animals, further north. They drive their flocks and herds towards the salt springs

Taking tea is a central part of the day. This time for relaxing is also a moment for exchanging information. Tea unties tongues and "soothes fatigue". Conversations often revolve around the activity of managing the herds. In the evening or in the shade of the trees, men occupy themselves by playing *dera*. Around a checkerboard traced in the sand, players and spectators challenge each other in an atmosphere of excitement".

I was attacked by a ferocious *razzia* of Kel Ahaggar

I accept to challenge him with the sword and to fight with him unto death

The preparation of tea

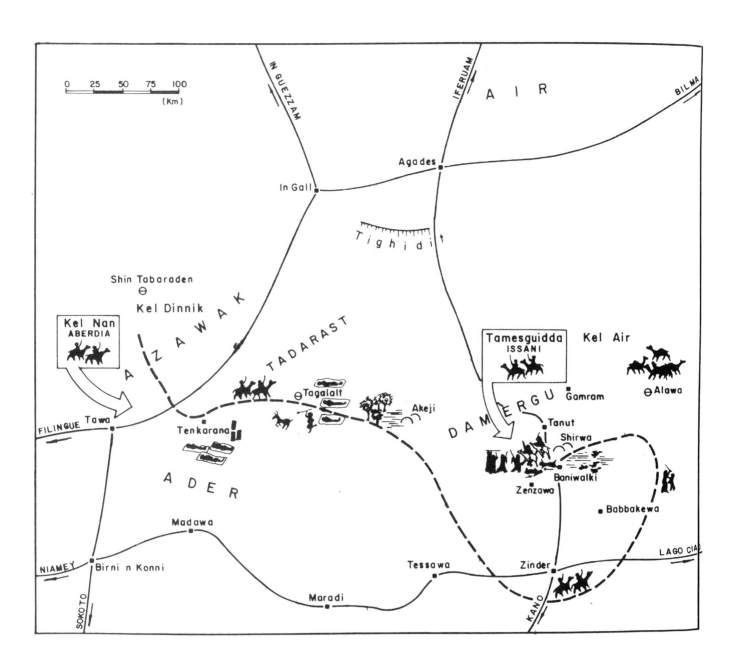

Above:
The battle of Baniwalki.
The itinerary followed by
the Kel Nan to direct them
to the enemy, Tamesghidda

Page 62:
Father and child
©Jean-Marc Durou

Page 63:
A girl at the well
©Jean-Marc Durou

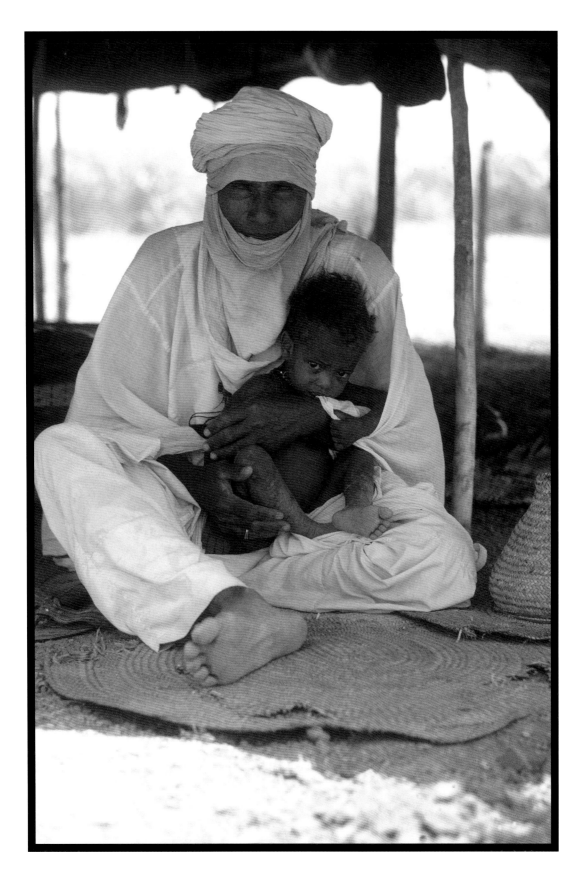

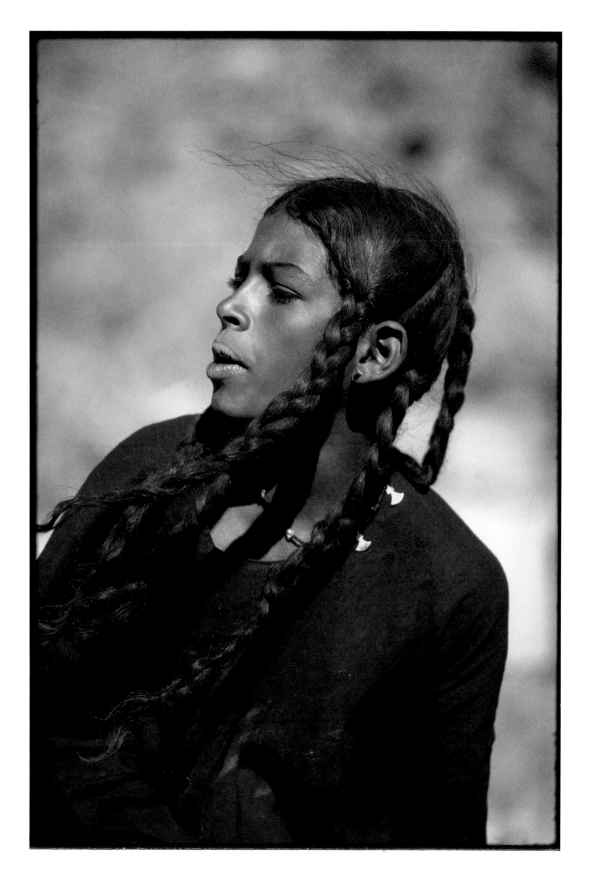

THE WORK OF EDMOND BERNUS
The geographer's geographer
by Caroline Bernus

Edmond and Suzanne Bernus spent much of their more than thirty or so year careers close to the Tuaregs of Niger. While Edmond worked as a geographer for ORSTOM-IRD,[1] Suzanne was an anthropologist at CNRS.[2] In contrast to the myth of the mysterious, majestic men in blue – as the public knew the Tuaregs through popular literature and colonial military accounts – Edmond actually encountered the Tuaregs in Ivory Coast, when studying how poor immigrants from the Sahel were living in Abidjan, where they had come in search of work. These people referred to themselves as Tuareg.[3]

His curiosity roused, Edmond wanted to see the reality of these Tuaregs' home environment – which happened to be in Niger – and this was the beginning of a long quest which would last until his death in 2004.

Edmond began his working life in Guinea in 1954, studying a Malinke village called Kobané. It was here that he took his first photographs, with a (now legendary), Semflex. From 1956 to 1961, he worked in Ivory Coast, first in the suburbs of Abidjan and then in the Kong region to the north of the country. In 1962, he began to study the Tuareg, undertaking several expeditions in the Hoggar heights of Algeria, then in Burkina Faso, and then in the Niger-Mali borderlands around In Atès. However, most of all, it was in northern Niger where he really deepened his knowledge of the Iwellemeden Kel Dinnik Tuareg population.

Further to his life-time's study of the Iwellemeden, at the end of the 1970s he lead an emergency archaeology programme in the Azawagh Valley to investigate the area before the uranium mining operations were set up, and in 1990, he went to the north of Mali to meet not only the Tuareg of Adrar des Ifoghas in the Kidal area, but also to study about the '*Gens d'avant*'[4] – particularly the fragments of their stories which talk of giants who built the wells and towns. The '*Gens d'avant*' lived in what is now Tuareg territory before the arrival of the nomads, and there are numerous traces of them. Yet unfortunately, events prevented him from continuing this research. He did however undertake several other, short research trips in Africa – notably in 1993 when he returned to his Malinke village, Kobané, 38 years after his first visit.[5]

Edmond studied numerous and varied facets of Tuareg life. At first, he concentrated on a single tribe, the Illabakan, who roamed the In Waggar region in the Azawagh Valley. With its lack of aristocracy and religion, and its total independence, Edmond considered this tribe representative of the Tuareg as a whole. He spent several months living with them on more than one occasion: this way of working allowed him to develop a genuine closeness to his subjects and go beyond being a simple observer. The result of this research was a monograph which was truly unique in its genre.[6]

In this way, Edmond created ties with Najim, the chief of the Illabakan, and his family – ties which proved so strong that Edmond would worry about them during difficult periods as he would have worried about his own family. Famously, in 1968, when the Parisian streets below were wild with the rioting students, Edmond was fretting about the seasonal rains of In Waggar. 'I missed a moment in history', he said, but without regret, 'more concerned in whether there was fresh pasture [in Niger]'. Sometimes, Edmond and Suzanne took us, their children, to the camp, reinforcing the bond between them and Najim. Later, Najim's sons came to Paris to visit the Bernus family.

The more these links became established, the more the aspects of Tuareg life became clear to Edmond. He could study not just the elements of everyday life associated with animal husbandry, but a whole range of activities connected to it, such as caring for the

Right:
Notebooks from the field,
left to right, top to bottom :
the design on the blade of a
sword, indicating its Spanish
or Moorish origins, Edmond
Bernus, 1965 ; sketches
of the Agadez cross by
Suzanne Bernus, 1968 ;
drawings and descriptions
of the *takuba*. or sword ;
sketches of a camel, or
dromadaire, by Edmond
Bernus, 1963

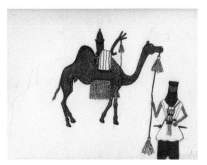
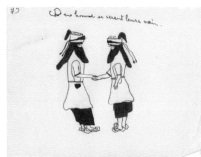
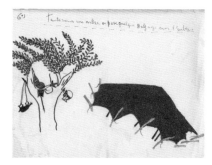
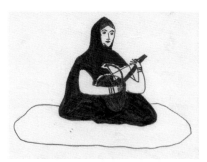

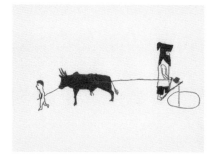

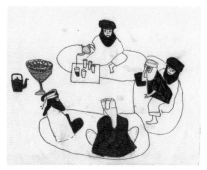
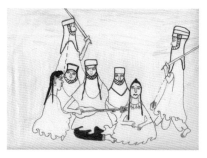

animals, finding water and pasture, forming caravans, and seasonal migrations – including the summer movements known as the 'salt cure'.[7] Films were made to show camp life, for instance during the dry season.[8]

Of course, Edmond also devoted his attention to culture: the Tamasheq language and its written literature, the Tifinagh script, and the rich oral traditions. He was particularly interested in wordplay, riddles, proverbs, poetry and songs, of which he made a number of recordings (which are currently being digitised), and he looked at Tuareg handcrafts, in particular, at the role of blacksmiths in the society. He also studied Tuareg festivities and events, behavioural codes and notions of time, space and geography. It was in looking at these that he realised that, for all that the various tribes had in common, there were regional differences related to the environment (were the people plain or mountain-dwellers?), or to work (did they have livestock or did they participate in caravans?), and to history (were they masters or slaves?). This research, covering all Nigerien Tuareg groups (where this part of the title, 'Cultural Unity and Regional Diversity' alone explains much about Tuareg society), was the subject of his seminal doctoral thesis.[9]

Their caravans, the *Cure Salée*, their origins and history, mean that the Tuaregs moved beyond the borders of their current states, which came into being during colonisation. Although numerous in Niger, the Tuaregs also live in Algeria and in Mali. It therefore seemed only logical to Edmond to investigate to what extent the differences he had discovered in Niger existed in these other countries too – and to assess what was happening to the overall unity he had recognised in Niger. This was the motivation behind his ultimately aborted research in Adrar des Ifoghas.

As well as the camel, which is a symbol of prosperity, and women, who represent love, another symbol of primary importance in Tuareg poems and songs is vegetation, being a guarantor of life. As such, plants are used as words of choice for lovers, as in *L'amour en vert (en vers?)*,[10] but they also designate time (1906, for instance, was the year of the *alwat*),[11] and places – such as Tegidda n tageyt,[12] or In Tamat.[13] The variety of medicinal benefits from plants is also great, especially for animals. Plants are indeed used in all kinds of medicinal practices: *agar* (*Maerua crassifolia*), for instance – said to be the 'tree of genies' – is considered to offer protection from both rabies and spear injuries, and it soothes the necks of animals irritated by pack saddles or other wounds.[14]

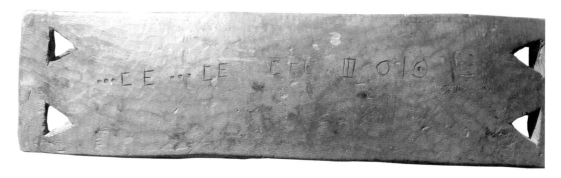

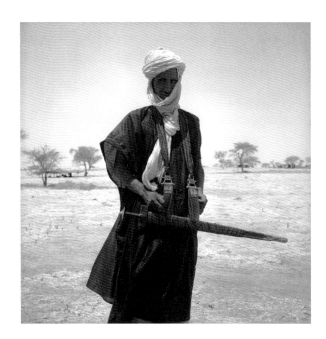

Top to bottom:
Tuareg man with his sword,
part of his heritage from
his father or a male elder,
1960s

A Bella tent with a leather
hide roof, Niger, 1962. The
skins of sheep or goats,
or sometimes gazelles or
ostriches, are stitched
together and placed over
the tent's wooden frame.
The vellum may be fully
raised and folded over the
frame, or otherwise folded
down depending on the
direction of the sun and wind
Edmond Bernus

Tuareg couple, north of In
Gall, Niger, 1967

A meeting in the northern
plains during the seasonal
movements. A man on
his camel and a woman in
sumptuous robes occupy
an empty scene, as
witnesses frozen on a
past horizon
Edmond Bernus

Right:
Illabakan Tuareg, In Waggar,
Niger, 1967

L'Harmattan, a Saharan
wind of sand and dust, lifts
the boys' tresses; they do
not yet wear the veil
Edmond Bernus

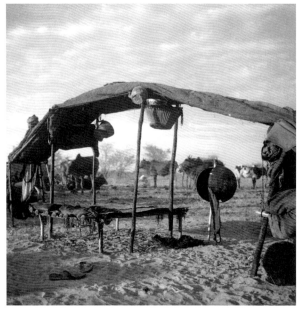

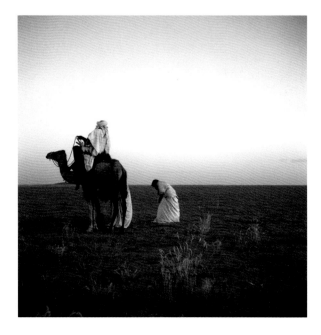

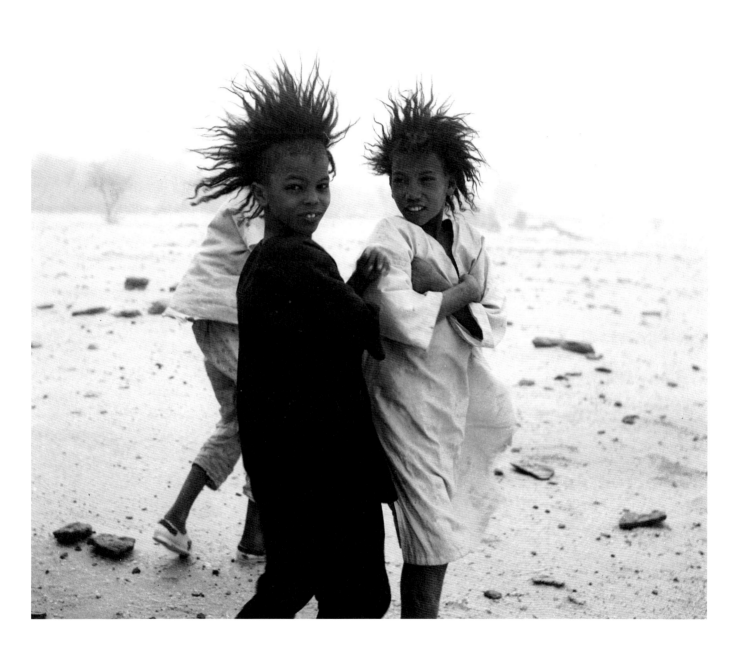

The tornado is now upon us; the wind blows like a hurricane, the red powdery dust is so thick that one can't see further than one's feet. The tents squeak and creak; their roofs flap noisily. The lungs whistle and objects fly away; the "mehara" [camels] bellow sorrowfully
Cortier as cited by Edmond Bernus

If the classic proverb for the rest of the Sahara is 'water is life', here, in this region, the motto would be 'plants are life'. If the rains come too early or too late, are too weak or too strong, then no pasture can grow and the water will be useless for livestock, which, in turn, will make life difficult and could lead to a period of scarcity.

It was this recurring problem – which Edmond observed several times over the years – that made him take a closer look at the phenomenon of desertification. From the 1980s onwards, he accrued much expertise in this area and compared what he had noted in Niger with observations made by other researchers working on the same issue in areas such as the Middle East, in the Atacama desert, or in the north-east of Brazil. Besides the periodic cycle of this phenomenon on a geological timescale, on a local level it would seem that desertification accelerates when 'easy water' is found and livestock are vaccinated *en masse* – this leads to overpopulation in the animal kingdom and, as a consequence, the disappearance of some forms of vegetation. The steady collapse of social structures in these arid Saharan regions has led to poor pasture management by those raising livestock more recently: this has accentuated desertification even further.

Edmond referred to his work as 'happy research': he had thoroughly assimilated with the society, being part of the landscape, as it were – fundamental for a geographer. Beyond his writings, he used film and photography to express himself. His great friend, the film maker Jean Rouch, encouraged him, and Edmond's work is highly regarded by critics and photographers alike. His collection of photographs in *Éguéréou*,[15] showing some of the stages in his long research career, first brought his talent for photography to the wider public. The book did not go unnoticed, and the Centre Régional de la Photographie du Nord-Pas de Calais bought some of the photographs.[16] It might be said that Edmond was one of the last all-round researchers, following in the steps of the masters from whom he had learned.

Since Edmond's death, life has got harder in this region, troubled by the rise of terrorism, state corruption, islamism in Algeria, instability in Chad, the powder-keg that is Libya, and foreign interests in mining and oil. and so on – with all that this implies for displaced people and livestock. Without a doubt, the golden age of Edmond Bernus' 'happy research' is over.

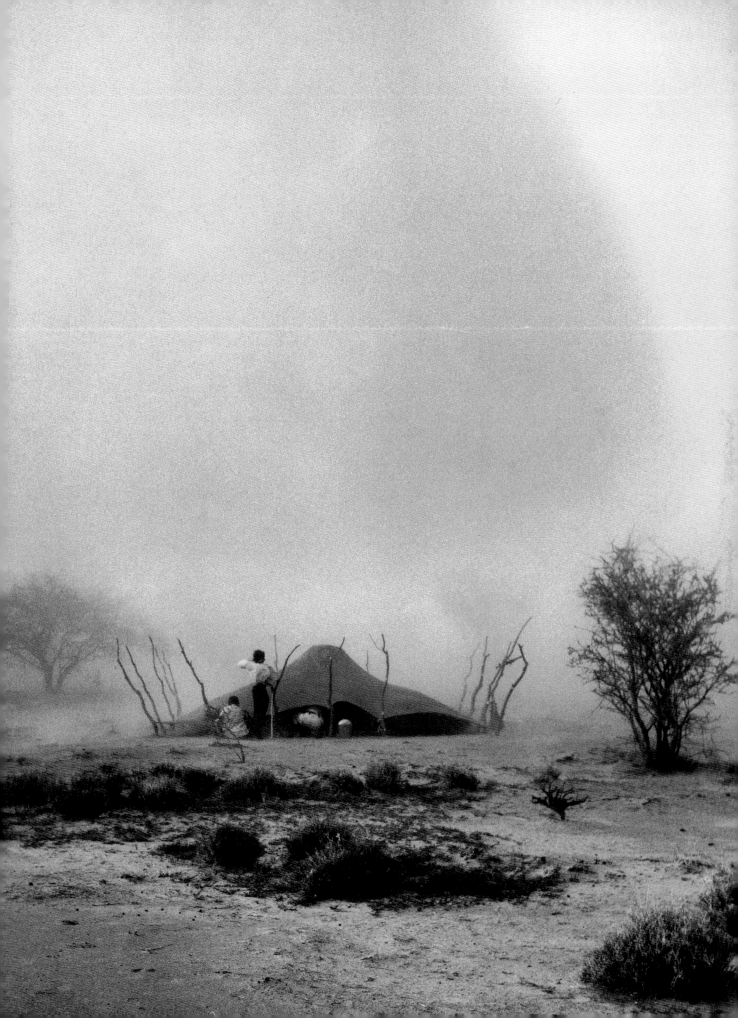

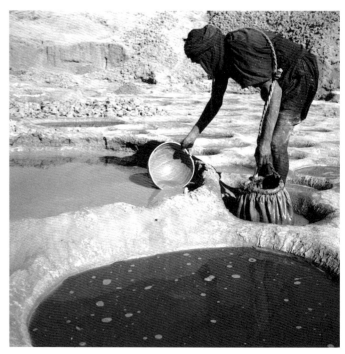

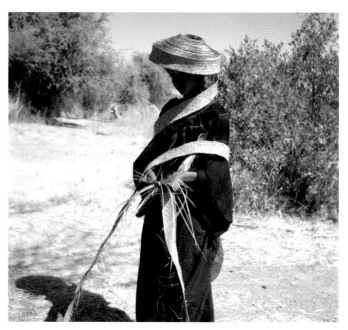

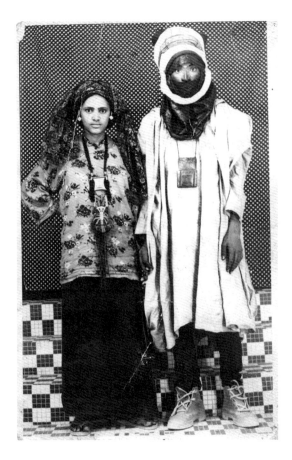

It goes without saying that Edmond never stopped encouraging young researchers to study topics with more relevance to current affairs – such as the Tuareg diaspora, the *ishuma*,[17] or new Tuareg music like that of Tinariwen. He was always committed to the Tuareg, defending their cause alongside their leaders – such as Mano Dayak – never hesitating to hold authorities to account when he could. He welcomed refugees who were part of the diaspora in France in times of crisis in their regions; he was also very generous whenever individual Tuareg were in difficult situations.

After the publication of *Eguéréou*, he understood the value of his photographic archive, rich with more than 6,000 images, and he was driven to classify, number, and caption them. His grand-daughter Gaëlle helped to organise the pictures but, given the size of the collection, they were eventually passed to the IRD, and a lot of them are in the Indigo database.[18] The first part of this work gave rise to an exhibition in Paris in 2006, which then toured several countries and formed another beautiful book.[19]

Today, his archives – written and audio-visual – are held at Aix-en-Provence in the *Archives d'Outre-Mer*. His collection of plants is at the French National History Museum in Paris (*Muséum National d'Histoire Naturelle*). Fabien Bordelès, in charge of carrying out the inventory at IRD, did a tremendous job enhancing this collection, a part of which was shown in 2014 at an exhibition in Cahors.[20] The efforts to promote the collections have been much appreciated by the Tuareg themselves, who consider Edmond Bernus' work as fundamental to them.

Edmond left a great mark on the Tuareg. The place where the Illabakan first met him is now called Wan Bernus ('that of Bernus'). One of Najim's grandchildren is called Jacques, as a memory of Edmond's son Jacques' stay in the Illabakan camp. And our tribe, in Paris, is called 'Kel Bernus'. Using the Tuareg's word is meant to be humorous, of course, but also shows how dear we have become to the Tuareg. The ties between Edmond to the Illabakan and their 'cousins', similarly unite his children to Kili Kili, Baz, Abdoulaye, Tahir, Alhassane, Ousmane, Boukli – they are our brothers.

As Edmond said of himself and Najim, 'We recognised that we shared the same values, inscribed in two distinct cultural registers, but which are joined by the same feeling for the world.'[21]

L'AMOUR EN VERT (EN VERS ?)
by Edmond Bernus and Ekhya Agg-Albostan Ag-Sidiyan

Love sprouting (in poetry)

An anonymous woman's skin is likened to trees and plants refreshed by recent spates of rainfall. The poem is an ode to the Sahelian plant kingdom, which is continually threatened by drought.

"Her skin is like…"

Free translation

Her skin is like the thick bushes of *adraylal* grass from Ajar,
Her skin looks like green shoots of *alwat* which carpet the ravines,
Her skin is like the *tinazamen* leaves as they unfurl,
Her skin looks like *imadarsalan* that no one yet has touched,
Her skin is like blades of *tarada* when they begin to intertwine,
Her skin evokes the wooded dells where the *amshekan* compete,
Her skin is like the soil of the *teneden* caressed by the flood,
Her skin is reminiscent of the *tarakat* bushes from where the oryx has been chased by the overflowing waves,
Her skin is like the hollow where the *asghal* mingles with the rampant stems of wild gourds, girls of lightning,
Her skin looks like the tuft of *agargar* that blossoms in a land full of water,
Her skin is like the desert gourds enlaced by the swirls of their stems,
Her skin is evocative of small acacias, their branches laden with pods,
Her skin is like a young evergreen *tabszgint* covered in red berries,
Her skin is reminiscent of a *tedey* which has struck a thick cloud,
Her skin is like young *tidarsen* after a shower of fine rainfall,
Her skin is like the little *afagag* of Agogh to which the gazelles flock.
The end.

This poem was recorded in November 1986 at Fagoshia (a well 150 kms to the west of Agadez in Niger), in a camp of Kel Ahaggar, who had settled in this valley to prepare for the *cultures de contre-saison.* They are 'Hoggar of Aïr ' according to the administrative terminology, who arrived at the begining of the 19th century, [now] of Nigérien nationality, living permanently in the west of Aïr.

Right:
Tamanrasset 2004

Page 76-77:
Tiguidit, Niger, 2007

Page 80-81:
Dunes near Arakao, Air, Niger 2005

God created countries full of water for people to live in, and deserts for people to find their souls

Moussa ag Amastane, Amenokhal of the Kel Ahaggar, c.1900

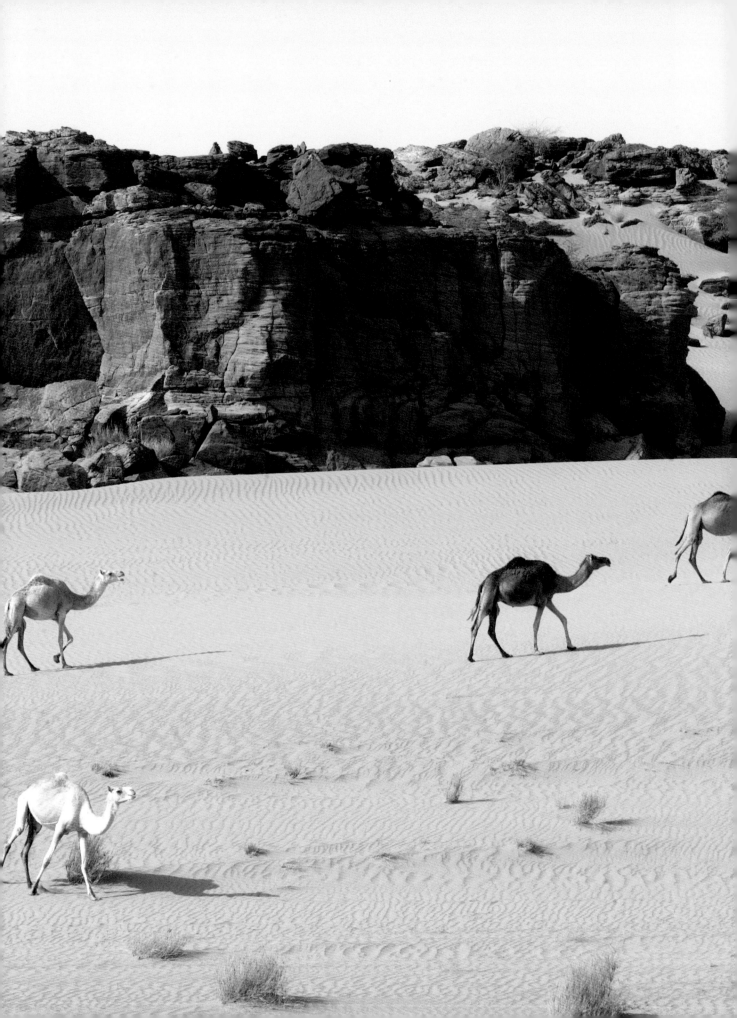

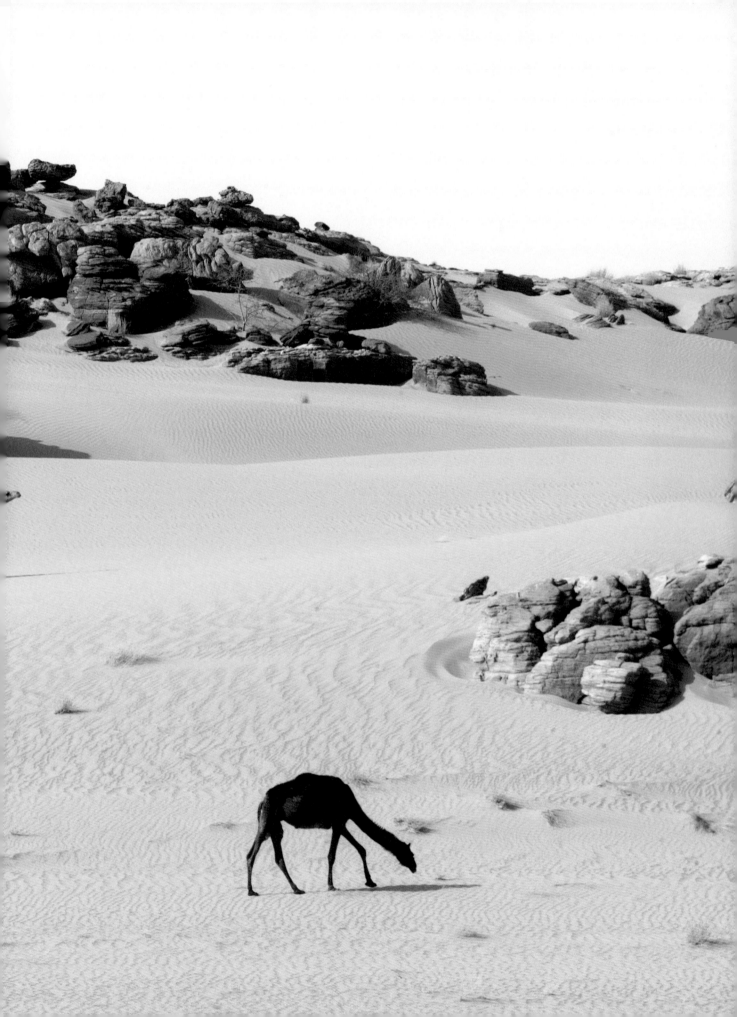

Chapter 2
European Exploration

– from Altruism to Subjugation

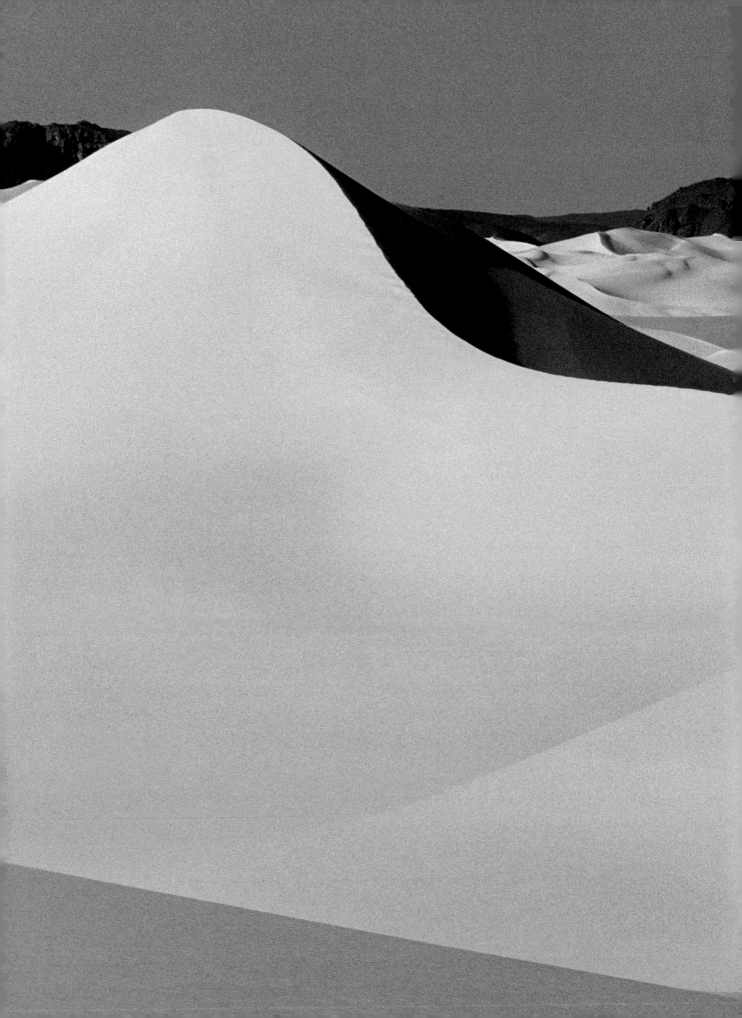

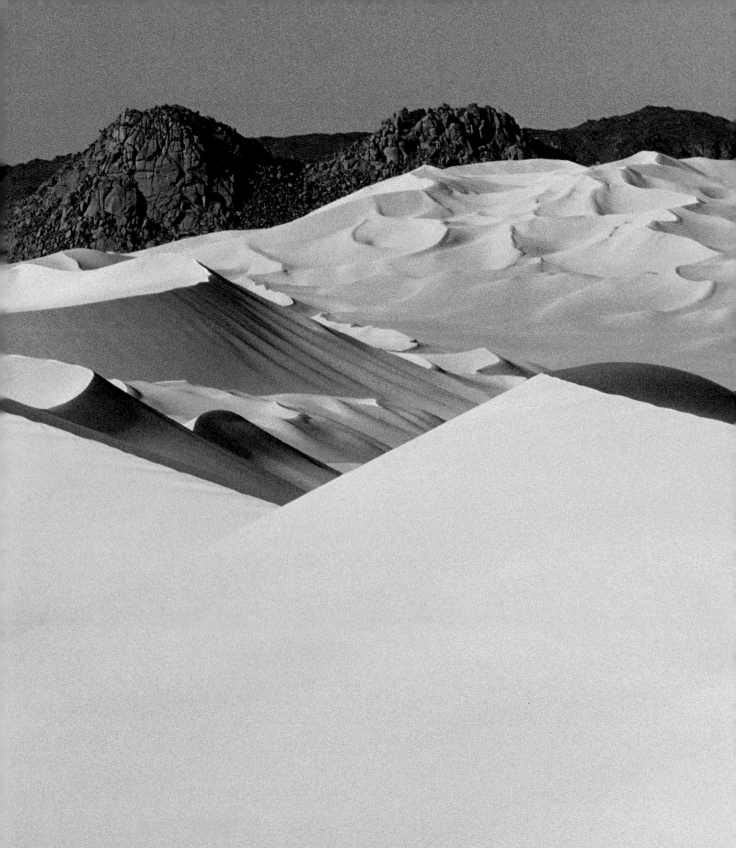

Top right:
Major Alexander
Gordon Laing

Bottom left:
René Caillié

CENTENNIAL CELEBRATIONS - Mission Timbuktu, and in the footsteps of those who have gone before

In 1928, French newspapers triumphantly lauded the centennial celebrations of René Caillié's "discovery" of Timbuktu, the mythical, gold-laden and learned city from where, throughout known history, not a handful of white men had returned alive. Caillié's return from Timbuktu was the first for a couple of hundred years. "The whole of France is full of glory", cried *Dimanche Illustré*, showing a slightly incongruous portrait of Caillié in white tie. The image was a far cry from the Caillié of the Sahara, either disguised as a Muslim to evade discovery of his Christian faith (for which he would have most likely been killed), or the be-draggled wretch who crawled into Rabat at the end of his famous journey, penniless, ill with exhaustion, and so unconvincing that thanks to the French consul, Caillié spent his first night in safety in a cemetery.

Caillié had started his adult life as a cobbler. Two years before his hasty, uncommissioned personal jaunt - inspired not least by France's Société de Géographie's 10,000 franc reward, and fame - a Scottish Major, Alexander Gordon Laing was in fact the first white man, or Christian, to write home from Timbuktu, "for God and country", he wrote somewhat loftily.

However, Laing's fearfully romantic story - worthy of Hollywood - ended fatally. Forty kilometres, or two days north of Timbuktu on his return journey, he fell victim to local politics - the pig-in-the-middle of warring tribes, a common regional hazard - and there he took his last breath. Somehow, five months later a letter from Laing from Timbuktu dropped onto the desk of Tripoli's British Consul, Hanmer Warrington (also Laing's new father-in-law), confirming Laing had attained the elusive goal - but this would be the last news any ever received from him. Indeed Warrington would not know that Laing had actually died until yet many more months after receiving the now famous letter, "the first ever letter written from that place by any Christian", Warrington noted alongside it in his files.

On 13th August 1826, Laing had excitedly walked through the shadow of what had been the great, twelfth-century city of Timbuktu. Curiously, Laing wrote positively of it: Timbuktu "has completely met my expectations...my perseverance has been amply rewarded". He scours the historical records, "which are abundant", and affirms European assumptions of its prosperity. It would be Caillié who, despite fabricating things in his *Travels through Central Africa to Timbuctoo* that he didn't actually see or witness, would accurately describe the city's fallen state: "'the sight before me did not answer my expectations...The city [was] nothing but a mass of ill-looking houses..all nature wore a dreary

Mr. Caillié méditant sur le Coran et prenant ses Notes.

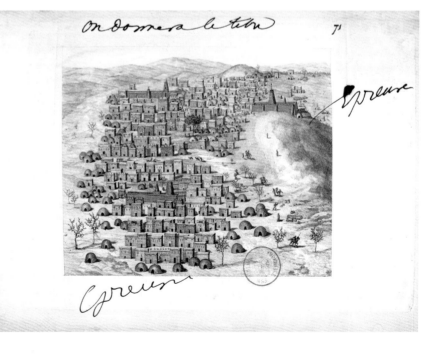

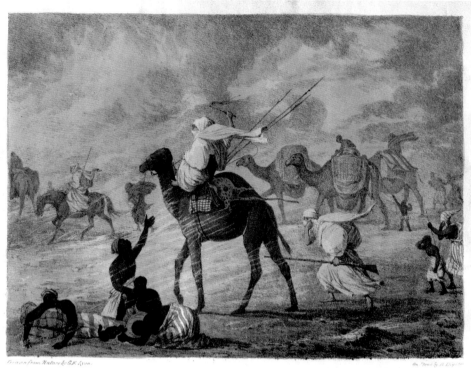

Right:
"A Sand Wind on the Desert", by Captain Lyon, 1821, showing a typical caravan that the explorers would tag on to for 'safe' passage across the dangerous wildernesses towards their destinations. Cargo included many slaves as well as the flow of regular trade goods, the slave-trade being rife throughout much of Africa. The Tuareg, as Lyon says, "are always at war with the Soudan states and carry off from them incalculable numbers of slaves"

A SAND WIND ON THE DESERT.

Laing's letter to the Consul in Tripoli, also his father-in-law, describing his "twenty four horrid wounds", 10th May 1826

"When I write from Timbuktu, I shall detail precisely how I was betrayed & nearly murdered in my sleep, in the meantime I shall acquaint you with the number and nature of my wounds, in all amounting to twenty four, eighteen of which are exceedingly severe. To begin from the top, I have five sabre cuts in the crown of my head & three on the left temple, all fractures from which much bone has come away, one on my left cheek fractured the Jaw bone, & has divided the ear, forming a very unsightly wound, one over the right temple, and a dreadful gash on the back of the neck, which slightly scratched the windpipe: a musket ball in the hip, which made its way through my back slightly grazing the back bone: five sabre cuts on my right arm & hand, three of the fingers broken, the hand cut three fourths across, and the wrist bones cut through; three cuts on the left arm, the bone of which has been broken, but is again uniting. One slight wound on the right leg, and two .. with one dreadful gash on the left, to say nothing of a cut across the fingers of my left hand now healed up. I am nevertheless, as I have already said, doing well, and hope yet to return to England with much important Geographical information".

aspect, and the most profound silence prevailed".

Perhaps for Laing, it was the fact *he had made it* to Timbuktu that affected his reporting. Unlike poor Mungo Park, Laing had made it with his mind and nerves intact (if not his body). He would describe it how he wished! Perhaps, contrary to his heroic letters, he secretly feared he might not make it home. He was longing to get home, particularly to Emma, his new bride. . . .

The race to claim Timbuktu had been fierce well before it became an international issue. Although this was initiated by Sir Joseph Bank's African Association, after the Association had failed for some thirty years to achieve this founding goal, the British Foreign Office and its empire building ambitions was now also casting an eye over this unusually unmapped area of the world. Where the Association's motives had been largely scientific or ideological - a great hope was the abolition of the regional slave-trade - the Foreign Office wanted to trade, particularly if the area was still as wealthy as many imagined.

Following Lyon, firstly in 1818-1821 with Ritchie, and later with Clapperton, and then Denham and Oudney - none of whom got to Timbuktu or went deep into Central Sahara - Laing, the son of a Glaswegian pastor,

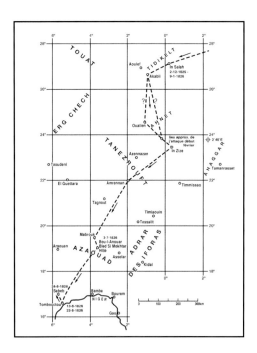

was commissioned by Henry, 3rd Earl Bathurst, the head
of the Foreign Office. Leaving Tripoli in July 1825, three
days after marrying Emma - after written assurances to
her father, the Consul, that the marriage would not be
consummated at this time - Laing joined the usual trade
caravans criss-crossing the desert, as all the explorers
did. Laing's ran south-west of Tripoli towards the desert.
Ploughing through strong, hot winds, and losing the bulk
of the scientific equipment or arms that he had when he
set out - whether due to the bumpy camel-ride, the heat
or the "gouty foot" of one camel crushing his rifle, Laing
reached In-Salah, a desert frontier town, relatively easily
on 3rd December 1825.

However, leaving the town in January, they were
soon trailed by Ahaggar Tuareg who demanded payment
for their safe passage. This was given but, several days
later, with the party now deep in the bleak, scorching
Tanezrouft, the same group approached them again.
One account relates how Laing's guide took Laing's guns
and ammunition and gave them to the Tuareg against

Right:
Laing's letter to Consul
Warrington dated August
13th 1825, a few weeks into
his journey, a year to the
day before he would enter
Timbuktu, written two ways
due to lack of paper

Pages 88–89:
Oeud, Air, Niger 2002

Pages 90–91:
Tuareg chief. Adrar Chiriet,
Air, Niger 2001

Extract of a letter from Captain John Washington - a founder of the Royal Geographical Society, at this time also its Secretary - to a member of the Société de Géographie on the news of Caillié›s death, 1839

"Along with the portrait of René Caillié, I received the historic Notice that you were so kind to send me; I read it with great pleasure as well as the last letters that you received from this traveller. They carry the print of his enthusiasm which enabled him to cross the African deserts, and prove that this ardouwr for discoveries inspired him right up to the moment when his weakened body gave into exhaustion. It is beyond doubt that this fire that animated him would have driven him to new discoveries...and that the name of Caillié must be added to those of Hornemann, Parck [sic], Burckhardt, and Laing, the most eminent among those who have consecrated their lives to the cause of African discoveries.

The copy of the Notice and of the large-format portrait were presented to the Royal Geographical Society of London, and you are to receive a letter of thanks.I think we make one body, working as we do in the same field for the advancement of geographical sciences and human civilisation. May we encourage each other to make new progress every day in the cause for which we are established".

Laing's wishes, to appease them. And the guide insisted to Laing that there was no danger of the Tuareg's presence. Yet that night they "surrounded Major Laing's tents and fired into them without saying a word. They then rushed upon the tents cutting the cords and canvas, entered that in which was Major Laing wounded by their fire, and again wounding him in various parts of the body, left him for dead". The Tuareg killed or wounded all the others who had not turned blind eye to the attack (which many had), and stole all of Laing's less valuable possessions. This attack by Tuareg was the first documented European brush with the feared Tuareg, masters of all Saharan passage outside of towns.

How Laing survived the next two months travelling over a good 400 miles, severely wounded, is uncertain; some say he was strapped to a camel or a horse. According to his mother, Laing steeled himself before the journey for hardship or unforseen circumstance by, amongst other things, sleeping on the ground and learning to write not only with his left hand but with a pen between his toes. Taken to the home in Azawad of the eminent religious leader Sheikh Sidi Mokhtar of the

now well-known al-Kounti family, Laing recuperated there for several months before finally setting of for and reaching Timbuktu. His letters from the journey produced new geographical and social facts about the Sahara, but he was of course never seen again by either his "beloved" Emma or her father, his "dear Consul".

Doubtlessly weakened by the "24 horrid wounds" from the Tuareg bandits, the second time he was attacked, on leaving Timbuktu, he was killed rapidly - perhaps even decapitated, and by his own guide, apparently for refusing to convert to Islam. His remains were to lie at the foot of a desolate tree in the arid scrub thirty miles north of Timbuktu until 1912 when what were thought could be some bones were found and taken to Timbuktu. The bones were analysed and deemed to include those of a European.

Similarly, Laing's journals never made it home. The loss of the journals caused a furious row between the English and French governments, "exceeding a mere dispute between two Consuls in a far-off Levantine sea-port". Laing's *death* becomes almost forgotten in the vast and heavy tomes of correspondence "overflowing with consular spies" relating to the mystery of the disappearance of the Journals. Warrington, who never liked the French, blamed them publicly - did René Caillié somehow get his hands on them and make up his discovery of Timbuctoo, he went so far as to say?

The journals were possibly stolen by someone, perhaps indeed sold to the French Consul, Rousseau, whom Warrington despised and had accused him of the theft - whether or not Rousseau was the recipient of a baronetcy from Charles X, and a Legion d'Honneur. To add to Warrington's distaste for Rousseau, Rousseau's son had recently died of, surreally, mis-placed love for Emma Warrington - although perhaps she had been in love with young Rousseau too, as well as with Laing. If indeed taken by Rousseau, the journals were most likely promptly lost again when Rousseau, now dismissed from office, left Tripoli in late 1829. The humidity of the sea-water on his cargo's crossing to Marseille destroyed 424 of Rousseau's 460 manuscripts, which may also have included writings by Ibn Battuta thought to have been collected by Laing in Timbuktu. Rousseau died in ignomy in Marseille a couple of years later. Although the journals could have been burnt with Laing's effects by his murderers - or perhaps survive today in America. The mystery of the Journals, "God alone knows", Theodore Monod concluded.

A hundred years on, in 1930, two years after any self-respecting French citizen was celebrating the

Private.

Malm...ik on the borders of Fezzan
Lat 29.35 N. Long. 13.50 E
August 13th 1825

My dear Consul

As I learn that after the consideration of
[the remainder of this letter is written in dense, crossed handwriting and is largely illegible]

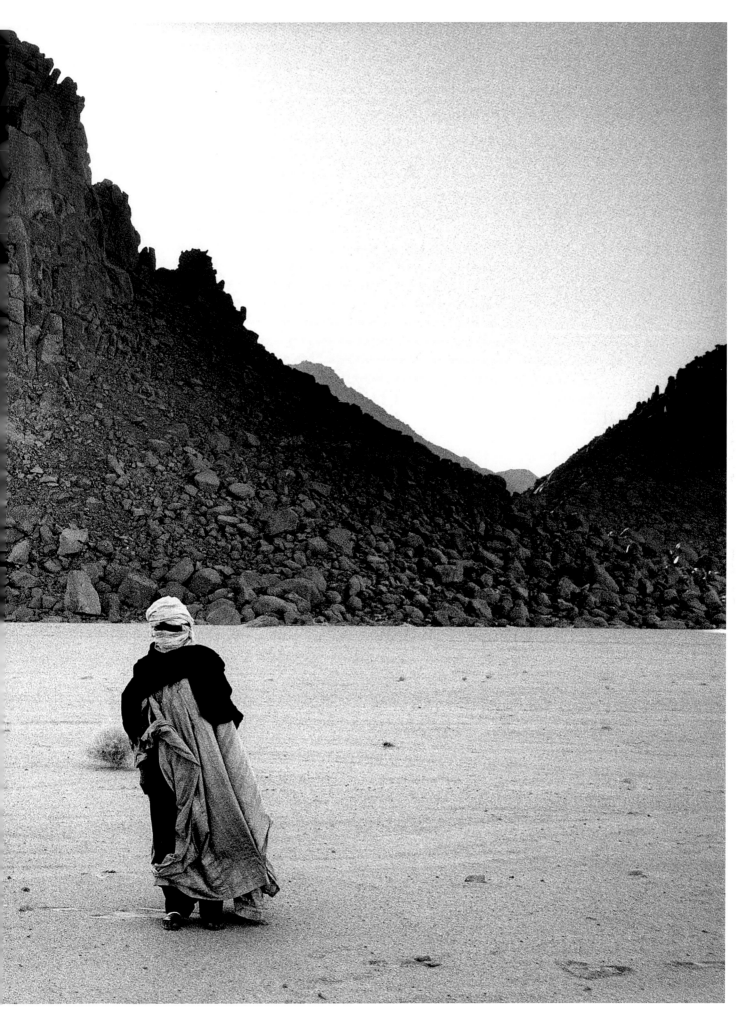

Praise be to God! May He be glorified!

On the part of Clarendon, Minister to the Queen and Government of England, to the greatly honoured and very noble Sheik, the learned among scholars who shines by his intelligence, Sidi Mohamed El Backay, ben Sidi Mohamed, ben Sidi Mokhar El Kounti; to whom we address our thanks and the expression of our consideration. May God reward him! So be it!

Salutation be with you.

May God accord you His mercy and blessing with the purest of His graces!

I would have you know that the Queen of England has heard the report of Doctor Barth (named Abdel Kerim among the Arabs), who visited you at her command, in your country, to renew the friendship existing between you and us, and to make you known to her. Barth has made known to us the goodwill with which you received him and which can never be forgotten. You have protected him from a faithless people who were unable to distinguish good from evil (may God reward you for the good actions His law recommended to you!). He has informed us of your strength and courage, and we have felt great joy thereat.

The letters you sent by him have arrived. We have read them and well understand what they contain. It has been a great pleasure to us. The hopes of the English Government have been understood by you. What we wish is to open the eyes of the Arabs of the south to commerce and all appertaining to it, and we are now aware that you have looked upon our mission with pleasure and have accepted our friendship with joy.

We have given you our word that the friendship binding us shall not diminish through the centuries, and that all that the Arabs require of us we will do, without increase or diminishment. We will assist them in all that they are unable to perform, and as our government is very powerful we will protect your people who turn to us, above all with the aid of your Lordship, who have long shown your power and your friendship for us.

The Queen experienced great joy when she knew the benefits with which you loaded Abdel Kerim, who was enabled to return in peace owing to your reception and the honours with which you surrounded him, and she sends you presents of products manufactured in England.

These presents have been packed in cases and sent to the Consul-general of Tripoli, who will send them on to you. God grant that they may arrive safely and in good condition, and that they may please and rejoice you.

We request and recommend you to say to the chief of the Aoule-midens and the chief of the Tademekkats, that the Queen of England has received the letters sent by them to her through Abdel Kerim. We have all been pleased by them. She begs you to say to these chiefs that she salutes them and sends them a poignard and a sabre, the poignard for one, and the sabre for the other. You will easily recognise these objects, for the name of the recipient is written upon each. To conclude this letter, we wish to say to you that our joy would be great to see one of your people, above all a child of your own house, whose visit would honour us. We wish to show him our power, our manufactures, and many other things.

May God prolong your life and preserve you to live.

Your friend,

CLARENDON,
Minister of the English Government, London, the fifteenth day of April 1859.

Association member as Bank's esteemed map-maker, Rennell is remembered today as the father of British geography, notably for his work charting Indian geography and ocean currents, and the currents around the South African Cape. Not insignificantly too, in 1791 Rennell analysed "the rate of travelling as performed by camels". Distances between places had previously been understood in terms of how many *days* it took a camel to go from A to B ; by charting the camels's pace, distances could be measured scientifically.

The most ardent voice remembering James Rennell in 1930 was the winner (in 1928, the same year as Caillié's centenary), of the Royal Geographical Society's Founders' Medal. Awarded to Britain's still greatest explorer of Tuareg and Saharan lands, the winner, Francis Rennell Rodd, was also James Rennell's great-great-grandson.

A lot had changed in the Sahara in the hundred years between James Rennell's and Francis Rodd's studies of it. The fascination with science or geography, and exploration on behalf of trade and worthy principles, had ultimately just aided colonialists' penetration and, after some effort, the colonialists' absolute control of the Sahara. In this part of Africa, after a pact between the English and the French in 1890, the colonialists would be French. The deep respect and integrity of the wishes of Victoria's Empire in the 1850s in its relationship with the various Sheikhs and Sultans (see the letter above left), didn't square with the 20th century European wishes of invasion, usurpation and domination. Now all Africa, as far as Europeans were concerned, was peopled by savages.

centenary of Caillié's victorious Saharan voyage, the British Colonial and Foreign offices squabbled over who might pay for a memorial plaque to Laing in Timbuktu, which had been quietly proposed by the Royal African Society. The Colonial Office finally selected its nearest second-rate civil servant to Timbuktu to represent Britain, and to liaise with the delighted French military in Timbuktu, Timbuktu being firmly part of French West Africa now. The French were gracious and only too obliging, honoured to host commemorations for the unfortunate Laing, their heroic Caillié's fore-runner.

More prominently in England in 1930, the Royal Geographical Society was celebrating their founder in all but name, James Rennell. An honourary African

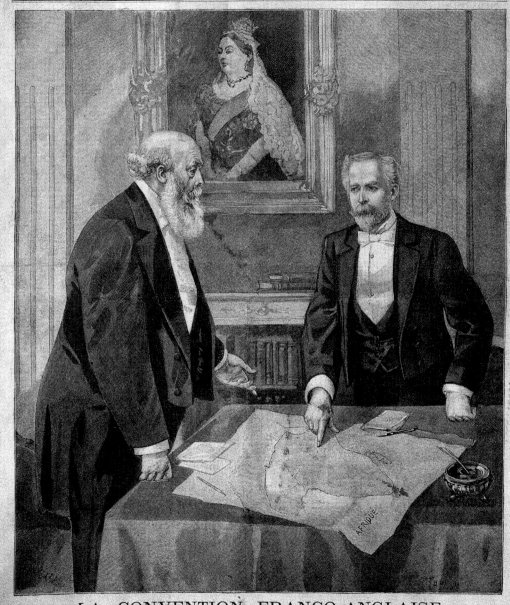

Le Petit Journal

Le Petit Journal
CHAQUE JOUR 5 CENTIMES
Le Supplément illustré
CHAQUE SEMAINE 5 CENTIMES

SUPPLÉMENT ILLUSTRÉ
Huit pages : CINQ centimes

ABONNEMENTS

	SIX MOIS	UN AN
SEINE ET SEINE-ET-OISE	2 fr.	3 fr. 50
DÉPARTEMENTS	2 fr.	4 fr.
ÉTRANGER	2.50	5 fr.

Dixième année.　　　DIMANCHE 9 AVRIL 1899　　　Numéro 438

LA CONVENTION FRANCO-ANGLAISE
M. Paul Cambon et Lord Salisbury

FRANCIS RODD
Britain's greatest explorer of Tuareg lands

In 1918 the resilient but crucially, disunited Tuareg had
finally been subjugated. Francis Rodd, in Libya during
the war - soon requested leave from his new job at the
Foreign Office. Smitten with the desert when in Libya,
and reflecting too on his forefather Rennell's Saharan
interests, Rodd arrived in Aïr (in current-day northern
Niger), in 1922. A military man, Rodd himself went
on the odd surveillance *tournée* with his new friend,
Lieutenant Gramain. Spending nine months in Aïr,
he produced the seminal *People of the Veil* which was
published in 1926.

In the Preface to *People of the Veil*, Rodd apologises
for the long time (2 years) after his return to produce
the book and for its consequential "deficiencies". The
book is however astonishingly accurate and hugely

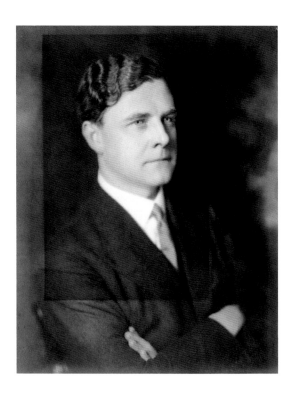

admired internationally, appreciated for its erudite
detail of extraordinary latitude by any self-respecting
Tuareg enthusiast. Like Heinrich Barth, his great hero,
Rodd describes all and everything: from architecture to
artefacts to history, the environment, nomadic life, trade
and social government, and to religion and superstition.
Though accounts of the Tuareg's history or the region's
geology may lose the non-academic reader, Rodd writes
simply with some charming flashes of humour. Talking
of the veil, the Tuareg's emblematic distinguishing
feature with symbolic as well as practical use, he relates
it to English customs beautifully: "The Tuareg, unless
they have become denationalised, would as soon as
walk unveiled as an Englishman would walk down Bond
Street with his trousers falling down".

After his two journeys in Aïr (the second being in
1929), and well into his later years, Rodd corresponded
with all the key figures exploring and commenting on
the Sahara - from, to name a few, Conrad Kilian to
Henri Lhote and Theodore Monod, an article of whose
Rodd translated for British publication. Even Professor
André Basset, a son of Foucauld's publisher (it was in
fact André Basset who first published the complicated
Dictionnaire in 1951), "had polite words to say about you
on account of the Tifinagh poetry you had published",
according to an American, G.I. Jones.

Similar to Wilfred Thesiger, whose mother lived not far from Rodd in Powys, Rodd despises the modernisation of Tuareg country, abhorring the new adventurers seeking to cross the desert at speed in cars. Rodd describes a photograph he has received from the same G.I. Jones in 1936 to the eminent Pitt Rivers Museum curator, Henry Balfour:"a gruesome picture of modern travel in that place which has decided me never to go back there again if I can help it". And he didn't.

Replying to G.I. Jones, Rodd expresses his distaste of the new trend: "Soon the Hoggar and Aïr will have become a health resort". Rodd wrote in 1926 that his time with the Tuareg in 1922-1923 was "the happiest year I have ever spent"; when he died in 1978, these memories were reflected on his tombstone.

After his great-great-grandfather, James Rennell, Rodd's great inspiration - clearly mirrored in the detail of *People of the Veil* - was the indefatigable Heinrich Barth. Indeed, Rodd and his group had traced Barth's footsteps through Aïr.

PLATE 21

CAMEL-BRANDS SEEN IN AIR.

Brand.	Name & Place.	Owner.	Brand.	Name & Place.	Owner.	
A A	Cheek or inverted on Neck.	Kel Agellal.	Slit Ears.		Ikaskazan, Kel Ferwan, Ifadeyen.	
///	Neck.	Kel Azañieres.	Y		Immikitan.	
⋈	Neck.	Kel Azañieres.	#	Neck.	? Kel Fares.	
⋈	Neck near Shoulder.	Kel Tadek. (sub tribe).	X	Neck.	Kel Tadek.	
⋇	Tamellalif. Neck.	Kel Tefgun, Kel Anuwisheran.	//	Cheek.	Imezegzil.	
⤧	Neck.	Assode Tabellawatan.	⌃	Neck.	A tribe of Kel Owi.	
/		Neck.	Igdalen of Agades.	⋀	Cheek.	Imasrodang
⃝	Neck.	Igdalen.	O	Neck.	Ifoghas.	
= //	Below ear 'Izaggan' Neck behind ear 'Teknauen'.	Kel Timia.	◎	Neck.	Ifoghas.	
" "	Shoulder and quarter off or near.	Kel Nugguru.	\|o\|	Neck.	Emagedezi.	
=		Kel Fares.	↑	'Tegeis' Neck or thigh.	Kel Geres.	
∨		Aulimmiden.	O II		Chief of Kel Geres.	
⟁	Thigh. Also inside a circle.	Ghadames.	⊐	Thigh.	Family of Amud of Ghat.	
Ⅎ	'Hatita'. Neck.	Ghat.	++		Arabs of the Western Azawad.	
⊥		Bu Bakr Agalngwi of Ghat.	ﺩﺑ	Neck.	Sultan of Katzina.	

Tifinagh Form.	Name.	Sound	Libyan.	Punic.	Tifinagh Form.	Name.	Sound	Libyan.	Punic.
•	Tar'ent.	[1]	. — \|		\| — /	Yen.	N	\| —	\|
⊡ ⊞ ⊖ ⊘	Yeb.	B.	⊙ ⊡	⋣	∴ .:. ∴.	Yek.	K.		
+	Yet.	T.	+ ×	×	...	Yaq.	Q.		
∩⋏∪∩∪	Yed.	D.	∩⊏⊐	⋌	⁞	Yegh.	ġ.	·\|·+ IIII[4]	
Ⅰ⋇⋈Ⅹ Ⅰ	Yej.	J.			Ⴑ Ꮆ Ꮢ Ꮇ Ꮙ Ꮯ	Yesh.	Sh.		
# # ⊞	Yez.	Z. Empha.			⁞	Yah.	H.	IIII ≡[5]	
Ⅰ⋇⋇⋏	Yez.	Z.			∃ Ε ш	Yadh.	ḍ.		
□ O	Yer.	R.	⊙ □		::	Yakh.	ḳ.	≡[6]	
⊡ ⊙	Yes.	S.			:	Yaw.	W.	= II	
⊺ ⊥ ᴜ _·	Yeg.	G.[2] Soft	⊥ T[3]		⋛⋜⋝⋞⋟⋠⋡	Yey.	Y.		
⋈ ⤬ ⊗ ⋇ ✕	Yeg.	G.			Ⴒ	Yeñ.	Ñ.		
⨅⨆⨌⊔⨍	Yef.	F.			⊞	Yesȥ.	Sȥ.		
II =	Yel.	L.	II =		⊟	Yet.	ḷ.		
⨆⨅⊏	Yem.	M.	⨆ ⊔	⋔			G, Y or S		
Forms peculiar to Air.					Ligatures.				

⊐ ⌐ ⌐	? G.			⋅⊟⊕⊖	Yebt.	+ ⊖	
⇌ ⇒	? K.			丗	Yezt.	#+	
┊ 2 = Χ				⊞ ⊕	Yert.	+ O	
⟋ 1 = ⟨				⊕ ⊕	Yest.	+ ⊙ □	
⎮				⊟ ⊟	Yemt.	+ ⊐	
⎰ ⌐⌐	? S	ᴡᴴ		+ ⊤	Yent.	\| +	
				⤪	Yegt.	+ ⋈	
				ᴴᴴ	Yelt.	II +	
				⋅⊟	Yesht.	+ ?	
++				⊤⊤	Yenk.		

1. Neutral Vowel: a, e, or i. Arabic alif or hamza.
2. There is no equivalent in Arabic or English.
3. Letourneux calls this G, but Halévy V or U.
4. ,, ,, these G or Gh,, ,, Â(e).
5. ,, ,, this H or Q,, ,, H.
6. Letourneux calls this Q, but Halévy H
7. Recorded by de Foucauld, but not by Hanoteau.
8. ,, ,, ,, Freeman ,, ,, ,,
9. ,, ,, ,, and de Foucauld ,, ,, ,,

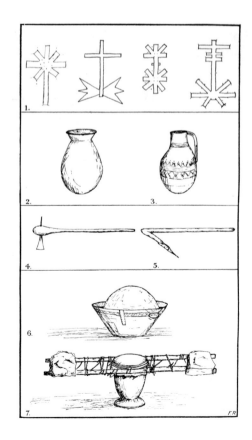

Nut-shell used as
an ink-pot,
TOUAREG, TINTELLUST,
AÏR, FRENCH W. AFRICA

d.d. F. Rodd, 1923.

Artefacts collected by
Francis Rodd on the 1922
trip are at the Pitt Rivers
Museum in Oxford. The rag
camel is a child's toy

Francis Rodd (Lord Rennell), 1895-1978, by his grandson, Dr Philip Boobbyer

It was while working on a British intelligence mission to Libya in 1917 that Francis Rodd first encountered the Sahara - and his imagination was caught. "The desert thrilled me", he reported enthusiastically to a friend. He was in Libya to help negotiate a settlement with the Senussi Bedouin, a Sufi sect that had been threatening British forces in Egypt [members of the Senussi were responsible for Foucauld's death in 1916 and supporting the Tuareg in Niger, notably during the Siege of Agadez in 1916-17]. It was not just the remoteness of the desert that Rodd found fascinating – the encounter with Senussi culture had intrigued him, including eating food with his hands! Rodd's interest in such wild places and non-traditional cultures was to grow profoundly over the next few years, fostered also by his family background. His father, James Rennell Rodd, was a distinguished diplomat with an extensive knowledge of Africa, and Rodd had geography in the blood – his great great-grandfather was of course the cartographer, James Rennell (1742-1830).

After Eton and then Oxford (just from 1913-14), Rodd, now 19 or 20, spent a year with the Royal Field Artillery on the Western front before moving to intelligence and administrative jobs in Italy and North Africa in 1916-18. He then joined the Foreign Office, but he couldn't get the 'East' out of his system so in 1922 he sought leave to go on an expedition to the Central Sahara – to Aïr in Niger. With the explorer, Angus Buchanan, and the cinematographer, T.H.Glover, he followed the route taken by the famous German explorer Heinrich Barth in 1850-1851 (with Richardson and Overweg), but taking the reverse direction. They were based for much of the time in the village of Auderas in the mountains, and it was here that Rodd was drawn to the life and customs of the Tuareg. He made friends with a local chief, Ahodu, and a legendary desert guide called T'ekhmedin. T'ekhmedin was indeed one of few Tuareg men that Rodd saw unveiled. "[The Tuareg] leave one with the impression that they are descended from a race of Kings", he recalled later. On his return to England, he donated roughly 100 items of Tuareg origin to the Pitt Rivers Museum and embarked on *People of the Veil*, his acclaimed study of the Tuareg.

Inspired by the 1922 expedition – both by the work of exploration and what he called "the companionship of the road", Rodd returned to Aïr in 1927. This time he went with his brother Peter (later the husband of Nancy Mitford), and the future Arctic explorer, Augustine Courtauld. In their 80 pieces of luggage there was much modern equipment, including a sandproof Marconi radio -frequently tested on the ship on the outward journey, where they also did at least an hour of strenuous exercise every day to get themselves into shape. Travelling north from Nigeria by camel, they had erudite conversations about Greek history and the origins of words. Their caravan had no fewer than 12 servants and more than 30 camels. Rodd once observed of the camel that the truest thing ever said of the animal was that Providence had manufactured it in a "fit of abstraction". A major legacy of the journey came from calculations which resulted in the whole of Aïr being moved between two to five miles East of previous positions fixed by the French. For these travels and writings, Rodd was awarded both the Royal Geographical Society's Cuthbert Peak Award in 1927 and, in 1928, the Society's Founder's medal.

Geography was just one of Rodd's interests. After the second Saharan expedition, he became absorbed by international finance, notably working for Morgan Grenfell from 1933 until retiring as a partner in 1961. He had a meteoric wartime career, finally as an acting Major-General and the Chief Civil Affairs Officer of the Allied Military Government of Occupied Territories. As President of the Royal Geographical Society between 1945-48, Rodd sought to give the Society greater financial stability, and to find ways of broadening the appeal of geography in the UK.

Personally, Rodd was absorbed by the historical geography and agriculture of the Welsh border near his home in Herefordshire, and from 1952 he was a regular visitor to Western Australia where subjects as varied as beef-production techniques and sand dunes attracted him. He succeeded his father to the peerage in 1941 and was soon a regular contributor to debates in the House of Lords, first as a Liberal and then as a Conservative, mainly speaking on economic or colonial issues.

A generalist rather than a specialist in outlook, Rodd had a big personality and obvious leadership qualities. He brought curiosity, energy, and a passion for problem-solving to all that he did. There was also an aesthetic dimension to his geographical interests: the loveliness and remoteness of both Aïr and the Welsh border evoked powerful emotions in him. He was a man whose feelings stirred strongly beneath a tough-minded and sometimes fierce exterior. He was part of a wide circle of people interested in desert landscapes and peoples -- Lawrence of Arabia, Wilfred Thesiger, Rosetta Forbes and Ahmed Hassanein Bey were all friends.

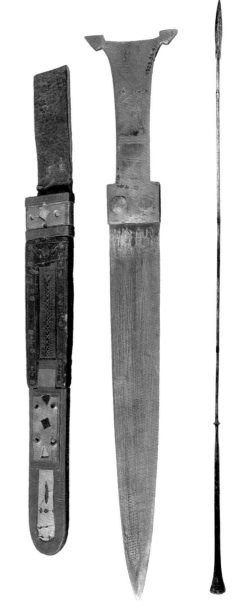

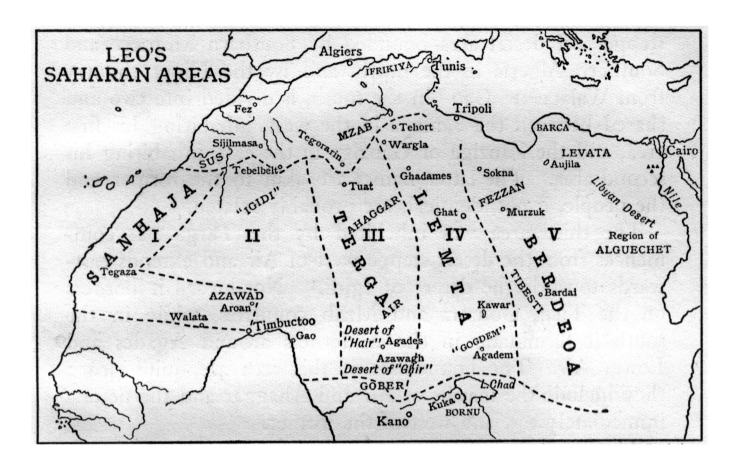

LEO'S SAHARAN AREAS

Top left:
Sheath knife and spear: a war spear or *allagh* (as opposed to a hunting spear) - below the head are barbs; the curved bottom is almost as sharp as the tip so the spear is useful at both ends

Bottom left:
Francis Rodd in the field, date and place unknown

Above:
Rodd devotes a thick chapter to the complex origins of the Tuareg. With Leo Africanus' early 16th century map as his starting point, he confirms the former slave turned historian's demarcations of Saharan land. Each divison is home to Tuareg but Tuareg of different ancestry - whether Targa driven down from the mediterranean regions of Libya into "Terga" (Ahaggar and Air), or as Lemta people now known as Kel Ajjer in the north or, in the south, Tuareg driven out of Bornu and pushed west - these are the ancestors of the Iwellemeden. The Tuareg or Muleththemin, people of the veil, or litham, stretch across the entire Sahara yet each "confederation" has distinctly different origins

Right:
Francis Rodd, later Lord Rennell Rodd, died in 1978. He had last visited Tuareg regions in 1929. Rodd led a full, distinguished life but overall the inscriptions reflect the powerful connection he felt for Tuaregs. At the top is the cross of Agadez; the Tifinagh phrase, or greeting, which is the sole writing on the front of the first edition of *People of the Veil* (meaning "naught but good" or, more literally, "peace only"), is more prominent than his eminent awards

HEINRICH BARTH, sole survivor, obsessive researcher - the phenomenal, largely forgotten African explorer

Heinrich Barth's African research was unrivalled. During his over five-year excursion from 1849-1855 for the British Foreign Office, originally under Major James Richardson, Barth covered over 10,000 miles of central and sub-Saharan Africa. Richardson and the (eventually), two other explorers would die leaving Barth the sole survivor of the expedition. Heinrich Barth's extraordinary journals and numerous letters or reports, whether written in English or German, or sometimes both, or in Arabic, detail and dissect Saharan landscapes, peoples and customs as a scientist would an ant, with infinite precision.

No element is overlooked. Barth merrily translates most local dialects he runs into - about eight - at the same time as chronicling the geography, the stars, regional architecture and its variants or inspirations, plant-life, local economies and diet, cultural mores, general daily life and the characters of the people he comes across. When frustrated if being 'held hostage' in one place or

H. Barth Dr.

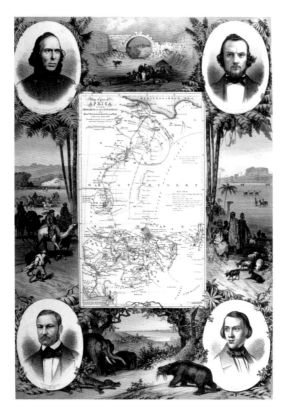

another - which he often was - whether because he was broke and waiting for funds to pay off this or that person, or buy camels and provisions for the next step of the journey, or gifts for the local dignitaries he must placate, or if he was ill (frequently, considering the phenomenally challenging environment), or if he was trapped due to the latest war outside the town he was in, he would distract himself by studying something, studying anything and everything. His five volume *Travels and Discoveries in North and Central Africa* is an endless tome of Saharan and the fringes of sub-Saharan life.

Though largely unknown in England, Barth is, perhaps obviously, the most famous historic figure of Agadez in northern Niger - and particularly venerated by the Tuareg. The descendants of the family who offered him lodging still preside over "his" house in a courtyard of their compound. The Barth "museum" or "La Maison de Barth" is the first stop for tourists - or it was, when there were tourists in Agadez. Barth was the first known Christian to see Agadez - which was brave, he was not in disguise - and he stayed there for three weeks, investigating the history of this ancient trading town, best described before by Ibn Battuta in

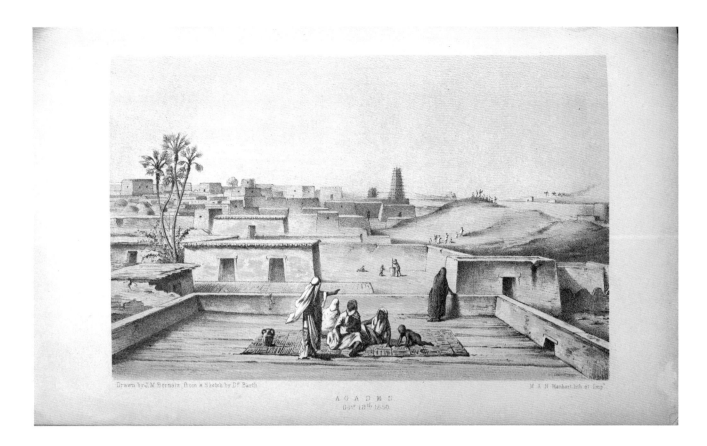

Drawn by J.M.Bernatz, from a Sketch by Dr Barth M & N Hanhart lith et imp.

A G A D E S
Oct. 12th 1850.

Above:
Agadez on 18th October 1850. Barth spent three weeks here
having left his companions in Tchin-Tchoulous. The first Christian
ever to see the town, he was mostly amazed why it held none of
the mystique that Europeans had for its twin, Timbuktu. Though
evidently also passed its hey-day, Agadez was as vibrant and
romantic as Timbuktu, and a crucial historic trading crossroads,
noted on some of the oldest Saharaan maps. As always
(wherever he went), and despite his personal lack of interest in
commercial treaties the explorers were asked to broach with
appropriate Sheikhs or Sultans, Barth discussed the British will
to trade with the Sultan of Agadez, giving the Sultan a robe on
behalf of Queen Victoria.

Right:
Francis Rodd's picture of "The Christian's Hill", the Tuareg's name
for the site - still remembered - where Richardson, Barth and
Overweg camped at Tchin-Tchoulous in Air for two months, under
the protection of the Kel Ewey Amenokhal. Richardson studied
Tamasheq, making a small "Arabic-Kailouee-English" dictionary,
and writing down "Fezzan songs" that the Tuareg sung and
danced to at night, entertaining the travellers

Power	Arabic Form	Tefinag: Alphabet of the Tawarek
Ay	ا	•
W	و	•• ••
Gh	غ	•••
K	غ غ ج	•• ••
Hh	ح	
Kh	خ	•• ••
H	ج	• γ
Q	ق	•• ••
B	ب	⊙ ⊙ ⊙ ⊡ ◇ (⟨ ?)
T	ت	+
		• • • (wanting)
D	د	∨ ∪ ∩ ∧
Dh	ذ	I H
R	ر	o ◇ □
Z	ز	X X ⵝ
	ط	Ш E Ǝ
	ظ	�
L	ل	‖
M	م	⊐
N	ن	/ ̶
S	ص	# ⋈ (?)
		ᛈ b (?)
F	ف	ⵋ X X X (?)
S	س	⊙
Sh	ش	ℓ Ɜ Ɛ Ǝ
Y	ي	ϥ ϟ

1353. He dug into *the Chroniques d'Agadez*, analysing Agadez' unusual Sultanate created around the time of Ibn Battuta's visit.

The place in the Tuareg village of Tchin-Tchoulous where Barth, and the doomed Richardson and Overweg camped before Barth's solo trek to Agadez, and to where Barth returned afterwards, is still remembered today as "The Christians' Hill" or "The Christians' House". Seventy years on, Rodd photographed the spot and the ruined huts "no doubt...the remains of the camp". As friends of the most powerful chief of a vast region, "their houses had nether been inhabited nor pulled down". The expedition had moved to this spot after an attack a little way further from the village (having also just escaped death a few days north of Tchin-Tchoulous). Seeing the site is clearly spine-tingling for Rodd and he feels "a justifiable glow of pride. Her Majesty's Government had sent the first successful expedition to Aïr...their memory survives in the land as the white men who were not French and who did not come as conquerors but as friends".

Barth carries on, going south to Zinder and across to Say, the old Hausa capital of the sub-Saharan region that would become a part of southern Niger. Niamey, the current capital twenty or so kilometres away from Say, is not yet born. Barth goes up the River Niger and he too finally enters the gates of Timbuktu, also the primary goal of his journey. Trapped here for six months he becomes close to the learned Sheikh Sidi Mohamed al-Backay, his protector; they exchange books and discuss philosophy. The Sheikh was also indeed the grandson of Laing's rescuer, and he even snubbed an equally prominent chief who was after Barth's Christian skin, the Sheikh refusing to hand Barth over to this man. Barth was in fact so respected by his new Muslim friends that he was called Abdel Karim by them - meaning "servant of the most Generous" or God - although the Sheikh's affront to the petulant chief almost caused war.

Sheikh al-Backay corresponded for some years with the English government after Barth's return to England, eager for an alliance with the English. Despite initial promises to receive the Sheikh in England, as the English became more interested in areas of Eastern Africa (and India), the Sheikh was gradually distanced from any future relationship, and killed not long after in a local war.

Significantly, Barth transcribes the Tuareg's elusive Tifinagh script and the local Tamasheq dialect - he was the first to transcribe it in detail in a Latin-based

language. Richardson had been working on the Kel Ewey's Tamasheq dialect in Tchin-Tchoulous, and on Fezzan or Tuareg "songs", but Barth goes further, jotting his usual reams of notes and phrases. These were doubtlessly an invaluable resource to Hanoteau, who published the first Tamasheq to Latin (or French), dictionary in 1887, and twenty years later to Motylinski and Foucauld. Barth even collects a Tamasheq version of the biblical story of The Prodigal Son. We are reminded of the Tuareg's long history, and how before becoming infamously lax Muslims, many Tuareg were Jewish. References to the Old Testament abound in their poetry and proverbs.

Barth's intensely academic account of his journey, published in 1857-1858, simultaneously in English and German (notably this version was not a carbon copy of the English book), provided much of the groundwork for the European acquisition of the Sahara. But in England it sold 3,000 copies as opposed to Livingstone's 30,000 sales of *Travels and Researches in Southern Africa*, also of 1857. Barth would never be the popular

hero. He received the Royal Geographical Society's Patron's Medal in 1856 (after Livingstone's of 1855), but he had to wait several years for a couple of British governmental decorations: one - the "Order of the Bath" - seems mocking even. Now considered the greatest of all European explorers, Barth died young, at forty-four (most likely from an intestinal bug picked up in Africa), mystified by the lack of greater interest in his work.

HENRI DUVEYRIER
The Tuareg's first European friend

Henri Duveyrier met Heinrich Barth in London in 1857, the year when Barth's *Travels* began to reach the wider world, having been sent to London by his father to learn English. Duveyrier, although only seventeen, had just returned from Laghouat in Algeria, on a six-week reconnaissance trip in Africa, with the idea that he would soon go deeper to meet little-known populations, a longing he'd had since a boy. By co-incidence, and "more than I ever dreamt" (as quoted by Casajus), he met a Tuareg of his own age, Moh'ammed Ah'med of the Kel Ajjer "with a voice as soft as a woman's who, when he is talking enthusiastically about something clicks his fingers, and who laughs wildly at all the questions [I ask him]", Casujus quotes. Duveyrier went home with a concrete plan - to return and meet his new friend's people in their homelands.

Of all the nineteenth-century explorers, Duveyrier's background was the most prestigious, and it was

28, RUE LAVAL, — PARIS —

intellectual too. Notably, his father was a senior member, even a priest, of one of the new Saint-Simon circles, a philosophical early social reformist and sometimes quasi-religious movement of the time which overall preached harmony between people of different countries. This influence helped mould the brilliant but shy boy into a hard-working, honest and sympathetic man, although Duveyrier was never a Saint-Simonian himself. Planning first to visit Moh'ammed Ah'med's country of the Fezzan, and the Tuareg's family, a still largely unknown people to the French - and with guidance from Barth, the two corresponding frequently - Duveyrier threw himself into studies of all the sciences, and of course Arabic. Duveyrier refused the idea of disguising himself as a Muslim; this would have been against his principles.

While Duveyrier's studies of Tuareg lands, that would culminate in the famous *Touaregs du Nord*, 1864, followed Barth's precision and latitude (Duveyrier notes astronomical positions, the landscapes' geology, draws maps and sketches of the plentiful Roman ruins of the region, and elegant pictures of Tuareg objects, learns Tamasheq, and studies plant life, medicine and animals), Duveyrier differs from Barth and all the former explorers, going further: in time, he lives with the Tuareg. Rodd describes *Touaregs du Nord*, as "the model of what a scientific book should be" and, also contrary to Barth's work, it also fascinates the public.

Duveyrier had originally planned to go on to Ahaggar after the Fezzan but when evidently that was out of the question, thanks to danger along caravan routes, he thought he would go south to Bornu and then perhaps across to the mouth of the Niger. In the event he didn't go further south than Ghat, or leave the Fezzan. Not on an official mission, he followed a random route from Algiers, at liberty, much of which he financed personally. Leaving France in 1859 he only met Ikhenoukhen, the chief of Moh'ammed Ah'med's group, the Kel Ajjer (see page 16), in Ghadames in August 1860. Richardson actually met Ikhenoukhen too on his first trip to the region in 1845. The guide called Othman, who introduced Duveyrier to Ikhenoukhen, was a Tuareg who Duveyrier would later invite to France. Duveyrier was not Othman's first explorer - Othman had been the unfortunate Laing's guide in 1826 (and had brought remnants of Laing's notes to Consul Warrington in Tripoli). But, thanks to Duveyrier, Otham was perhaps the first Tuareg to visit France, in 1862.

Nonetheless, Duveyrier was in touch with the French government and even the Emperor who asked that he

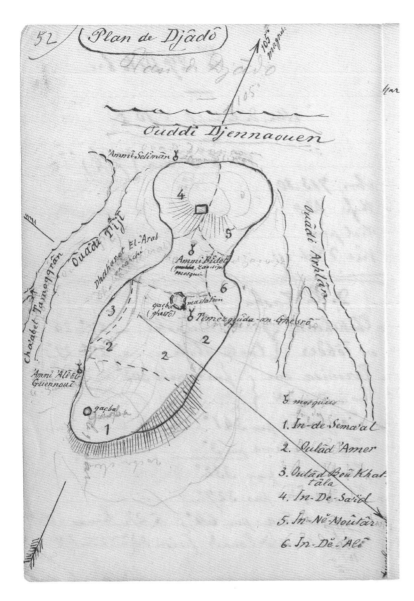

Ouddi Djennaouen

'Ammi Selimân

Chaibet Tamozzrän

Ouâdi Tiji

Dhahharet El-'Arâl

Ammi Bidê (mosqui)

Ouâdi Arhlân

4

5

6

3

qacba (jhero)

mastation

Temezguida-an-Ghelarô

2

2

2

'Ammi 'Alê El Guennoui

qacba

1

8 mosquies

1. In-de-Sema'al
2. Oulâd 'Amer
3. Oulâd Bou Khat tâla
4. In-De-Saïd
5. In-Nê-Moutâr
6. In-Dê-'Alê

Above:
Duveyrier's sketch of the ancient fortified settlement of Djado from one of his fieldbooks. At 1,000 feet above sea-level the town, with a mass of stone dwellings, the old town was however abandoned long ago (perhaps because of the dreadful mosquitos), and is now "an intricate maze of corridors and passages that lie in ruins"

Right:
At one time a President of Paris' Société de géographie's Commission centrale, Duveyrier was buried honourably after his suicide in Père Lachaise cemetery, Paris

tent, one of whom taught him Tifinagh. Duveyrier recounts these personal experiences in letters to his father or, sometimes obscurely, in his journals - such as an intimate liaison in Ghardaïa, partially described in German, about a clearly unforgettable night with a certain Aischa, favourably comparing her talented love-making to that of French women. During his time at Ikhenoukhen's camps Duveyrier notes the freedoms Tuareg women enjoyed in general - their male friendships and the absence of any husband's jealousy of these. Duveyrier passes his time in his tent or under the shade of a tree; for him despite all that he produced, it is a voyage of "inactivity" (Casajus).

Duveyrier had also planned much to follow these travels. Other books, other journeys, but, falling seriously ill with typhoid on his return to Algiers, still only 21, ill health would plague him for the rest of his life. As Rodd quotes Duveyrier, he felt like "an arm-chair explorer of the Sahara". He achieved a couple of less significant journeys in later years but not back to his Tuareg near Ghat.

There is controversy over who actually wrote *Touaregs du Nord*: the typhoid affected Duveyrier's memory, and his manner, which became somewhat childish. Many think Dr. Auguste Warnier, who nursed Duveyrier in Algeria, helped pull it together, presumably with reference to the journals too. Warnier remained like a shadow behind Duveyrier for some time, notably at the end of 1862 when Duveyrier, ostensibly fully recovered, addressed the Société de géographie in Paris after receiving their Gold Medal. But the illness left "discernable traces" (Casajus). As Warnier writes

study the movement of Caesar's armies in Africa. But while Duvyerier was pursuing friendship and cordial relations with Tuareg, he implored the French not to wage war in the region and hoped he might initiate mutually beneficial commerce between the Tuareg and French nations, but the French army started to penetrate the area. Besides crushing Duveyrier's trading dreams, Duveyrier was then himself subject to the jihad called for by local religious leaders to oust the invading Christians. It was Ikhenoukhen who saved Duvyerier from the marauding muslims who were after any Christian head.

Being trapped for seven months at Ikhenoukhen's camps was a radical change to Duveyrier's envisioned plan, and indeed to his life; he lived the daily life of the Tuareg. He chatted with the old men in their tents and the women at the wells, as Casujus quotes Capot-Rey, and joked with the many female visitors to his

in 1866, "Henri is not who he was before his voyage" (as quoted by Casajus).

Publicly, Duveyrier was fêted for the work. The military in particular took his relationship with Tuareg as a strongly positive sign: the Tuareg would (somehow), welcome their advances in the Sahara. And Duveyrier's archives at the Archives nationales de France show how he remained a key figure in Saharan matters - with notably a great fascination for the Senussi sect and Islam too - corresponding with later explorers travelling throughout the region, and researchers such as Hanoteau who produced the first Tamasheq-French dictionary in 1887. Duveyrier was also a President of the Société de géographie's Commission centrale, and always a Tuareg "specialist". The Tifinagh writings on pages 106-107 were sent to him c.1880 - it is possibly Duveyrier's hand attempting to decipher the script. The young Charles de Foucauld, before his religious conversion, was indeed Duveyrier's "last friend" (Casajus).

In the early 1880s, the news of the fate of Colonel Flatters' mission in Ahaggar, so coldly massacred by Tuareg, and that had depended on Ikhenoukhen's alliance, turned the reverence for Duveyrier into condemnation. Much was changing in the Sahara. The Tuareg were now conscious of France's greater plan but Duveyrier had enshrined the memories of his idyllic days with them of twenty years earlier: he blamed Tuareg disunity. Writing to Ikhenoukhen (now 96 and effectively powerless, and also ultimately under Turkish lordship), Duveyrier enquires after the affair, asking for details of whether "your enemies [the assassins] are our enemies" (as quoted by Casajus). He received no known reply.

As Rodd says, Duveyrier recounted the sorry tale to the Société de géographie about Tuareg of quite a different ilk to "a people he [or Warnier?] had described picturesquely, but with some exaggeration, as the "Knights of the Desert"". Gradually Duveyrier's reputation declined and supporters slipped away, along with his finances. And Duveyrier bore the guilt heavily. In 1892, on a quiet street in Sèvres, he shot himself. He was 52.

Henri Duveyrier is buried in Père Lachaise cemetery in Paris, jumbled up to others in an unassuming plot. The modest tombstone erected by the Société de géographie remembers him as "The explorer of Tuareg lands" (see page 105), but he was soon forgotten by the public at large, and the main inscription on the top of the headstone is now well worn away.

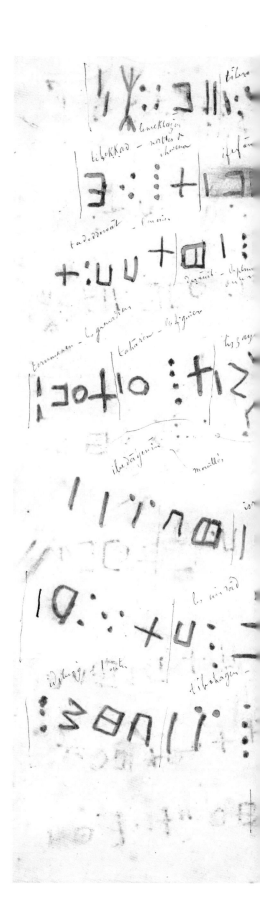

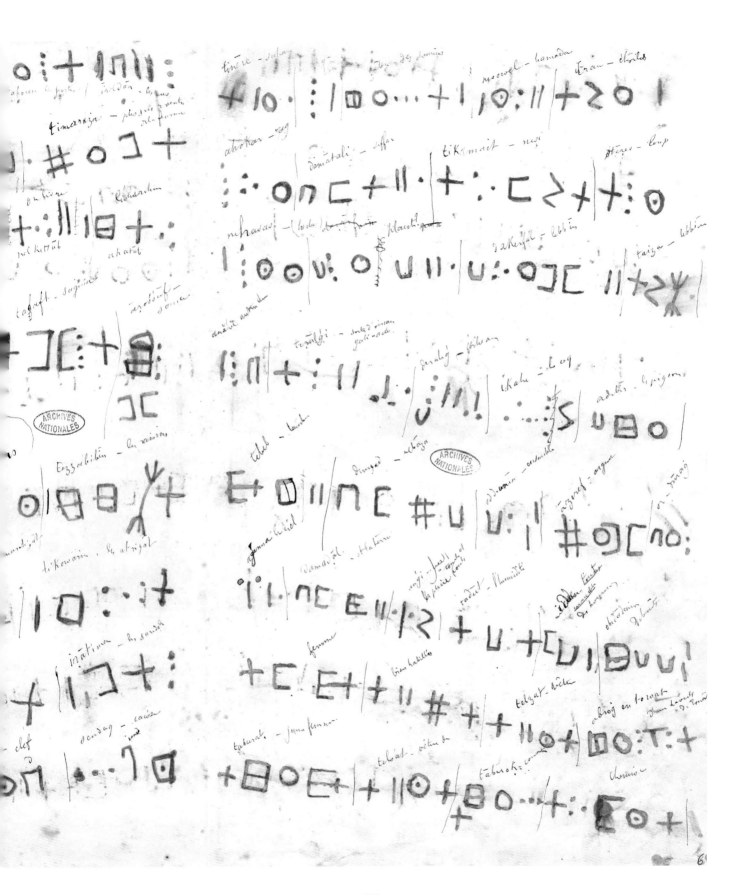

Right:
Captain Bissuel's map
of 1888 is famous as
being the first map of a
Saharan region made from
information given by Tuareg
- although the Tuareg were
prisoners of the French at
the time

Pages 110-111:
The Mosque tower, Agadez,
Niger

Pages 112-113:
A family in Tiguidit, about
sixty kilometres south of
Agadez, 2005. While the
women and children lead a
semi-nomadic life, the men
go regularly to Agadez, for
the odd job or supplies

THE HISTORY OF THE KEL DENNEG
or *L'Histoire des Kel-Denneg*

While throughout the 19th century the explorers had steadily reached deeper into the Sahara, and deeper with their understanding of Tuareg culture (and the French military put a few small toes in the water and towards the end of the century markedly bigger ones), and despite Duveyrier's accounts of his rather sheltered experiences with Tuareg, 19th century Tuareg were freely pursuing their traditional way of life that they had developed over a good millenia. Economically, besides pastoralism and the camel caravans trading and ferrying goods north and south of their regions, life largely revolved around inter-tribal warfare or raiding. The dangers from Tuareg that the likes of Caillié heard about and poor Laing experienced were being played out across the entire Saharan region that the nomadic Tuareg inhabited. If not attacking other African or Arabic tribes and pillaging whatever they could, the Tuareg were always busy attacking and stealing from each other.

The remarkable *Histoire des Kel-Denneg* by Ghoubëid Alojaly details the 19th century for the Kel-Denneg, a branch of the Iwellemmeden confederation. Alojaly puts onto paper - in a way not done before or since - the known history of this group (in both French and Tamasheq). Much is related through poetry, which is how the history was remembered (and of course orally). As is key to traditional Tuareg poetry, the poems all rhyme in Tamasheq although the rhyming is lost in the French translation. The book begins in the year 1804, noting the history of the Amenokals; the first poem is dated 1807. The history focuses on relationships between the Kel-Denneg's leaders, the valiance or strength of character of one over another, and the succession of the Kel-Denneg's leaders. The poetry chiefly describes the numerous *razzias*, or raiding wars between the Kel-Denneg and other groups whether, at varying times over the century, with Kel Geres, Itésan, Kel Away [sic], Kel Ataram, Kel Ahaggar or Kel-Aïr.

Interestingly, Alojaly notes a scene in 1815 where the father of a rival Amenokal converses with a Kel-Denneg leader, Eljilani - who the father supports - on the subject of war: "I propose that the Tuareg rally to become a single tribe, where there would be just peace and mutual aid, where there would be no question of causing each other to perish, and to not let a state of indiscriminate killing become established between [the tribes]. If the Tuareg were able to be allies together they would become masters of all who surround them". The Amenokal had other ideas however and persisted in warfare, to resounding defeat. Eljilani was also a poet; after other battles he recounted the wars in verse.

The whole of the 19th century here passes in warfare, eulogised in poetry, which nonetheless often starts with the poet's musings about the beautiful women close to his heart. It notes the seasonal transhumance to In Gall and how if tribes are on hostile terms they wage war to block their enemies coming to take the salt cure (or *cure salée*). Towards the end of the century, the French arrive on the scene. Defeating small groups swiftly they demand that the *razzias* cease and begin to install their forces in Tahoua, the largest town in the Iwellemmeden's region.

The most shocking warfare in the book - or retaliation after warfare - is that of the French who literally erase whole camps, including women, after the Tuareg fail when the Siege of Agadez collapses in 1916 (see page 130), this being their final revolt against the French usurption of their territories. The children are not killed but left to flee until, Alojaly says, "thirst would kill them". But, as Alojaly goes on to say, the French were not the only ones culpable of the numerous bloody massacres then. Hostility between groups had persisted such that Kaocen's partisans attacked groups who had not joined the fight against the French. The whole of Aïr was a ghastly bloodbath thanks to all involved. At least, when the Siege was over, a certain peace was established between Tuareg as the French, to whom all Tuareg were now subjugated, forbade the Tuareg fighting each other anymore, once and for all. Alojaly's powerful book, fascinating for its historical trajectory and the rich poetry - that would otherwise now be forgotten - tells difficult truths of the complicated French and Tuareg politics before colonisation.

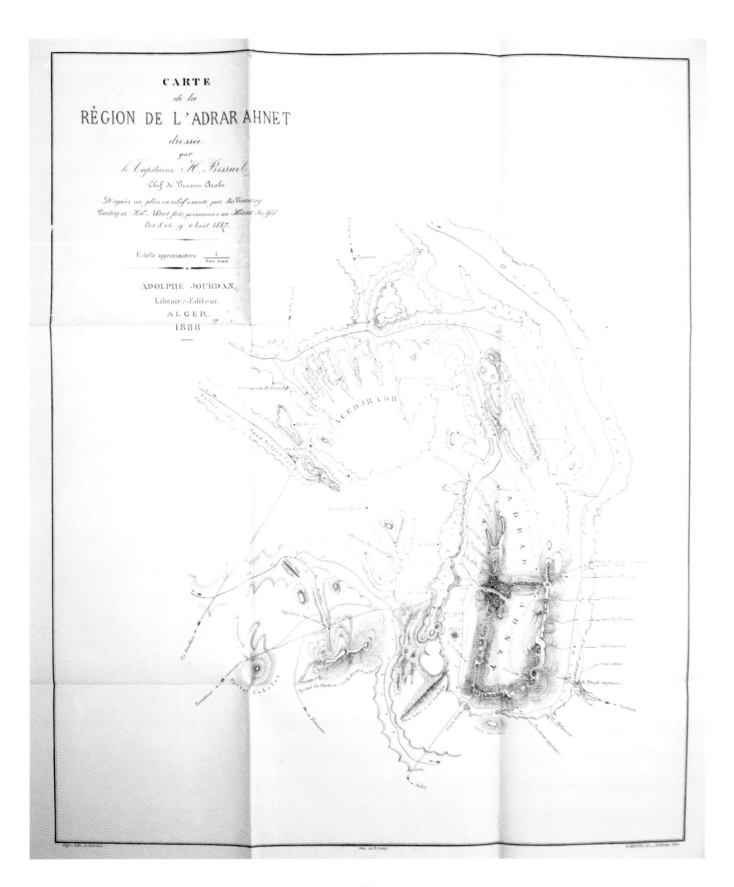

CARTE
de la
RÉGION DE L'ADRAR AHNET
dressée
par
le Capitaine H. Bissuel
Chef de Bureau Arabe

D'après un plan en relief exécuté par les Touareg
Tailog et Mol. Ahnet faits prisonniers au Hassi In Ifel
les 8 et 9 Août 1887.

Échelle approximative $\frac{1}{800.000}$

ADOLPHE JOURDAN,
Libraire-Éditeur,
ALGER.
1888

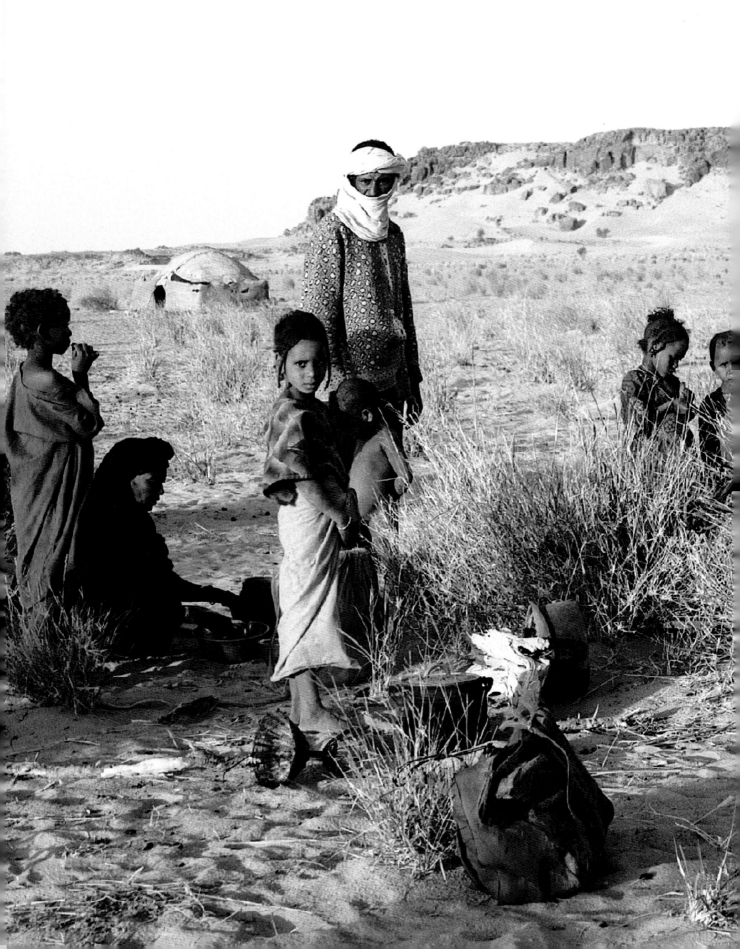

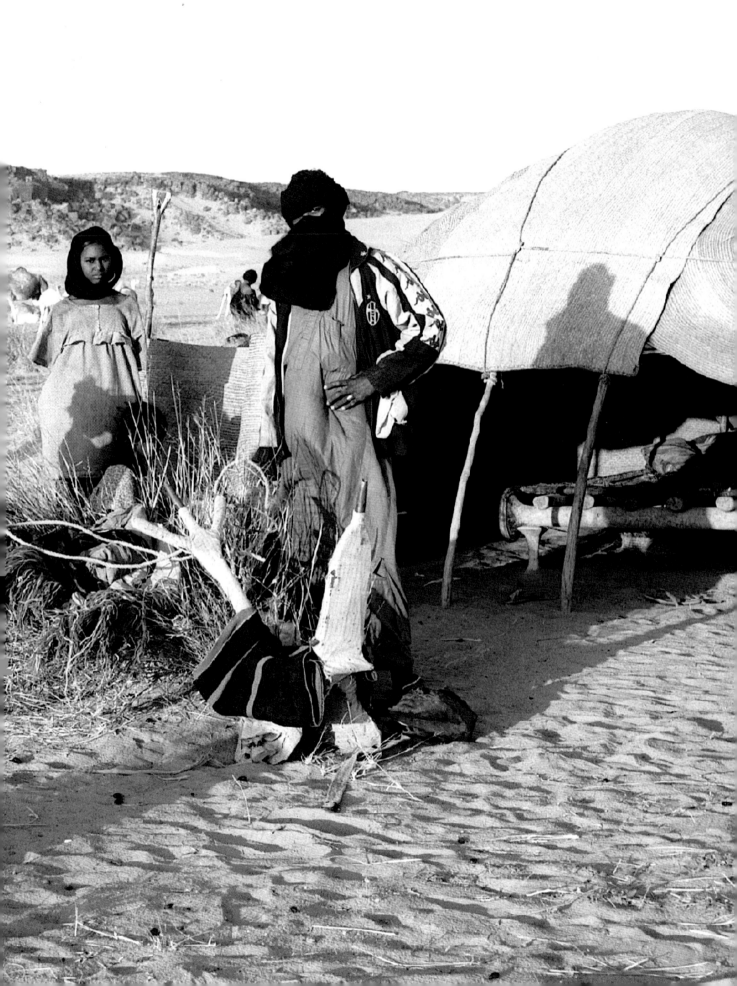

WAR, RELIGION & THE TUAREG

The Priest, the General and the Chief - the three who gave France the Sahara

The Comte Charles-Eugène de Foucauld enjoyed his time at the military school of Saint-Cyr in France. Though an insubordinate officer, his often distressing childhood as an orphan was past, and he took advantage of the dashing uniform which attracted the ladies, wooing them well into the morning. However, unlike his good friend, Henri Laperrine, Foucauld would not pursue a military career. His life would take an unusual turn: in his late twenties he had a religious conversion. Shedding his notorious "bad boy" image he soon strove to convert anyone he could to his new cause. Today, his great legacies, the Little Brothers of Jesus and the Little Sisters of Jesus and almost twenty splinter groups, have millions of followers world-wide. And Foucauld, murdered at the doorway of his house in Tamanrasset (in southern Algeria), in 1916 (in a muddled plot exacerbated by the turmoil of the First World War in Africa), was beatified in 2005 for his efforts to bridge the gap between Muslims and the Catholic Church.

It was however through his old friend, Laperrine - officially remembered as the "Pacifier of the Sahara" and who created the *Compagnies des Méharists*, the jewel of all French forces in Africa at the time - that Foucauld found his infamous literary path. Thanks to Laperrine he would produce two other phenomenal legacies, astonishing feats upon which current scholars of Tuareg language and literature still depend: his extraordinary, mammoth *Dictionnaire Touareg–Français, Dialecte de l'Ahaggar* - which was so intricately written in his tiny, neat script that it was unpublishable before the invention of the facsimile - and *Poésies touarègues*. This is a compilation of hundreds of Tuareg poems translated into French; those with known authors date back to the 1820s. Foucauld fortunately completed this three days before his unexpected death at the age of 58.

He had begun work on these shortly after he settled into his newly-built home in August 1905 (the interior of which is shown overleaf). Foucauld was primarily looking forward to the challenge of converting the unruly Tuareg, whose laws were unto themselves and who were significantly Tuareg first and Muslim second - they were even "abandoned by

God", the Arabs believed. Against Laperrine's advice, Foucauld chose an unusual spot near a oued, or river bed, called Tamanrasset - the Tamanrasset of today was not even a village but a place where the trade caravans rested. The Comte de Foucauld anticipated wrapping up both works in a year or two. They would however take up the best of the rest of his nine years of life and become crucial tomes of reference for both Tuareg and anyone with an interest in Tuareg history and culture, recording as they did Tuareg society in elaborately succinct and unforeseen depth.

Foucauld would famously build himself another home too - a small, primitive stone hut at the top of a high peak called Assekrem, perhaps a week by camel, or horse,

LAPERRINE

VISA DES COMPAGNIES

Above:

A spread from Foucauld's notes for the *Dictionnaire touareg-français* which had to await its four-volume publication until 1951, with the invention of the facsimile. Foucauld's handwriting is so tiny - and the dictionary's detail so vast - that it was impossible to reproduce it for publication otherwise. In these pages showing translations and descriptions of household utensils, it would seem surprising that nomadic people have so many

The room with Foucauld's altar takes up half of this house that
he had built in Tamanrasset in 1905; the other room is identical in
size to this one and now displays pages of the dictionary. Shaped
like "a loaf of bread", the house was the first in Tamanrasset,
then not even a village but a stopping point for travellers

Proverbes de l'Ahaggar

Tous les proverbes & dictons des Kel-Ahaggar recueillis jusqu'à ce jour sont réunis ici ; c'est à dire ceux qui ont été publiés par M. Hanoteau (grammaire tamachek), par M. Masqueray (dictionnaire français-touareg ; textes de la tamahaq des Taïtoq) & par M. Benhazera, interprète militaire à Insalah (six mois chez les Touaregs), ceux recueillis par M. de Motylinski au cours de sa mission dans l'Ahaggar en 1906. Le texte & la traduction des uns & des autres ont été revus par Ba-Hammou-el-Ançari ben Abd-es-selam, secrétaire de l'amenoukâl actuel Moûsa ag Amâstân & de l'ancien amenoukâl Ahitarel ag Biska. — Les proverbes recueillis par M. Hanoteau sont suivis de (H), ceux de M. Masqueray de (M), ceux de M. Benhazera de (B), ceux de M. de Motylinski de (1906). Dans ce volume abrégé, ~~la grossesse de volume~~, on ne donne ~~ici~~ ni ~~la traduction~~ mot à mot des proverbes, ni notes explicatives ; on trouvera et cette traduction & les notes ~~dans le~~ dans le recueil de poésies touarègues de M. de Motylinski.

1 — Ère Kai irân, Koud iemôus abaïkôr, é t terheled aked Kai. (H).
'Celui qui t'aime, fût-il un chien, tu l'aimeras aussi.'

2 — Our é erž aou Adem akous oua dar isâss. (H)
On ne casse pas le vase dans lequel on boit.

3 — Amettakat ou tt é iggeh haret a selid takat. (H)
L'homme bruyant il n'y a en lui que bruit [sans actes].

4 — Abouis en tažôuli itâžžeï, abouis n îles our itežži dar mân. (H)
La blessure faite par le fer se guérit, la blessure faite par la langue ne se guérit pas.

Above:
Foucauld's draft of the first page of *Proverbs de l'Ahaggar*, crediting the informants and predecessors of his work (notably Motylinski), translates sayings still popular for Tuareg today – and sayings much along the same lines as our own

from Tamanrasset, with a stupefying 360 degree view. There he would meet local Tuareg; they were his sources of the works. Foucauld would never make inroads into, or changes to the Tuaregs' faith at large (Foucauld achieved just two Tuareg conversions to Christianity), but, with everything else that was going on (including his production of two smaller tomes, *Proverbs de l'Ahaggar* and *Textes Touareg En Prose*), and with the futility of it evident, his religious quest soon became secondary.

The works were all done against the backdrop of French efforts to maintain their recent subjugation of the Ahaggar Tuareg - considered then the mightiest of the five Tuareg 'confederations' that together - despite being continually at war with each other - ruled the vast Central Sahara. Laperrine was key assisting the works' production and Foucauld, not at all unfettered from his military past, assisted him and other major military players in their surveillance of Tuareg, a large number of whom were hostile to the French for years. Despite his incredible literary work, and genuine religious conviction, many also consider Foucauld to have been the perfect spy.

France would gradually gain control of the Ahaggar region after the shocking battle of Tit in 1902, which had finally given French forces the victory they had sought over the Tuareg for some twenty years - notably since the spine-chilling Flatters Incident of 1881 when Tuareg cold-bloodedly wiped out the entire French contingent of Flatters' exploratory convoy into a part of Ahaggar. Flatters, and indeed the whole of France thought the Tuareg had nothing but benevolent thoughts towards them - thanks to the explorer, Duveyrier's nationally celebrated *Touaregs du Nord* of 1864. Quite rightly, the Tuareg foresaw in 1881 that the French *did* now seek control of their Sahara, wanting for one to give credence to their growing colony of northern Algeria. (French settlers first arrived in Algiers in the 1850s and later as refugees from the troubled Alsace region). The military had indeed scrutinised all the explorers' notes, published books, maps and charts to this end. Although the French were not *entirely* convinced that they wanted this desperately hot, apparently spartan region. But, having secured it from the British through the European treaties of the 1890s (which delineated which European country could seek sovereignty of which African region, see page 93), supremacy over the Tuareg would illustrate that they too, like the British, Germans, Belgians and Italians, could penetrate and colonise African lands.

Colonel Cottenest's victory at Tit was however only possible thanks to the help of a disgruntled Tuareg seeking revenge for a petty affront from a Tuareg of a rival group. Poignantly, Tit would be devastating for all Tuareg. Whole Ahaggar warrior groups were pulverised: Tuareg everywhere were incredulous. Never before had they been subject to such defeat. Their poetry relates this sorrowfully, understandably. It was the end of a millenia of the Tuareg's absolute supremacy over the Central Sahara.

When Foucauld took his first surveillance *tournée* with Laperrine in 1904, Captain Métois had only several months previously received the new Amenokhal of Ahaggar's submission, on behalf of all Ahaggar Tuareg. Crucially, Moussa ag Amastan, the Amenokhal, only acquired the kingship with the *agrément* of the French.

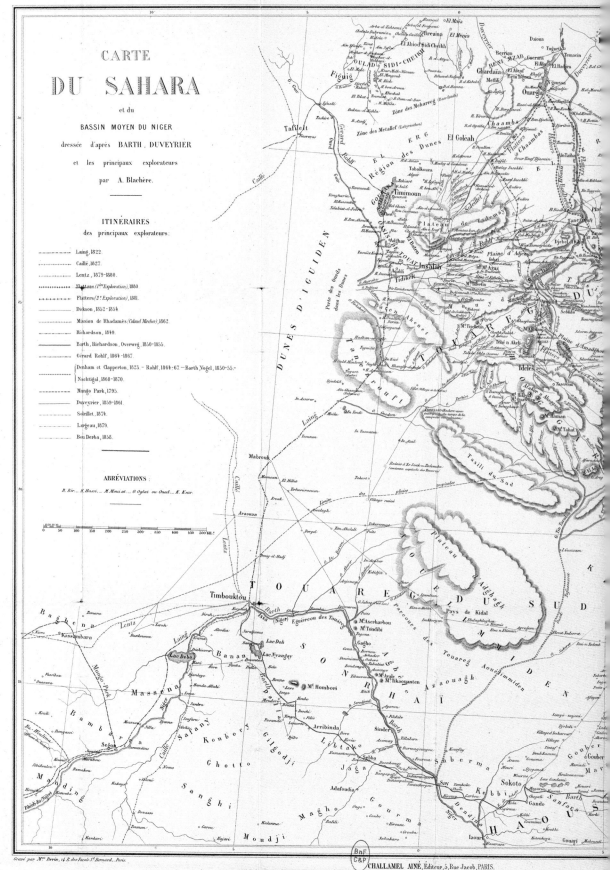

CARTE
DU SAHARA

et du

BASSIN MOYEN DU NIGER

dressée d'après BARTH, DUVEYRIER

et les principaux explorateurs

par A. Blachère.

ITINÉRAIRES

des principaux explorateurs :

Laing, 1822.
Caillé, 1827.
Lentz, 1879-1880.
Flatters (1ère Exploration), 1880.
Flatters (2e Exploration), 1881.
Dickson, 1852-1854.
Mission de Rhadamès (Colonel Mircher), 1862.
Richardson, 1849.
Barth, Richardson, Overweg, 1850-1855.
Gérard Rohlf, 1864-1867.
Denham et Clapperton, 1823. - Rohlf, 1864-67 - Barth Vogel, 1850-55.
Nachtigal, 1868-1870.
Mungo Park, 1795.
Duveyrier, 1859-1861.
Soleillet, 1874.
Largeau, 1879.
Bou Derba, 1858.

ABRÉVIATIONS :

B. Bir. - H. Hassi. - M. Moui at. - O. Oglat ou Oued. - K. Krar.

CHALLAMEL AINÉ, Éditeur, 5, Rue Jacob, PARIS.

DON 00-462
BnF C&P

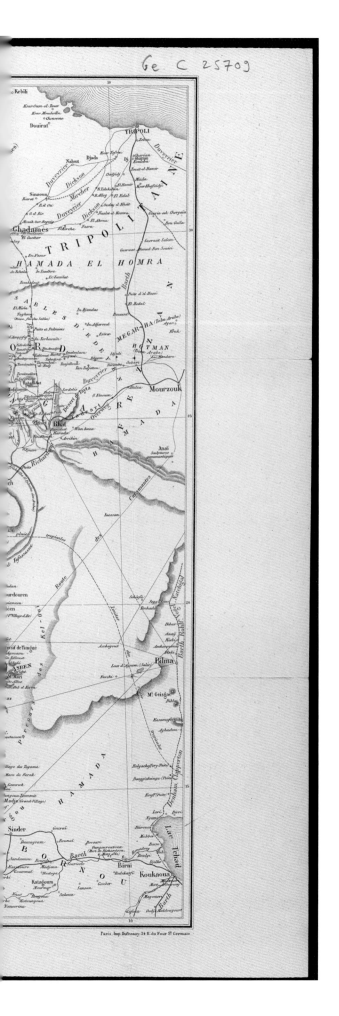

Paris, Imp. Dufrenoy, 34 R. du Four St Germain

Blachere's map of the Sahara (after 1881), is a visual summary of all the significant explorers' routes across the Central Sahara, drawn (presumably), for the French military, keen to penetrate the region but having to overcome the Tuareg first, the largely hostile masters of the territory

Right:
In this photograph collected by Rodd, the Père de Foucauld rides out with the celebrated Marshal Lyautey; most of the military were either friends or admirers of Foucauld. Herein lies Foucauld's seemingly duplicitous, at least contradictory attitudes - on the one hand revering Tuareg culture, the language literally "an artefact worthy of preservation", on the other being "a spokesman for colonization and Europeanization of Tuareg society". Jotting down Tuareg poems and proverbs in the morning, in the afternoon he was informing the French of political situations and advising on courses of action

Page 121, bottom:
Adolphe Motyinski's photograph of Tit, scene of the Tuareg's devastating defeat of 1902 which ensured future French supremacy in Algeria. A generation of Kel Ahaggar warriors fell here, stupifying Tuareg - never had they been brutalised on home ground by foreigners. As Fleming says, "six months later doubters were still visiting the site to ascertain whether these wild allegations were true". They found a vast open grave of camels and horses, and dead men who, according to Lieutenant Guillo-Lohan, were "stretched out fully clothed just as they were on the day of battle...this cemetery still reeks of an insupportable stench"

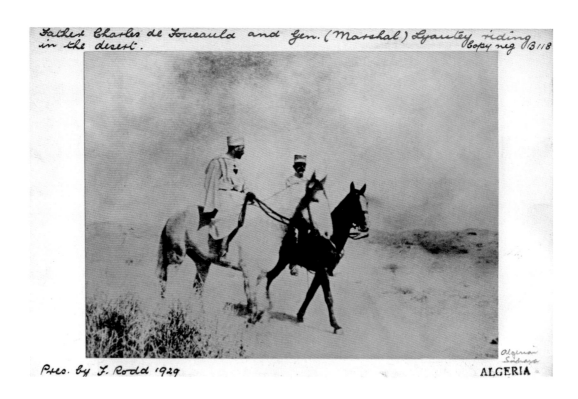

Laperrine was quick to see how useful the obsessed Foucauld could be to the military cause - in a letter of 1905, Laperrine muses to Métois about how Foucauld might one day soon take up a role as Moussa's Chaplain.

Laperrine pushes Foucauld to complete the dictionary, and writes frequently to the chosen publisher René Basset, a professor at the university in Algiers, keeping him informed of Foucauld's progress. The dictionary is eagerly awaited by the military, keen to understand the complicated Tuareg so they could continue to "pacify" numerous small rebel factions effectively. Foucauld is, seemingly ironically, chiefly helped by one of Moussa's entourage - Ba Hammou, who should have been credited for much of the poetry translation. Foucauld does however insist on crediting Adolphe Motylinski, an orientalist and military translator. Motylinski became passionate about Tuareg culture but, died suddenly of typhoid in 1907. Foucauld took Motylinski's work, furiously corrected it, and this formed the framework of the *Dictionnaire*. Motylinski was commemorated by the first fort of Ahaggar, Fort Motylinski: built at Laperrine's request, it was the French's regional centre before the administration made Tamanrasset its base in 1921.

Moussa revels in his position as Amenokhal, first requesting a smart seal for his letters and then not inconsiderable sums of money to finance himself and his royal household, both of which the French gave him. As early as 1906, he tells Laperrine of his greatest wish - to visit France. Moussa is incredibly loyal to the French: he helpfully informs the French of disloyal Tuareg activity and the French trust him implicitly - and somehow he also has the Ahaggar Tuareg in the palm of his hand. Laperrine thinks Moussa's wish to visit France is a great idea, as "it is necessary for us to win [the Tuareg] over onto our side definitively, and if we can equally send a young Tuareg...that he may realise our power and the lies that our enemies say [about us]", and he proposes it to his superiors immediately. It would however be four years in the making but, in 1910, Moussa finally sees the Eiffel Tower and his new allies' homeland.

On a cultural level, Moussa writes poetry, like many of the Tuareg warrior class did. Unlike most other aristocratic Tuareg who dabbled in poetry - poetry being a highly fêted talent - Moussa had a genuine gift. Moussa was also more than a little in love with his cousin, the greatest and still renowned female poet of the time, the beautiful Dassine. Foucauld naturally transcibes Moussa's and Dassine's work too - they were all the best of friends.

It is a genuine respect that Laperrine and Foucauld had for the Tuareg. Indeed many miltary personnel

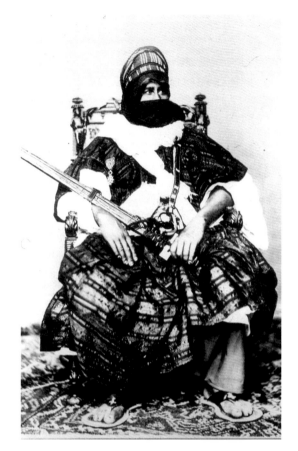

who controlled the region then and knew them closely during colonisation were in absolute awe of the bold, independent and fiercely proud Tuareg. The nobles were visually awesome too, in their flowing robes and with their impressive armour, seated high on their beautiful *meharis*, or camels, and always carrying their sword, or *takuba*. The military who appreciated the rich culture, with its strict, mannered and polite behaviour, and a class system not dissimilar to their own, related to the Tuareg as equals. And clearly, the Tuareg were not, and are still not interested in living outside of the Sahara, or in any other way. With such affection towards the Tuareg it appears to be a conundrum that the French began to control and upset Tuareg customs - notably the raiding or *razzias*, and the "slavery" - relatively speaking, the *iklan* or slave class was not in a hugely different social position to that of the servile or lower classes of Europe at the time. They were part of Tuareg families and respected as such. During colonisation the French would gradually turn the structure of Tuareg society upside-down and inside-out, ensuring its imbalance and degradation.

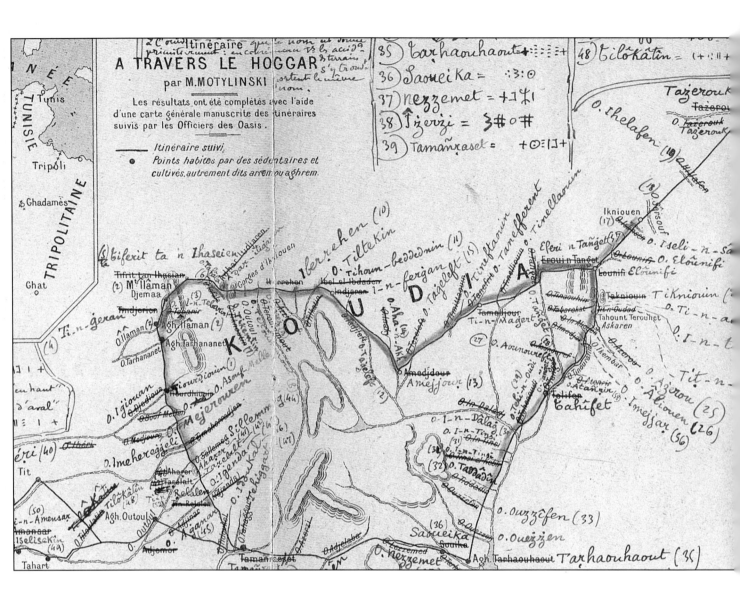

Above:

Motylinski, an orientalist turned translator for the military became fascinated with the Tuareg and made a long voyage of Ahaggar in 1906 shortly before dying of typhoid. Foucauld's first dictionary notes are a carbon copy of Motylinski's - indeed Motylinski had taught Foucauld Tamasheq. Foucauld would go deeper - here (a portion of the full map), Foucauld corrects Motylinski's (numerous) errors - but Foucauld had genuinely wanted to publish the dictionary under Motylinski's name

Right:

12th September 1910. Captain Neiger announces the arrival of Moussa and his entourage in Algiers, finally on their way to France

Page 123:

Moussa writes to Foucauld on 5 January 1914. Typical of Tuareg correspondence, over half of the letter conveys salutations and wishes from himself and friends for Père de Foucauld and people around him. Moussa mentions the military's wish for him to travel with them to Aïr, perhaps to display their authority to the hostile Tuareg there. At the bottom is Moussa's seal as Amenokhal of the Ahaggar Tuareg that was made for him by the French

It's me, Moussa, the Amenokhal of the Ahaggar
I say: I send to my friend and companion the Marabout
servant of Jesus, many many salutations. Praises
to God for your health. We miss you terribly.
I saw your young [friend] Ouksem, he gave us some news, thank you!
I wrote you a letter which I had carried to the Lieutenant at Boughessa,
he will send it to you. We, we are well if you are well. You have the greeting
of Tedawit, Akhamouk, Litni, of everyone, and of Rakhma.
I send greetings to the General Laperrine, to Nieger and to the whole of France.
The Lieutenant had the intention to join me near my tents and we would have gone together to Aïr. Now
he has changed his mind, he has given me a delay of two months so that I rejoin him at Ti-n-Zawaten
with all my people. There remains fourteen days before the planned date.
I write this letter the 7 of the month of Settafet
Do not abandon me! I [ask] you one thing: pray a lot for me. Goodbye! I am short of paper

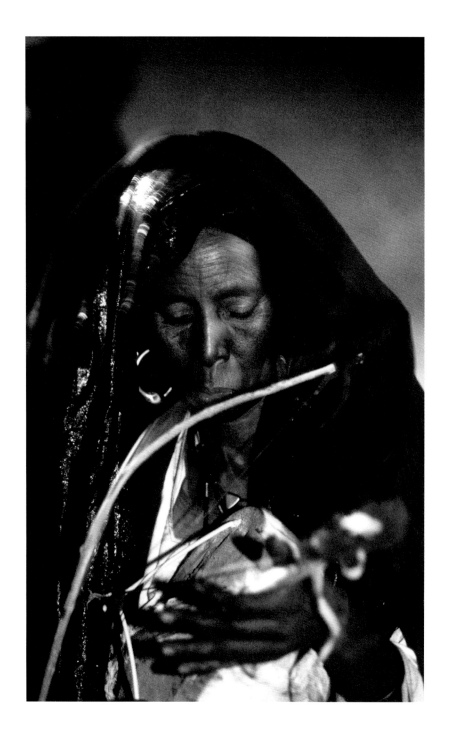

God gave a soul to the Imzad
Whereby the Imzad sings and all are silent
The refrains of the Imzad
In the wind of unfulfilled desires
The songs are the memory of the future

Translated by Père de Foucauld, author unknown

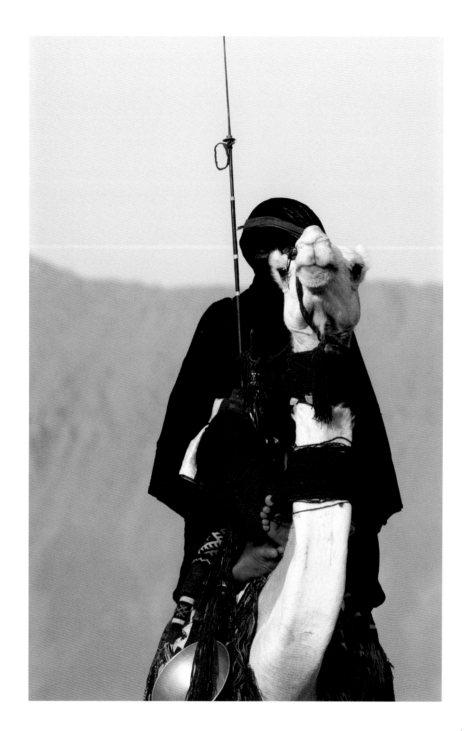

Tres-Haut je Te demande trois choses :
l'amour des jeunes filles,
la vaillance dans les conbats
et le pardon le jour de la resurrection

Translated by the Père de Foucauld, author unknown

Right:
General Laperrine

Bottom:
After Laperrine's death in
1920 his body was taken
to Tamanrasset and buried
alongside Foucauld's and
this monument built over
their graves. Foucauld's
body was however taken to
El-Golea (now El Meniaa) in
1929, against his declared
wishes

Page 127:
A Tuareg with his lance,
c.1910. A picture taken as
much for the French as for
the sitter

Laperrine became fascinated with aeroplane travel, being tested here alongside travel by car. In 1920, he would take one of the first flights over the Ahaggar but the plane never reached its destination, crashing in uninhabited wilderness. After three weeks of agony from his wounds, Laperrine died near the spot of the crash, aged 59. As Laperrine said to his travelling companions (who survived the crash), as he lay dying, "People think they know the desert. People think I know it. Nobody knows it". Except of course the Tuareg.

Laperrine's body was eventually taken back to Tamanrasset, and he was buried alongside Foucauld; the two share a monument there. General Laperrine and the Comte de Foucauld are also jointly remembered in Paris where streets named after them are side by side, the one runs into the other. Rue de General Laperrine is for "The Pacifier of the Sahara", the other, rue du Père de Foucauld for "The hermit and founder of the Charles de Foucauld fraternity".

Their mutual friend and Saharan pacifier, Moussa "friend and servant of the French government", according to Commander Sigonney, died the following January after Laperrine, also in his fifties. As Commander Sigonney went on to say, in a letter just a few days after Moussa died, "There, united again in death at Tamanrasset are three great friends, the Marabout de Foucauld, the General Laperrine and the Amenokhal Moussa".

The final curtain on Tuareg Saharan authority would fall in current-day Niger, when the Kel-Aïr (the Tuareg of Aïr), failed to beat off the French during the Siege of Agadez in 1917. Notably, it was thanks to Moussa joining the French side that the Kel-Aïr forces were beaten. Moussa had prevaricated for a while, liasing with Kaocen, the Tuareg of Aïr's leader, and for a good moment it seemed that Moussa might turn tail on the French. However, perhaps Moussa's new, Legion d'Honneur and the French riches that he continued to amass, persuaded him otherwise. Besides, the Kel-Aïr were old rivals and they probably always would be, he may have surmised.

Laperrine was serving on European fronts during the First World War. But with Foucauld's death in 1916, and the nomadic Senussis armed with guns by the Turks causing further trouble in Algeria, Laperrine, now a General, was called back to the Sahara in 1917. After he directed a few bloody battles which defeated the Senussis, calm returned.

After a few other skirmishes around Aïr - remnants of the Siege of Agadez - the Tuareg were now subjugated in all their Saharan regions, and the French began considering what to do with the pacified region. Old plans for a Trans-Saharan railway, that Flatters had actually been prospecting, were revived. And a new kind of person would soon arrive to marvel at the subdued Tuareg and their desert - the tourist.

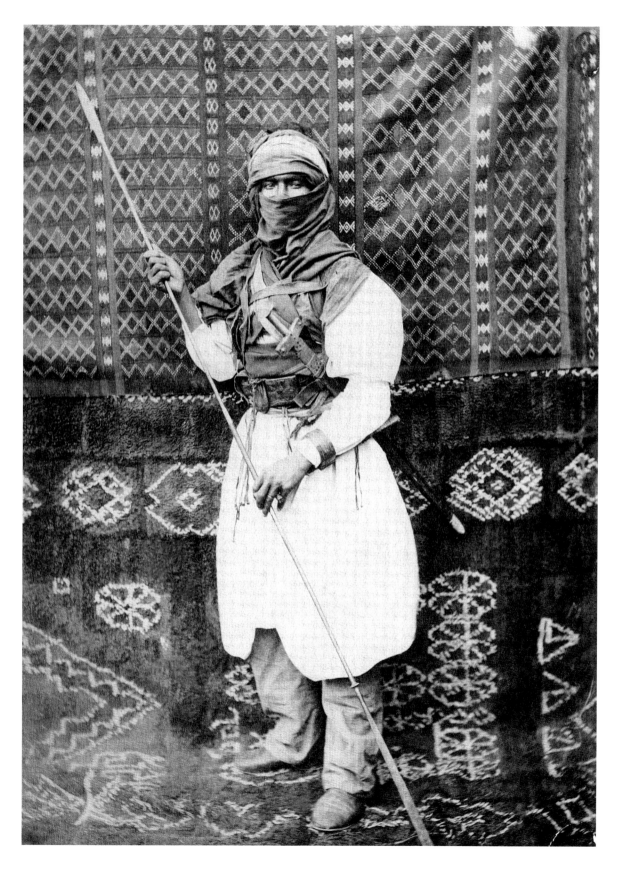

RÉSUMÉ, and a taste of things to come: A century of history by Jean-Marc Durou

At the beginning of the nineteenth century, Europe knew little more of Africa than its coastline; the interior of the continent remained *terra incognita*. Yet this mystery would soon be solved as Europe, during its transformation to an industrial society, saw this tantalisingly close "virgin continent" as one where it could grab new raw materials at a bargain price, without clashing with other more structured states that were recognised by the West.

In this context, a systematic exploration of the interior of Africa was essential prior to its colonisation. Two European countries would take the lead in this new race: Britain and France. The latter started colonising Algeria in 1830, to the great surprise of the other European powers. Britain, for its part, sent numerous explorers into the new territory thanks to the African Association which was founded in London in 1788. One of the best known of these explorers in western Africa was Mungo Park who, leaving from Gambia, discovered the Niger River. He was followed by Major Laing who, setting out from Tripoli, crossed the Sahara, and became the first explorer to enter Timbuktu in 1826 but tragically he was murdered on the return journey. The Frenchman René Caillé had better luck, succeeding in reaching the city in 1828 - and returning to tell the tale.

In 1850, Heinrich Barth started exploring the Sahara and the Sahel on behalf of the British government, travelling for five years, covering 16,000km on foot. He brought back an impressive quantity of scientific notes which essentially made "the discovery" of the continent. In 1860, he was emulated by Frenchman Henri Duveyrier, who explored the Tassili n'Ajjer, but who even lived with a people about whom practically nothing was known: the nomadic Tuaregs.

While all of the accounts given by these authors tell of their meetings with various African cultures, the Tuaregs in particular captured the imagination of European readers. The writings immediately gave the stereotypical image of the people as warriors where the men were veiled and resembled knights of the European Middle Ages – armed with their sabres, shields, and spears whose tribes were continually at war with each other.

If this image was creating a myth, it was not without worry that French military officers ensconced in Algeria, began exploring the Sahara themselves in the 1860s knowing that they would be confronted by these people before they could subjugate them. For many French pro-colonialists, this advance towards the desert expressed the desire to link the new colony in Algeria with that of Senegal, where the French were already established, and create a single, giant block of territory across the Sahara.

From 1852 onwards, General Faidherbe, commanding St Louis outpost in Senegal, launched a conquest of western Africa fearing that the British might appropriate the whole of Niger River which was a strategic route to everywhere in the region. In 1885, the Berlin Conference made rules for the European colonisation of Africa so that there would be no conflict between the interested nations. Five years later, in 1890, the French and the British signed a convention where the two divided western Africa. The French "inherited" the Sahara, on which Lord Salisbury in London drolly remarked, "We have given the Gallic cock more sand than it can count, let us leave it to scrape around in it all it wants to". Now the chips were down: the Sahara would have to be conquered, and to penetrate it the famous Tuareg tribes would have to be subjugated.

The French military began by making peaceable overtures to the northern Tuaregs, even attempting trade agreements with them but all approaches were in vain. So in 1881, France decided to send a mission to cross the Sahara from the north to the south. Led by Colonel Flatters, it would navigate the Hoggar. But the Tuaregs of Hoggar resisted and massacred the mission. From then on, the French were convinced that only force would open the doors to the Tuareg's Sahara. In 1894, at the edge of the desert, colonial forces of Senegal (who had been there for forty years), conquered Timbuktu. However the Tuaregs of the Niger River Bend swiftly mounted a counterattack and massacred a regiment led by Colonel Bonnier at Takoubao. The full force of the colonial troops there was now unleashed on the Tuaregs here - after many violent battles these Tuaregs were subjugated.

In 1902, in the north of Algeria, the military who had taken the In Salah oasis two years earlier, subjugated the Tuaregs of the Hoggar after the battle of Tit where14,000 rounds of ammunition were fired by French rifles in just one afternoon, killing or scaring to flight three hundred Hoggar warriors. This same year, Colonel Laperrine created the first Méhariste company in the Algerian Sahara which was made up of of Chaambas; they made a new conquest, the Tassili n'Ajjer.

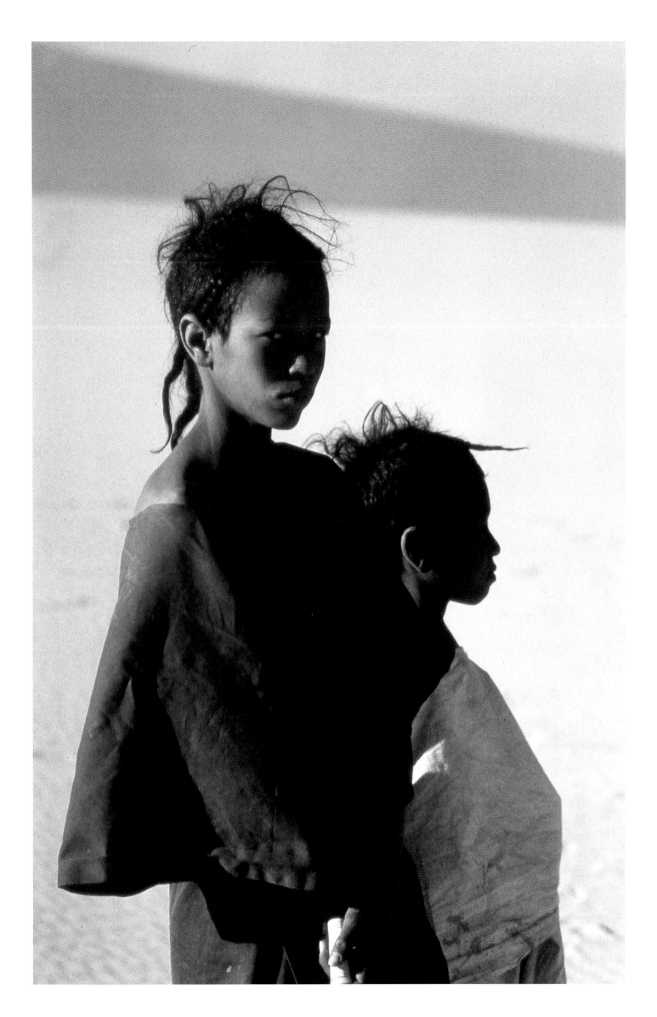

In 1903, in the south of the Sahara in what is now Mali, the colonial troops had only one objective: to colonise the regions of the future Niger and then to subjugate Chad. The strategy was simple: the troops advanced slowly into the central Sahara from the north and the south and closing the Tuareg lands in a vice-like grip, they would subjugate this Tuareg country. In this conquest, there would be no negotiation, submission would be by the force of guns.

By 1910, all of the Tuareg lands had been subjugated except Tassili n'Ajjer, where French troops found themselves facing serious difficulties as the region backed onto Tripoli in current day Libya, Ottoman territory at the time. For the Ottomans, Britain and France with their moves to colonise Africa since the 19th century posed a serious threat to the Ottoman Empire's own colonies. But lacking the means to fight the two countries and ignored diplomatically by the rest of Europe, the Sublime Porte encouraged African populations everywhere to a revolt in the name of pan-Islamism wherever possible.

In Libya, the Ottomans encouraged the Senussis - a secret sect of xenophobic Muslim extremists - to declare a Jihad against all Christians in African lands, so the Ajjer Tuaregs were given guns and ammunition. If the Tuaregs of northern Mali and Niger had been subjugated by force, there was no shortage of resistance in the Libyan camps and the chiefs waited for the day when the French invader would be weakened.

The moment of weakness came soon - in 1914 the First World War broke out. With the French against a German army twice its size, the French had to reduce the numbers of its troops in its colonies. In west Africa, entire rifle battalions and their French officers were repatriated to fight on the Western Front: everywhere, whether in the desert or the scrublands, French forces were drastically undermanned.

In 1915, the Amenokal Firhoun of the Oullimendens, a great tribe whose territory was to the north-east of the town of Gao in Mali, launched an insurrection. Yet the colonial troops reacted fiercely and despite his warriors courage, much of the tribe's blood was spilt at the battle of Anderaboukane. In the north of Algeria in the Ajjer region, the Tuaregs – this time armed with rifles – began a perilous attack on the French Méhariste forces. But here too the military finally regrouped and crushed the resistance.

In 1916, Kaossen, a Tuareg warrior of Niger who was acting under Senussi orders gathered a powerful troup at Ghât in Libya; going to the French fort of Agadès he laid siege to it. As Kaossen's column passed through Niger, large numbers of Tuaregs from Aïr regions joined him, but despite the strength of this army, the French fort held out. After a two-month siege, French reinforcements from Zinder retook the town and crushed the revolt.

By the end of the First World War, the entirety of the Tuareg region had been subjugated by France and the regions of northern Mali and Niger were in ruins. The French military administration would now govern all Tuaregs by imposing borders and administrative regulations ill-suited to the Tuaregs' nomadic lifestyle. The Tuaregs were soon impoverished: with the clan structure subordinated, the Tuaregs could only pursue their traditional pastoralism, from which it was hard to survive alone.

From 1930 onwards, French colonial propaganda, wanting to justify the use of having conquered this desert for France, used the admiration of a new generation of officers who were fascinated by the Tuaregs, publishing the officers' stories about the Tuaregs. These young officers were not fighting the Tuaregs but they co-existed with them as numerous Tuaregs had enlisted in the Méharist units and helped them discover their immense knowledge of the desert. Some of these officers wrote numerous works about Tuareg society and about their lives with them. In the French mainland, these articles and books full of exoticism completely intrigued the public at large - a few novels were even made into films.

The Tuaregs were then represented as veritable knights of the desert; ths myth would endure for many years to come. Unfortunately, the image of the handsome Tuareg veiled in blue on his white méhari, which is certainly a reality, hid a less romantic reality. They were a people dominated and sidelined from the outside world, a world which was changing rapidly and from which they would also be excluded.

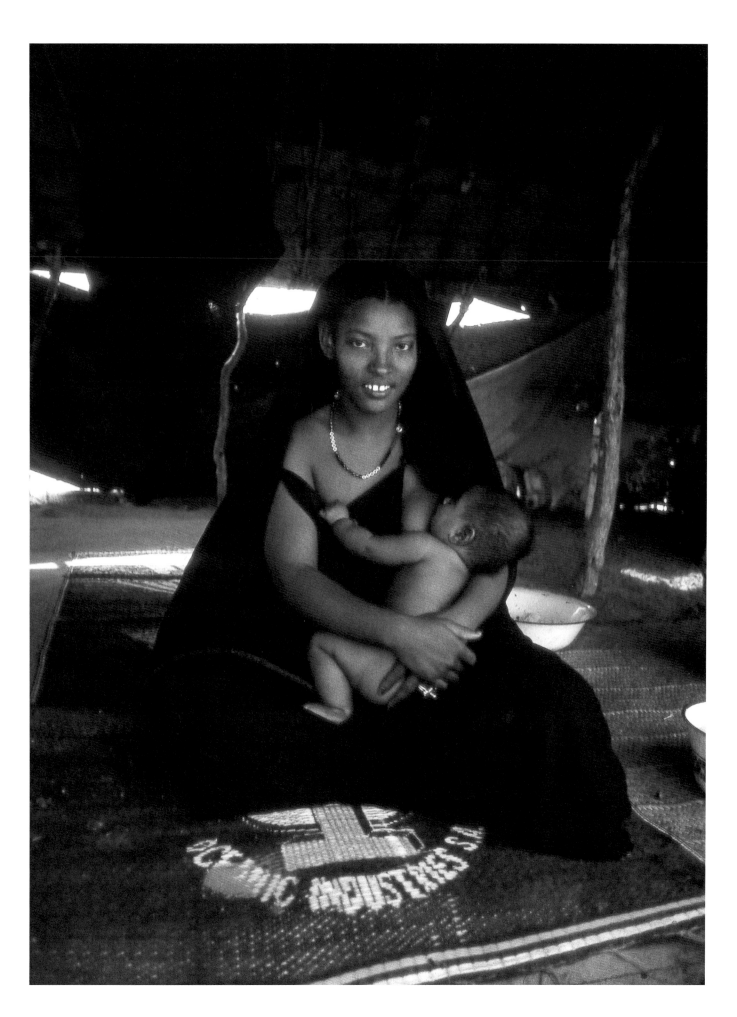

Chapter 3
Colonisation

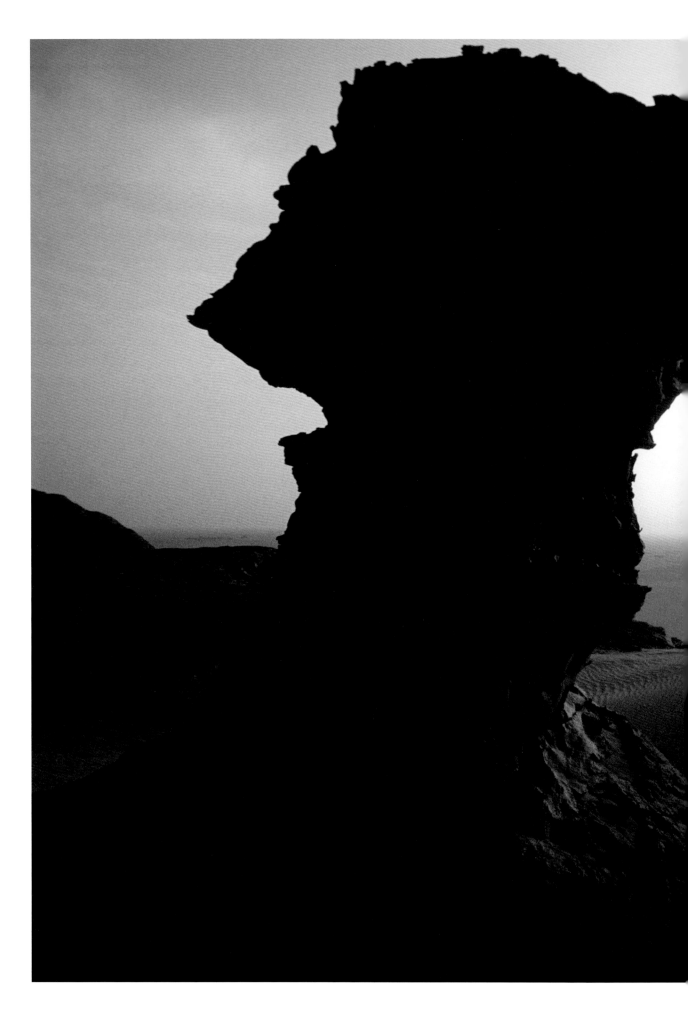

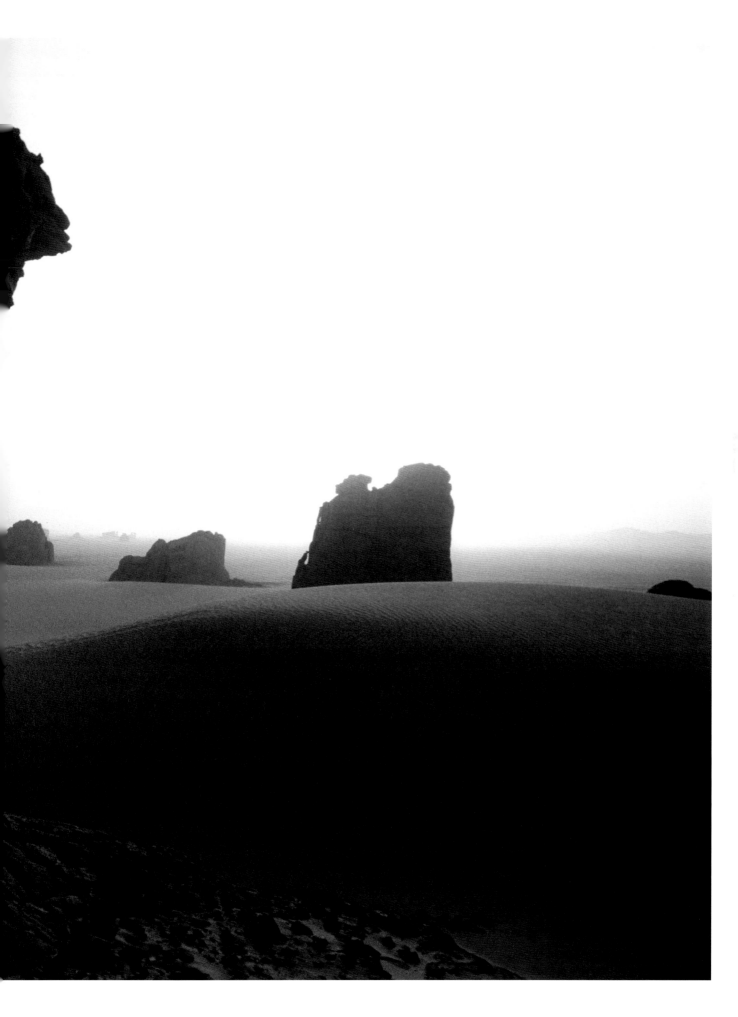

Right:
Laperrine's photograph
of Tachcha ag Serada,
the second chief of
the Kel Taitoq and a
former collaborator of
Commandant Bissuel.
Most interestingly, the
photograph shows how
the Tuareg's shield is
transported

INROADS OF "PEACE-TIME":
Tourism, *Tournées* and Treasures

Over the following forty years, until the end of
colonialisation and the political structures of the current
Saharan countries formed - and indeed beyond - the
Tuareg's Sahara would be subject to an ever-increasing
variety of foreign activity. New kinds of explorers and
researchers (mostly French), fell upon the Sahara in
droves, inspecting the territory from every angle - from
the skies, to under the ground and what existed upon it.

Firstly, France's old dreams of a trans-Saharan
railway were revived (the idea dated back even to
the 1870s). Whole departments of military and civil
personnel would spend these forty years fiddling with
calculations and musing on hypotheses towards this end,
inspired too by the British Cape to Cairo railway dream.
All would be fruitless.

Otherwise, aviation and automobile advances were
precariously tested over and on the challenging desert
terrain. These ventures were more successful than the
elusive railway line. For the still novel aeroplanes, the
suffocating heat caused rapid evaporation of petrol
reserves: the elementary 1920s' aircraft could only fly
for three hours without re-fuelling. The pilots and
co-travellers were brave - any crash onto the desolate,
unmanned surface would usually be fatal - if not dying
immediately they'd be lucky to be found alive by
someone, anyone. Laperrine's fellow travellers were
shadows of their former selves when eventually found
with his body about a month after their plane came down.

The cars invariably got bogged down in the sand
- even with the caterpillar treads that the first models
had. Cars also suffered fuel limitations thanks to the
heat besides limited storage capacity. (There were no
pit-stops with helpful mechanics and supplies). But
Citroën, in particular, took the challenges on with relish
and in 1923 a team crossed from Ahaggar to Timbuktu
through the dreaded Tanezrouft - the perilous "land of
fear and thirst", the scene of Laing's attack by Tuareg
- in an unimaginable matter of weeks. The Citroën
drivers needed all their powers of persuasion to secure
local guides: whether Chambas, Maures or Tuaregs,
many guides would quietly slip away when fully aware
of the planned routes.

And French civilians or tourists started to make
an appearance - both those of the second or third
generations of the French settlers in northern Algeria,
who famously rarely thought of venturing south, and

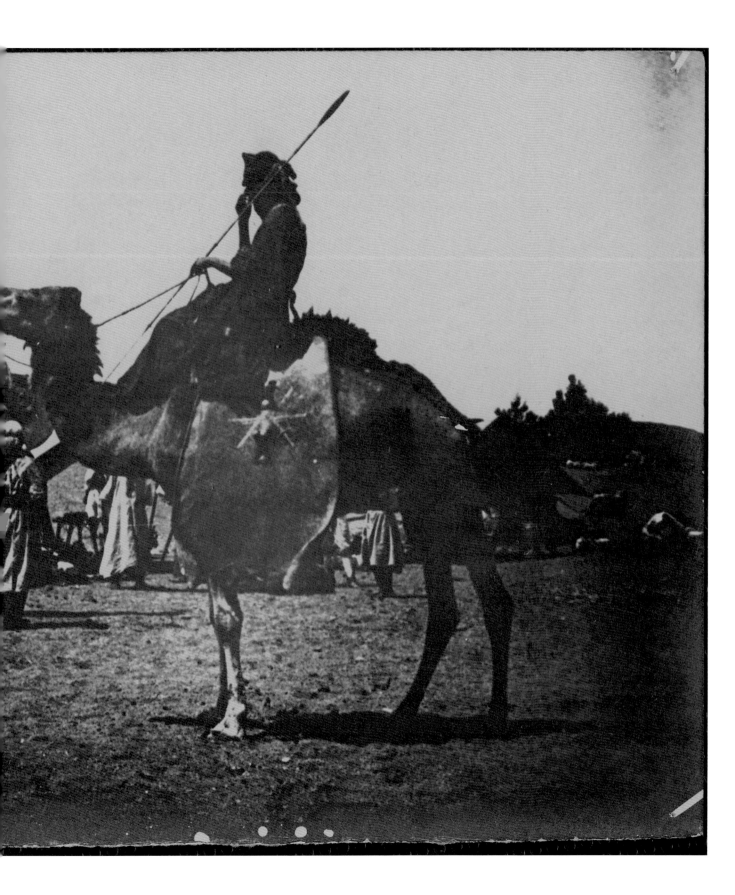

LIGNE DU HOGGAR

Left:
The 1930s saw the flourishing of the "Ligne du Hoggar", taking tourists into the once hostile Tuareg territories. The feared Tuareg were now decorative attractions of the desert, like lions trapped in a wildlife park

Right:
In 1923, Haardt and Audouin-Dubreuil achieved an unimagineable crossing of the Tanezrouft, the "land of fear and thirst", by car. The Sahara became a playground for reckless adventure. Even Bugatti hosted their "Raid Bugatti" of 1929, sending five cars at speeds of a hundred miles an hour over the hard flat wilderness

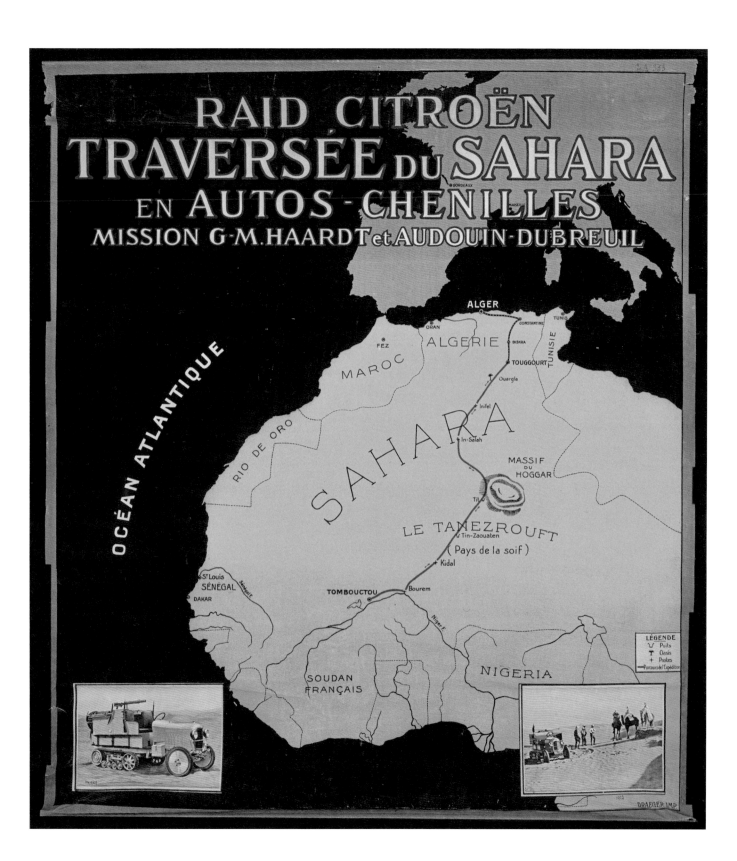

Bottom right:
A badge created c.1933
for the 3rd Squadron AOF
(French West Africa), a
flying unit stationed in Gao
(now in Mali).

visitors from mainland France. Algeria was officially now a part of France, as opposed to the current regions of Niger and Mali which was the Soudan or, for the French, Les territoires du sud.

Boundaries between these two regions were drawn - according to where wells and sound "roads" or passages were. There were of course no roads as we might describe them. (At the time of its independence in 1960, Niger had apparently just 12km of tarmac, in the capital, Niamey). Distinct and separate military units controlled either the Saharan parts of southern Algeria or *Les territoires du sud*, enforcing the division further. These were the boundaries that would be set in stone at the end of French West Africa, when Algeria, Niger, Mali and Libya achieved independence. Until this time, the Tuareg were however free to continue their traditional seasonal transhumance over the new borders; they could ignore the borders that would be forced upon their movement for the time being. (The French would however be concerned when swathes of Tuareg re-located two or three thousand miles from Ahaggar to Aïr or from the Tassili n'Ajjer to Aïr, as occasionally happened: which department was now responsible for surveilling these people? Their frustrated correspondence takes up no small amount of space in the military's files).

The tourists were doubtless intrigued by the Sahara. Dressed almost as if going to the races, they discovered it, and the few Tuareg who were friends of the military, from dedicated buses and were guided by army officers. Apart from the numerous surveillance *tournées* keeping tabs on both the contented Tuareg groups and the less than content - counting them, counting their herds, checking wells, checking there was sufficient pasture for animals and sufficient food for the populations (so that the Tuareg would not be distracted to revolt), and, crucially, checking that the razzias or raiding (how the Tuareg had formerly survived economically), were a thing of the past - some military personnel had time on their hands.

Many officers fell profoundly in love with the Tuareg, their culture and their desert. A number of officers would write books on their years in the Sahara and their relationships with it and its populations. Some of the books are still renowned. French army or air divisions used representations of Tuareg and Tuareg items as their own symbols (see right), although there were still groups of Tuareg who were "enemies". And it was military characters who, during

their random excursions everywhere, accidentally stumbled on some of the Sahara's completely unexpected treasures - notably the now renowned rock paintings on many a rock-face or in many a shelter all over the desert. The Tassili n'Ajjer in Algeria (for one), is a World Heritage Site now, in an attempt to protect the priceless pre-historic representations of former civilizations. One of the most exciting finds here, by a Captain Duprez, was of horse-drawn chariots and spear-holding people - the Garamentes. Current academics believe the Garamentes to be the ancestors of some branches of the Tuareg.

The discoveries of the rock art were soon public and experts followed the military. One in particular, in the 1950s, was Henri Lhote. Impassioned by the Sahara, Henri Lhote charted and compared rock paintings all over the Sahara, reproducing and carefully annotating all that were known to exist. Though there is controversy over his unconsidered methods of reproduction - tracing the pictures on the rocks directly onto paper - he was passionate about the art. His work, a mammoth inventory of pre-historic artists, was fastidious and unsurpassed.

Snaps from a tourist's photo album c.1930. At the top, they pose in perhaps not perfectly suitable attire for the forty-five degree heat, and bottom, mingle with friendly Tuaregs and French officers, who now had time on their hands - although there were of course still huge numbers of Tuaregs anti the French occupation

Aïn El Hadjaj

Tamanrant. Hotel

CONRAD KILIAN
the Gentleman of Oil

The most intriguing and, perhaps not surprisingly, most doomed of the young scientists who arrived in the Ahaggar at this time was without a doubt Conrad Kilian, a geologist. The son of Wilfred Kilian, an eminent geology professor in Grenoble, Kilian was twenty three when he made his first exploratory voyage in Ahaggar in 1922 - the same year as when Francis Rodd (barely four years older than Kilian), was following Barth's tracks in Aïr.

Kilian went to analyse the Ahaggar's rock structure and its components travelling with, as he soon discovered, the dubious Saharian veteran, Lacroix , who brought his mistress, Florence. Lacroix was in search of his fortune, looking for mythical emeralds "left by the Garamentes … the size of a pigeon's eggs", nestled somewhere amongst the fierce, spiky black stones of the granite mountains not far from where Flatters met his end. Lacroix thought Kilian's knowledge would be useful. However, temperamentally poles apart, the ill-matched men were soon fighting publicly. Despite being literally in the middle of nowhere, Kilian finally relieved himself of Lacroix's company - to the concern of Florence who had taken a shine to the polite young man, often siding with

him during the arguments. But Kilian soon found refuge from his risky, solitary existence at a Tuareg campsite. The women here were equally charmed by him - one in particular looked for him on the horizon for years to come. And Kilian too became enamoured of the Tuareg: "Few men combine so many elements of beauty by the splendour of their body", he wrote in his journal after his first sight of the oft-described Tuareg warrior of lore.

Returning home after this primary excursion, Kilian was convinced the rock formation or composition pointed to the presence of oil. René Caillié had also alluded to this, just shy of a hundred years previously. However, the idea that the Sahara had once been a deep sea, and areas had the ideal geological conditions for the presence of oil, had long been derided by academics behind desks. But Kilian was sure there would be oil and, if further conviction was needed, the rock drawings deep in the desert - with their cattle and mountain goats, but most remarkably with hippopotomi and rhinoceroses - assured him further.

Despite his father's contacts and prestige, Kilian had to finance his further voyages himself: the first solo voyage (of 1925), was financed by his inheritance from his mother. Like Henri Duveyrier, he travelled alone with Tuareg. He hunted high and low for firm proof of

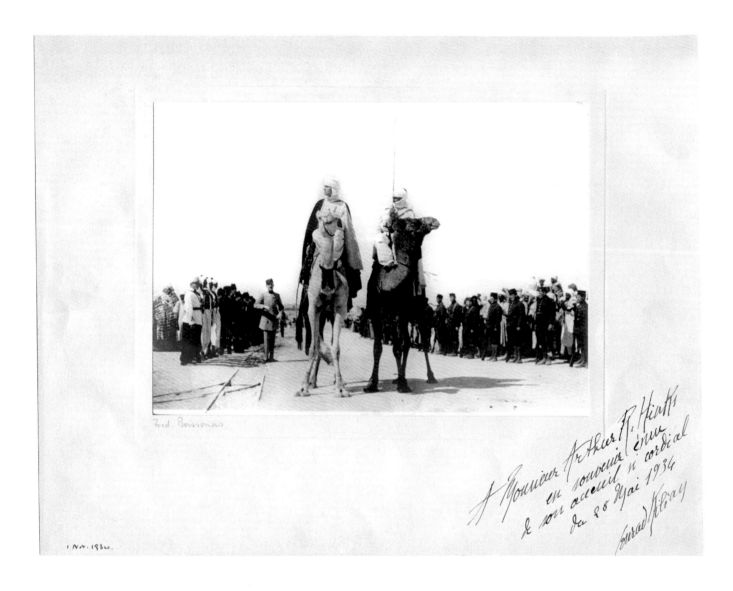

Fred. Boissonas.

À Monsieur Arthur R. Hiatts
en souvenir ému
de son accueil si cordial
du 28 Mai 1934
Conrad Kilian

1 Nov. 1934.

Above:
Kilian, on the left, was
likened to Lawrence of
Arabia for his empathy with
Tuareg. He was also known
for his striking white mehari
and stylish Tuareg dress

the black gold - across Ahaggar and the Ténéré desert
of Niger, and finally into Ajjer (partly in Libya, where
the English had a presence). The research took him
over twenty five years, during which time he took on
full Tuareg dress and superb white *méhari* camels, gently
broke more Tuareg hearts and, as Boissonade says, "in
the style of Lawrence of Arabia refused the throne of
the Sultans of Mourzouk". In 1948, he gave undeniable
evidence of oil to the French doubting Thomases:
he had discovered "more than [that] of Iran and Iraq
combined", and his finds were made public. But, a year
later, with echoes now of Duveyrier's fate, Kilian was
found dead in a hotel room in Grenoble, hanging from
a rotating window opener in the room. Some say the
British SAS killed him, others say it was suicide.

Kilian had doubtless been caught in a quandary.
Whether conscious of how his discovery would
negatively affect the region and the Tuareg in the future,
and was therefore driven to suicide, or whether he was
"taken out" for knowing too much, remains, like the
disappearance of Laing's journals, a mystery.

Kilian was the last of the true explorers of Tuareg
lands, accomplishing perilous journeys of endurance,
some with doubtful chances of survival. Despite his
love of fine camels and smart local robes, he travelled
modestly, in harmony alongside Tuareg, and he
participated in their lives. A sad irony then that this
mild-mannered man of science would die in rather
less amiable, depressing surroundings, and possibly for
reasons of his own making.

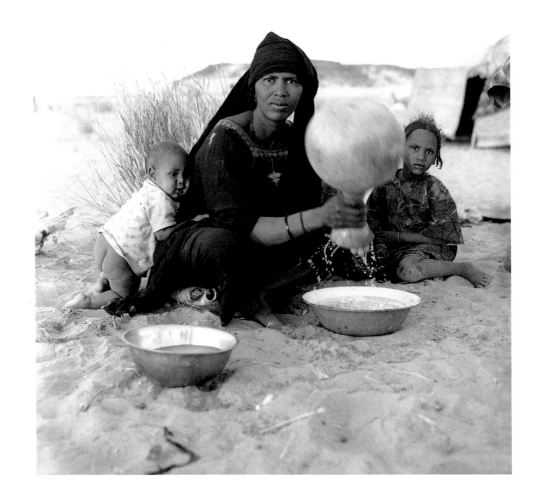

Above:
Tiguidit, Niger 2005

Right:
A girl swings what is a metal stove for making the strong green
tea that some Tuaregs may literally be addicted to; the motion
helps the wooden coals heat up. Tiguidit, Niger 2005

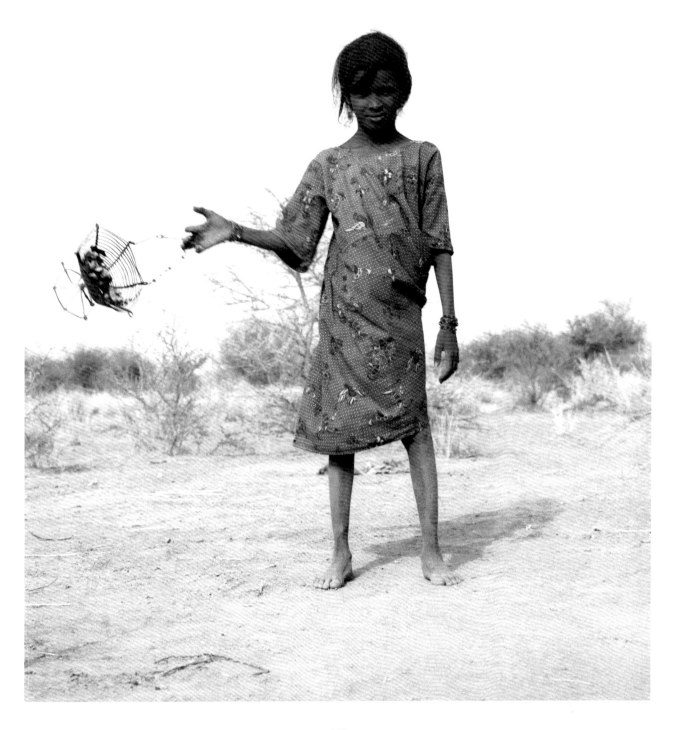

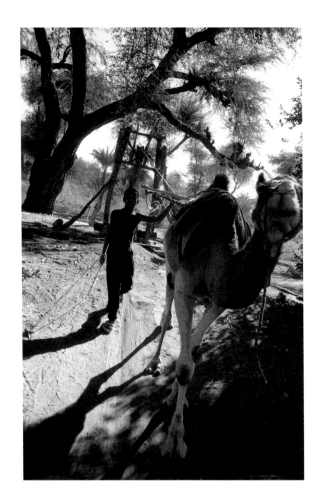

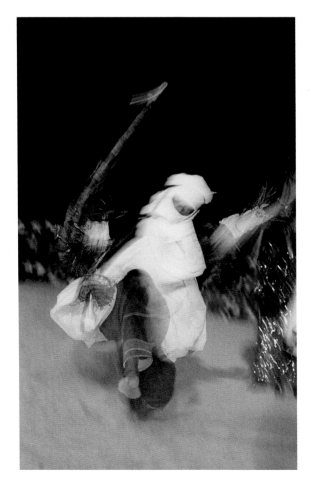

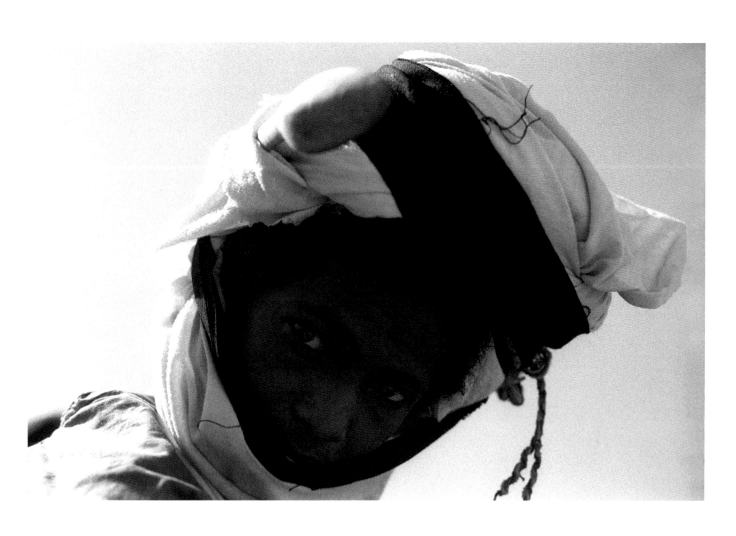

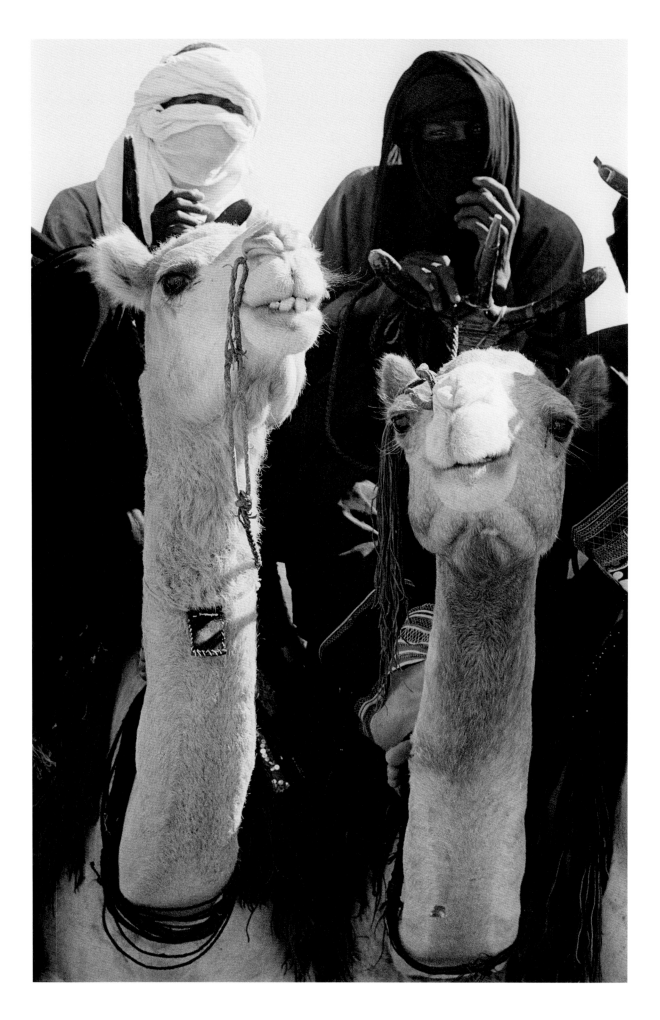

Left:
Nomads at the *Cure Salée*,
In Gall, Niger 2001

Right:
Scenes from Tiguidit,
Niger 2005

Pages 150–51:
An *Ilugan* at the *Cure Salée*,
In Gall, 2001. The camels
"dance" around the women
in the centre whose songs
praise the men, their valour,
their bravery and their fine
mehari

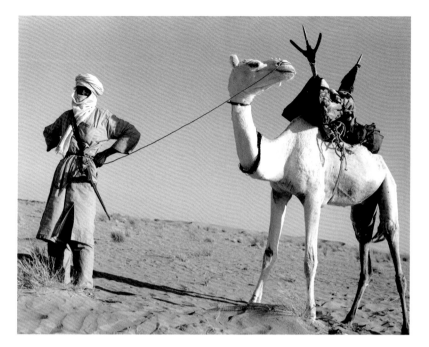

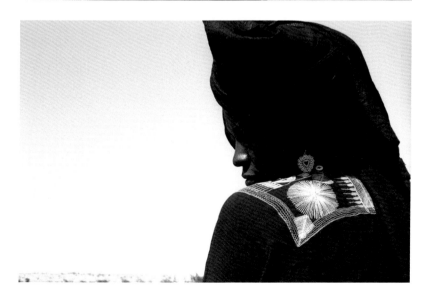

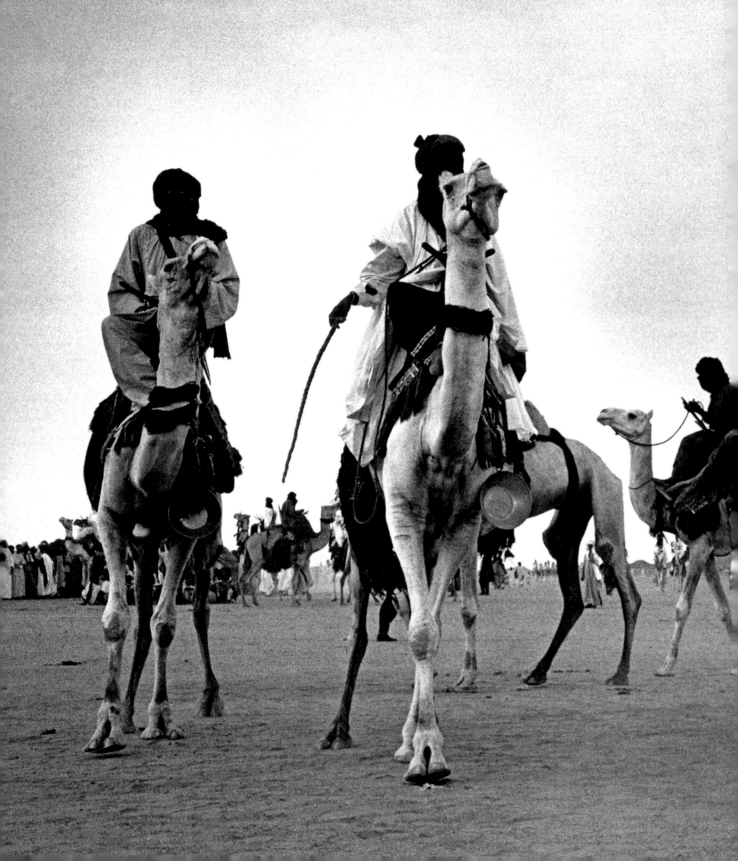

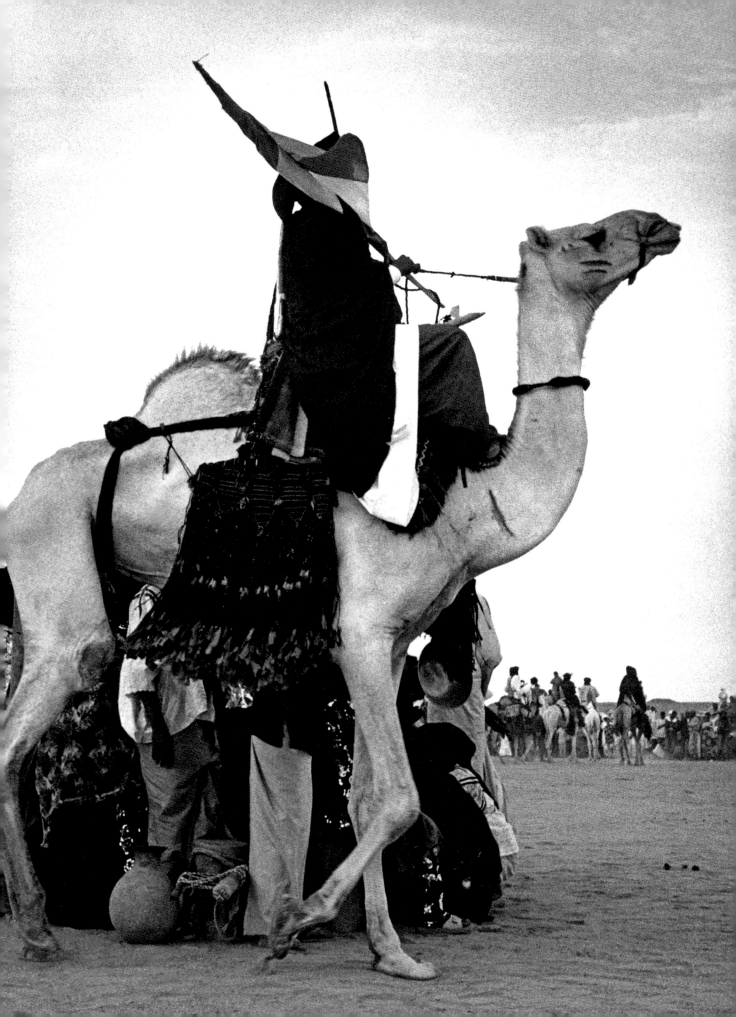

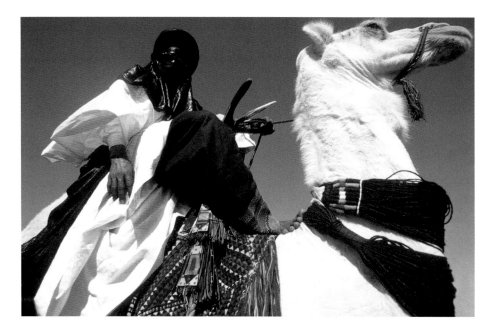

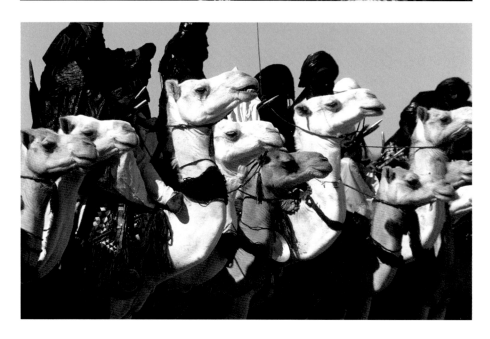

Left & right:
Scenes of splendour at
festivals in Niger

Pages 154-55:
A caravan, or *azali*. The
begining of the long journey
across the Ténéré from Aïr
to collect salt from Bilma,
take the salt to the south
of the country, and then
exchange it for goods there
– not least, the cherished
indigo cloth – and then
return to Aïr. The tough,
perilous journey may take
six months. At their peak
in the 1920s and 1930s the
caravans stretched for a
couple of miles with up to
20,000 camels. For boys,
who may be as young as
ten, the journey is a rite of
passage.

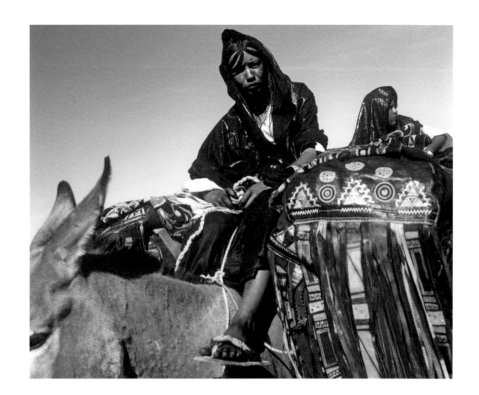

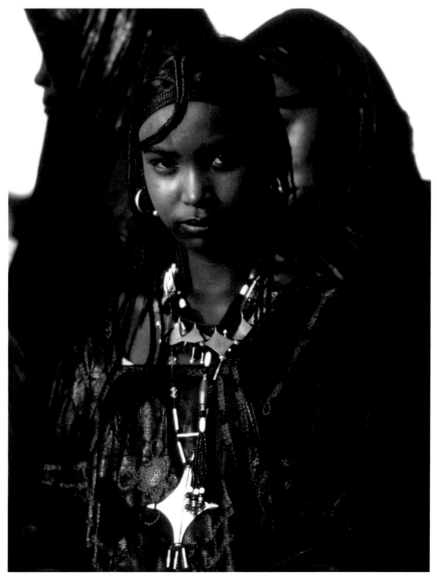

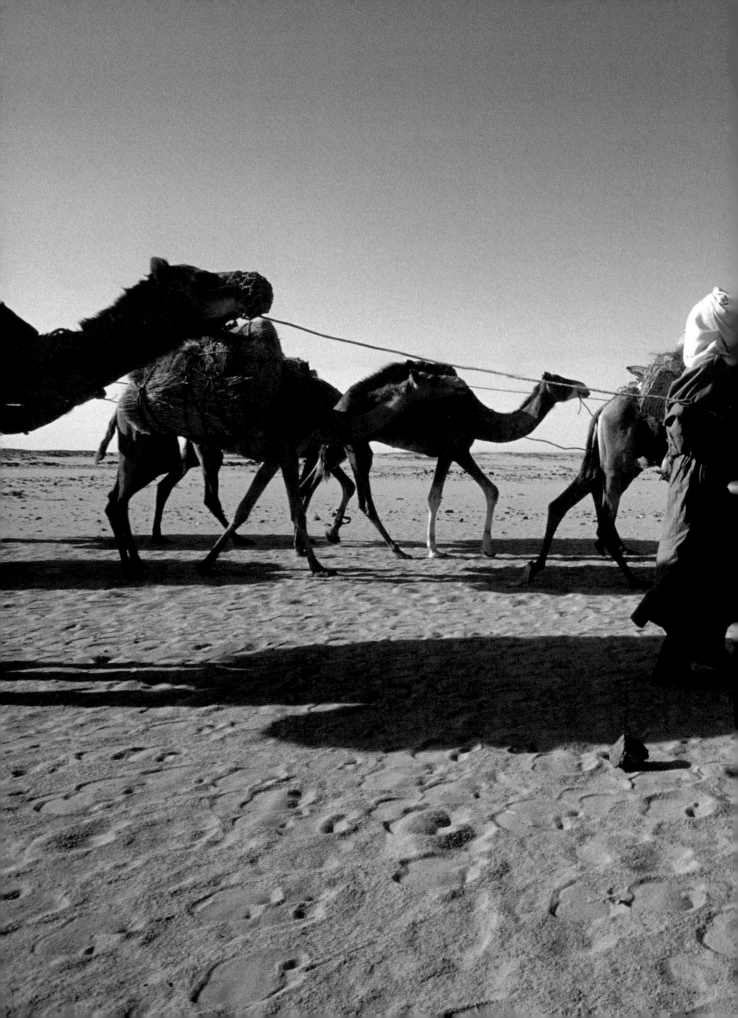

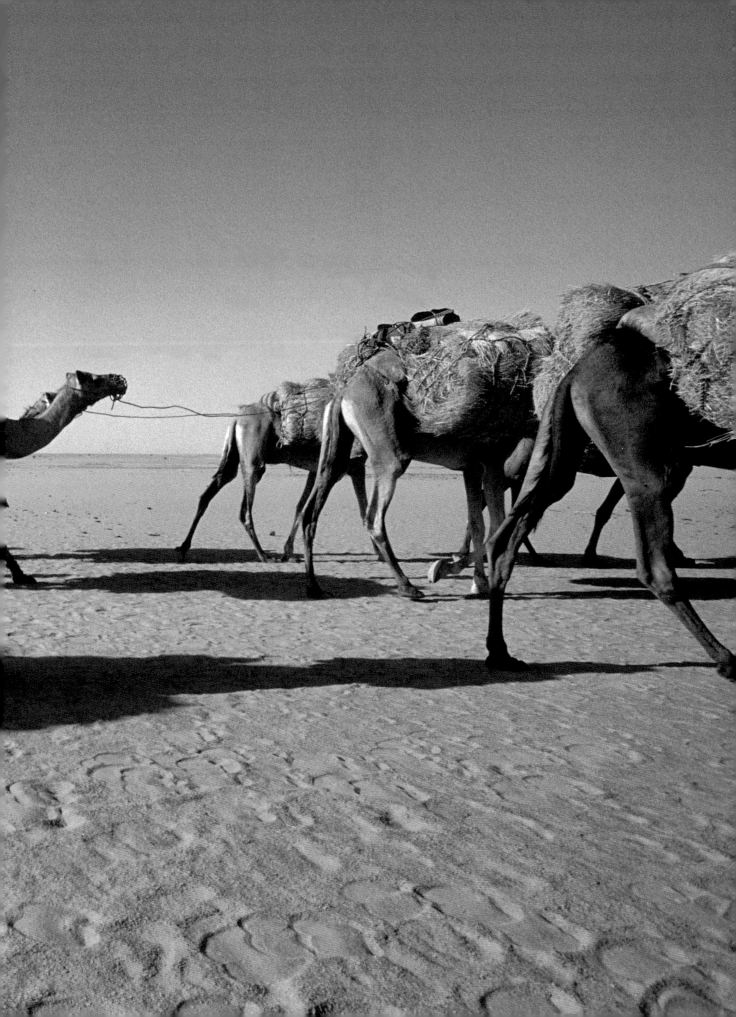

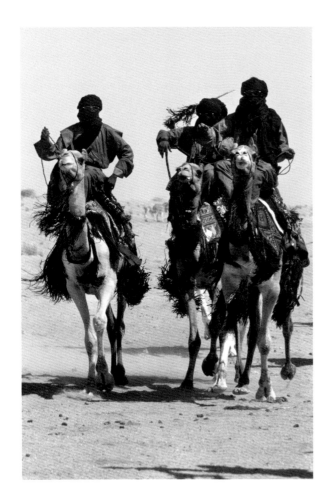

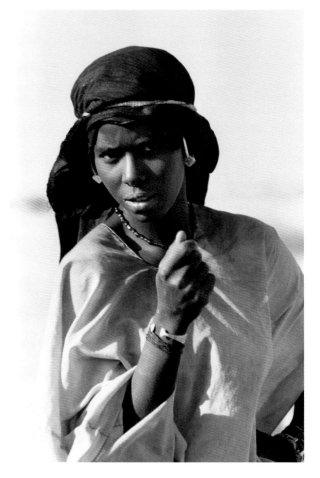

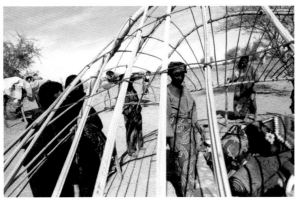

Clockwise from left:
At a wedding in Krevin; a
woman at a well; relieving
the camel of its 'harness';
a well in Taguedoufat ;
dismantling the tent – or
moving house

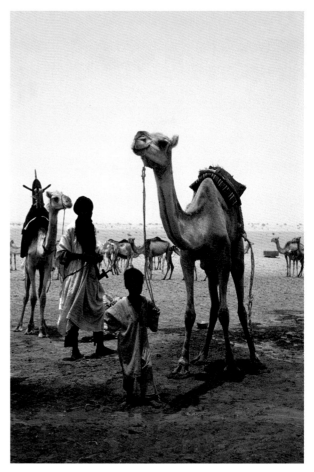

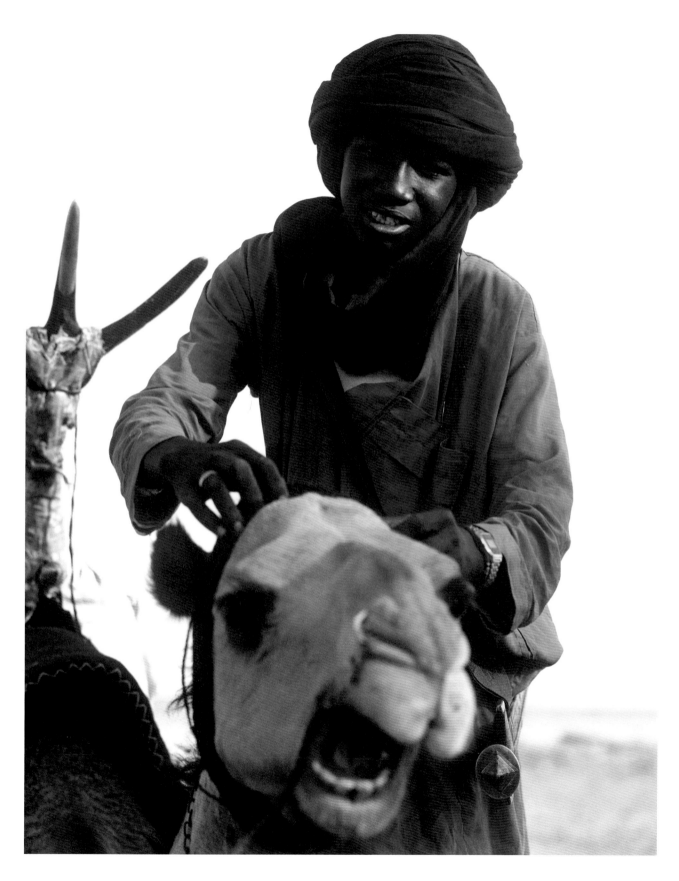

At a well in Tiguidit,
Niger 2007

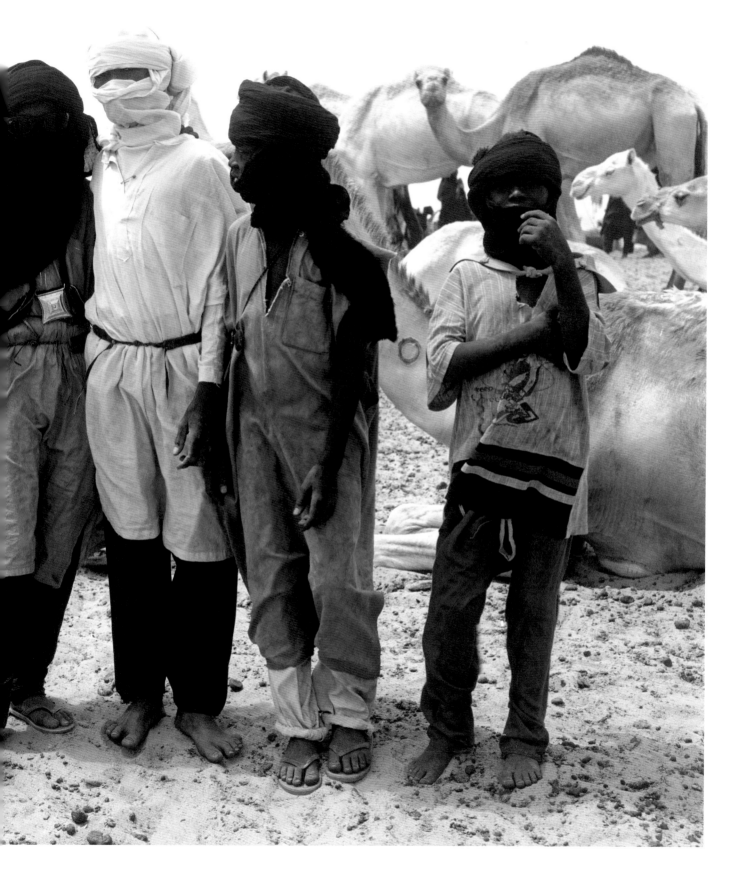

TAMANRASSET - the new face of Africa
by Henri Delord, 1955

Waking up early in a house in Tamanrasset makes a peculiar impression on our senses as civilised people, used to the comfort of our 'Nordic' abodes!

Before opening our eyes, there is already this feeling of stiffness, of rheumatism, coming from the long time we have just spent lying the coarse mat which is meant to be both bed and mattress. So the first thing we have to do is move, in big jerks under the twisted covers, so that we can jump up, or rather roll at ground level to the edge of the mat where – and this really is the height of sophistication – we can bathe in the freshness of the thick layer of sand covering the floor. Then again, it is not unpleasant to stay on our backs observing the basic furnishings of these lodgings, the little stars of brightness dancing on the walls, through the dark light. Then, we find that we want to crawl across the floor to the door, to be slapped in the face by the sunlight and the pure morning air while the house, quite damnably, now starts to fill with the hum of the squadrons mosquitoes looking for plunder!

Going to fetch water from the neighbouring fountain by the mosque, lighting a fire in the tiny courtyard, boiling water, jingling with the teapot, the sugar, and the little glasses – all of this hardly takes a minute. The crushed wheat flatbread, baked last night under the ashes, is utterly delicious dunked into the green tea with mint.

The old pauper who goes to the mosque turns the corner of the lane, reciting verses from the Quran.

The reeds on the roof rustle in the breeze.

The day has begun…!

. . . And yet this only one way in which the day can start.

The indigenous way, the Saharan way: this is limited to a few European politicians – termed adventurers, vagabonds, or eccentrics – by those of their compatriots who are 'settled'.

…It is time to wake up to reality, you dreamer! The oil company's trucks are driving along the tracks, and the children have not been afraid of the roars of their motors for quite some time now; electricity is no longer the devil's work! The Sahara-to-be-conquered has been extinguished. The past holds on, huddling under the tents, in the mountains, or in the nonchalance of the little donkeys, loaded up with wood for the villagers like they were a thousand years ago.

Tamanrasset, below the Tropic, in the desolate Hoggar – the mountain of poets – is a bubble on an effervescent surface. Irrigation channels lace the ground, watering gardens, running under the shadow of weeds and poplars. Naked children play while women wash clothes nearby. Tuaregs pass by: scrawny silhouettes, veiled in blue. At the end of the road is the track where the trucks and jeeps drive past; the metallic carcass of a house seems to cling to the clouds as the pylons of the radio transmitters climb into the sky. Under the noise of the motors, concrete is modelled into buildings. A helicopter passes, sparkling in the light; a weather balloon bursts up from the meteorological park.

Africa is a building site!

Right:
The title page - drawn by a Tuareg - of Henri Delord's 1955 Zellidja award-winning Rapport of his three-month stay in Algeria, partly in Tamanrasset, partly with the Dag Rali of Ahaggar. The essay here is an extract from this Rapport

TOUAREGS
JARDINIERS
et europeens

du HOGGAR

c hraïbou

The traveller, not attached to the country in any way and able to stay there as he sees fit, can see the mobile architecture of this new African society appearing in the blink of an eye. He cannot help but make an observation about these two ways of life, about the European and African mentalities, which is most remarkable by its contrast.

There was a time when the Sahara – whose riches remained entirely unsuspected – attracted people for the sake of people. Those who went to the Sahara were often high ranking men who wanted to work their way into the indigenous milieu, to become loved by them by gaining familiarity with their customs, with the way of life of these lands so different to ours. One was able to call them colonisers. There were very few of them, and they went to the root of things. Then one day, somebody in an office far, far away asked himself if it really could be that there was nothing at all under all this desert: so he sent in some men whose job it was to look under the earth, and they then found some, no: lots, no: enormous amounts of stuff! Then things happened very fast and now, the bewildered traveller can enjoy a spectacle comparable to the Gold Rush in America one hundred years previously – although with the notable difference that individual enthusiasm has been replaced by the machines of the exploration companies, that the prospectors are salaried employees, and that science has changed both the techniques and the requirements applied.

Henri Delord's motivation to share the life of the Tuareg was to understand them as people: he doesn't make a personal journal, describing his days, or the many tough challenges he had to confront, he studies the Tuareg ethnographically. He explains their habits and customs, from how they related socially and their social structure, how they divided or owned land and rights to land, to how they secured water or food and what it was that they ate and drank and how they looked after the animals, to the intriguing 'game' of *La Chasse aux ânes*. Then he explains the local Europeans' attitudes to the Tuareg, which were generally derogatory. The Tuareg were people who "lived in misery" to the Europeans living in Tamanrasset in 1955. Tuareg culture was of no interest to the 200-odd Europeans that inhabited the surreal, "wild west" frontier town. Largely scientists - geologists, meteorologists or oil prospectors - or anxious military personnel for whom the young man was possibly a spy - considering the turbulent politics of this time which was just a few years before the end of French rule in Algeria. The atmosphere of Tamanrasset was charged with doubt and increasing goals of commerce by day and descended into a free-for-all at night - which the few French wives, shielded in their customised, westernised homes, feared to go out into. Before visiting local ladies of the night, the Europeans would gather in the Bar de l'Amenokhal. "O ironie!", Delord exclaims with exasperation, as the Amenokhal - the head of the Tuareg of the region - was of course a teetotaler. At the end of the Rapport, Delord questions why the then western industrialisation should dismiss the human, or natural progression of Tuareg social development, of a kind that "the Romans helped us benefit from". Why could the Tuareg's difficult lives not be bettered by improving water supply and distribution, for instance, instead of just pouring millions of francs into building smart schools that few Tuareg were able to attend? All the more remarkable being a twenty-year old, he considers our evolution and why the Tuareg's desert culture couldn't be promoted, and such that the two cultures (western and Tuareg), could combine to produce something positive - and perhaps surprising - instead of the Europeans merely disparaging the Tuareg way of life and valuing only western goals.

Above:
Henri Delord, artist, designer, photograher, 2015

Pages 166-167:
Storm approaching. In Gall, Niger 2003

Pages 168-169:
At a wedding in Tidéne, the men pray. The little boy poses the question of what the future may be for him. Niger, 2005

Pages 170-171:
The poverty that tourists rarely saw; the reality of life in the desert for poor Tuaregs. Niger, 2005

1953/1954 SECOND VOYAGE DELORD HENRI

3EME PRIX

RAPPORT 2° VOYAGE

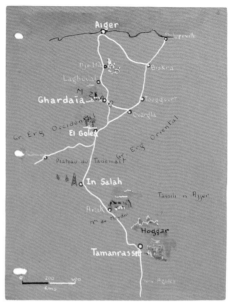

Etape.

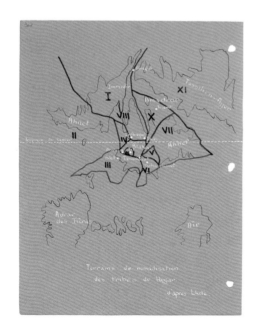

la chasse aux ânes.

Chapter 4
New countries, new boundaries, new questions – who are the Tuareg today?

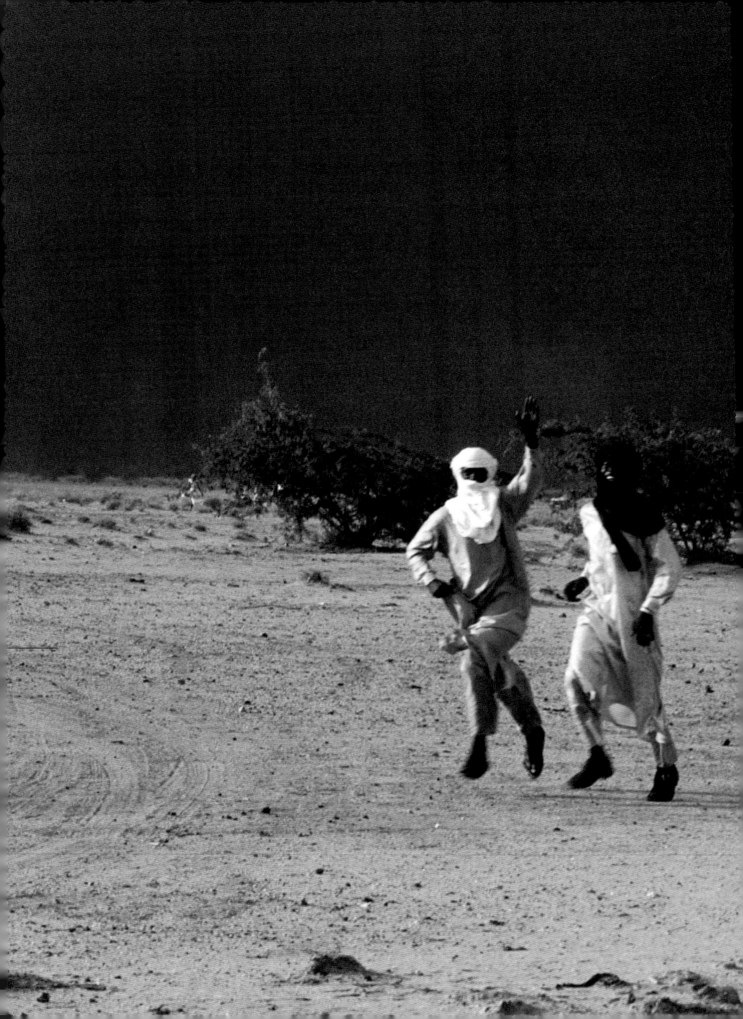

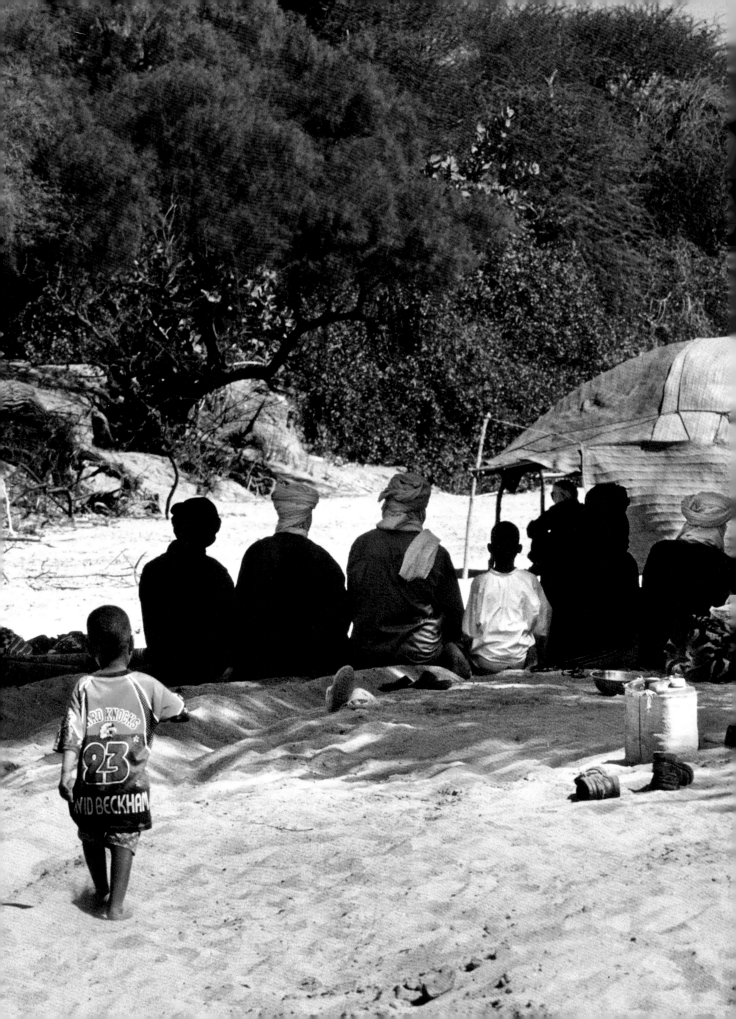

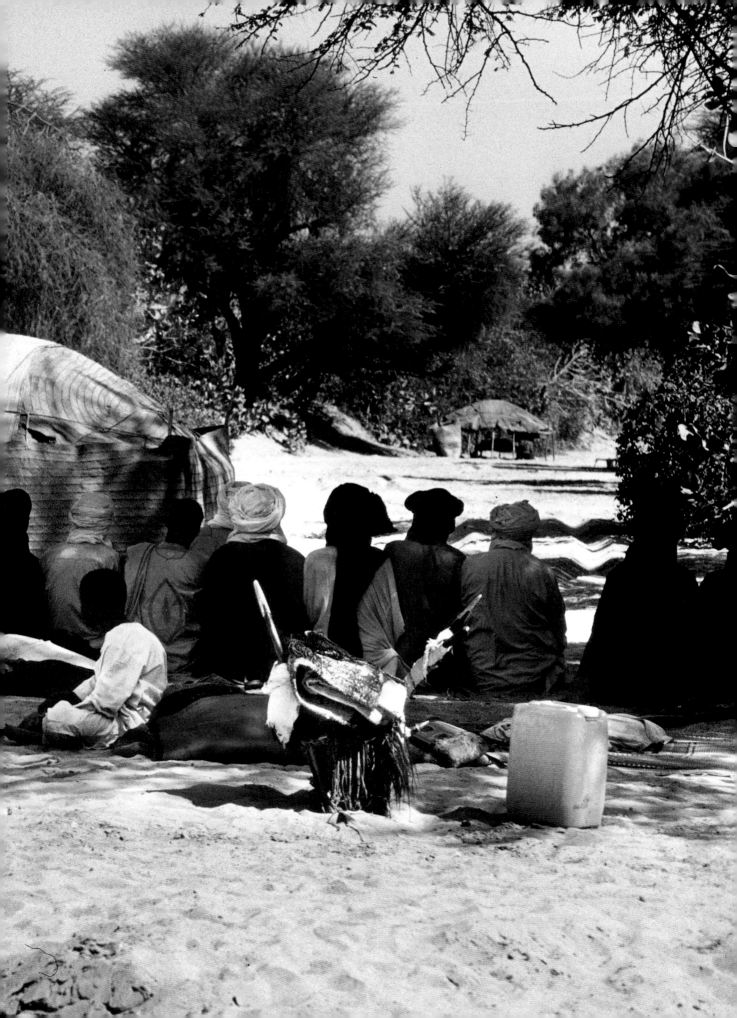

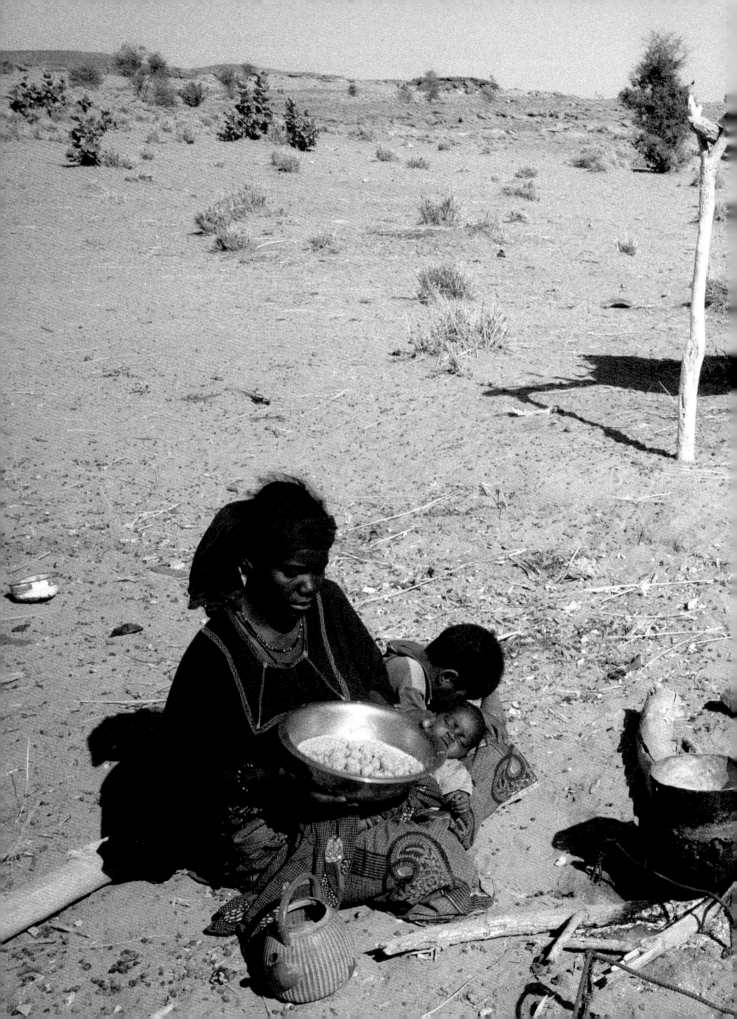

THE GRIZZLY REALITIES OF SAHARAN GEO-POLITICS
By Pierre Boilley

Until colonisation, the Tuareg moved without impediment from the Ahaggar mountain range in the north (today in Algeria), to as far south as the Niger river, and from the region around Timbuktu in the west through to the Ténéré desert in the east (today part of Niger).

But in the late 19th century, caught between the French troops of Algeria on one side and those of French West Africa (AOF), on the other, the main political groups – the Kel Ahaggar, Kel Ajjer, Kel Aïr, Iwillimiden, Kel Antsar, Kel Adadgh etc. – failed to unite against the conquest, and their territories were completely dominated in the first decade of the twentieth century.

The First World War, which forced France to reduce its military presence in Africa to answer the needs of men on European fronts, was however an opportunity for them to revolt against their foreign domination. The most famous uprisings were those led by Firhun ag Alsinar in the Niger Bend (1916), and by Kaocen in the the Aïr Mountains (1917) - and both played a role in the global geopolitics of the age, Kaocen most notably. He laid siege to Agadès for several months - putting the colonial army into a not inconsiderable state of panic - and he was linked to and supported by Germany through the Libyan Senussi order. But lacking co-ordination, in their turn, both revolts failed to push back French presence.

The War over, France could extend its administration of Tuareg lands, and a *modus vivendi* was established with the nomads. The administration was not looking to make profound changes to the customs of these people, but neither did it invest to improve an arid region then judged to be of little economic profit. The Tuareg were neither conscripted into the army nor sent to the Front during the Second World War but new infrastructure in the regions was minimal. More seriously for the future, an education system wasn't introduced until very late here - shortly before the begining of the 1950s. Even then, only a very small number of Tuareg were educated - to a standard barely passing primary school level. This had enormous repercussions on the decolonisation process. The Independence leaders of the 1950s were all from the south, educated in colonial schools, and they didn't know the nomadic world at all .

The Tuareg therefore played a very minor role in the process of emancipation from colonial rule – indeed, most of them did not understand the process at all. Surprised by the speed of the French departure, they had difficulty grasping why the French, who had not been beaten in battle, were replaced by an administration made up of people from the south who overtook the framework of the colonial administration for themselves. There were significant petitions reproaching the French for this state of affairs, demanding that General de Gaulle didn't leave Tuareg territories under a new domineering regime that was considered just as foreign as the former colonial government.

The petitions, of course, had no effect except to re-inforce the distrust harboured by the new Malian and Nigerien administrations toward these populations, who were already suspected of being unruly and separatist. These suspicions had been exacerbated by a last attempt at colonial power politics. In 1957, following the discovery of Algerian oil, the French had created the *Organisation commune des régions sahariennes*, or OCRS, a confederation aiming to group the arid regions of Algeria, Mauritania, the

French Sudan (now Mali), Niger, and Chad under one administration. The project was fought by advocates of African independence, who relied on maintaining their Saharan territories, now evidently rich in oil and mineral resouces – and they were mistakenly convinced that France was intending to create a pan-Saharan state that remained tied to Paris. The new administration saw this as evidence of an alliance bewteen the former colonialists and the Tuareg, in a plot against the new independent States.

In newly emancipated Mali, these tensions took a tragic turn in 1963 and 1964. The socialist state wanted to eliminate the chiefdoms which it considered "feudal". The many misunderstandings between the populations and the Malian administration helped a small spark of resentment ignite the explosive powder. One night, two young Tuareg stole military equipment and two camels belonging to auxiliary soldiers. The Malian government saw this as the sign of a rebellion and immediately sent most of its military manpower to combat it.

The Kidal region was brutally repressed; security zones were established and anyone staying in the region without authorization could be summarily shot. Humiliation was the rule. The soldiers made old people remove their veil – the supreme shame for the Tuareg – or forced locals to applaud as prisoners were executed. These intimidations came on top of the massacres of animals and camps, and revolt was crushed. Over the whole zone, the Malian state established a lead blanket of military and police forces for years, reinforcing the feeling of Tuareg populations that independence was just another form of colonisation, and much tougher than that of the French. Also housing the notorious prisons of Kidal and Taoudenni, the region could only be passed through: no outsiders - even European travellers - were allowed to stay there. For employees of the administration and the Malian police, Kidal and its surroundings became areas of demotion - assignment to posts here was considered a punishment.

It was against this backdrop that a new catastrophe occurred. Re-inforced by the political situation, the droughts of the 1970s and 1980s led to the loss of thousands of animals. Western food aid was by and large diverted away from the region, and people in Bamako (Mali's capital), witnessed the construction of the famous "drought mansions". Deprived of resources, people fled the region, finding refuge in

the south of Mali and Niger or, in the north, on the border with Algeria. Whole districts of southern Algerian towns, such as Tamanrasset or Bordj Mokhtar, were settled by Malian Tuareg – although they were regularly driven away by the Algerian military police. Without livestock, without livelihoods or work, thousands of young Tuareg (many of whom would become known as *Ishumar*), left to try their luck in Algeria or, above all, Libya, the rich and welcoming Eldorado of Oil. Muammar Gaddafi was quick to see the advantage and opened recruitment of the youngsters to serve in his foreign wars, which stretched from Chad to Palestine. It was the opportunity for these *Ishumar* – a name coined from the French word *chômeur*, or "unemployed" – not only to train militarily, but also to organise themselves politically, and clandestinely, for a new rebellion designed to break the political and economic marginalization of the Tuareg.

These years of preparation ended in June 1990 with the outbreak of a new rebellion in Mali, soon followed by a parallel Tuareg rebellion in Niger. These two movements, however, were not co-ordinated and each group fought against their respective state. In Mali, the Tuareg rapidly gained the upper hand over the army, who were ill prepared to a fight guerrilla war made up of raids and sudden attacks on the desert posts. The soldiers of the south, poorly equipped and trained, and ignorant of this environment that frightened them, didn't know how to withstand the surprise onslaughts. Then, at the same time, the population in the south rebelled, also against the authoritarian rule of dictator Moussa Traoré. In 1991 this regime fell, and the first Malian democracy came into being. A national pact was signed with the rebels, whose key aim, significantly, was above all integration in Mali. Calm returned with difficulty but in 1996, the Flame of Peace ceremony - when thousands of the rebels' weapons were burnt in Timbuktu - seemed to herald the beginning of Malian reconciliation.

Yet disenchantment returned quickly enough. The rebels were integrated into the ranks of state forces (the army, police, and customs offices), albeit with delays, but the special statute agreed for the Tuaregs as part of the national pact was soon abandoned in favour of a general, poorly executed strategy of decentralisation for the whole country. Commited development funds were subject to numerous diversions; improvements were barely noticeable. Several groups started fresh rebellion. New accords

Being French Muslim citizens we have the right to express our wishes
and we have the honour to declare very sincerely again that we
would like to stay French Muslims. We confirm our formal opposition
to being included in an autonomous or federalist system of black
Africa. Our interests and our aspirations can in no way be defended
when we are attached to a territory largely represented and governed
by a black majority whose ethnicity, interest and aspirations
are not the same as our own. We assure you that we can in no way
submit to this African authority which, if not French, ignores us
completely.

October 1959
A note taken by a member
of the Military Cabinet in
France

For some time, and notably since the evolution of Mali towards total
independance, the nomadic populations [of Mali] demonstrate their
traditional spirit of independence and dislike of the blacks in a
manner which is increasingly marked. Disorder reigns.

Armed Tuaregs are numerous and it is not impossible that after
the departure of the French, insecurity will take over the region
rapidly.

November and December 1959
A note taken by a member of
the Military Cabinet in France

A former representative of Tuaregs in the Niger River Bend, now fled
to Libya as a refugee, has sent a circular letter to all the nomadic
representatives of the region. He declares that he will never accept
that his people must live under a black government with which the
nomads have no relations - religious, traditional or historic. The
nomads will seek to solidify and refuse to be a part of Mali but to
govern themselves with the help of the large Arab countries.

An accord has been concluded between all the Tuareg tribes from the
Mauritanian frontier to the Hoggar and to Niger. The Tuareg will
be ready to defend their interests with arms. They already have an
important depot of arms and ammunitions, of Italian origin, thanks
to the help of their friends in the Hoggar

Directed by the principal Tuareg chief In Tahoua, the nomads of
Niger envisage two possibilites: if France stays in Niger and
in all the Saharan zones the status quo will remain; if France
withdraws, there will be the creation of an independant nomadic
State, totally independant from the Blacks

Clauzel, at the end of a
forty seven page report
June 1961

The psycholigical situation is uncertain and nobody knows if the
Tuareg will be abandoned by fate to become a minority destined
to be under the control of others

were signed – notably in Algiers in 2006 – but the
situation didn't improve and dissatisfaction grew.

Two other factors aggravated the situation. From
2003, the GSPC, the *Groupe Salafiste pour la Prédication
et le Combat*, which would become AQMI (or AQIM,
Al-Qaida in the Islamic Maghreb) in 2007, started to
settle in the north of Mali and began a lucrative trade
of Western hostage-taking and ransom collection. The
Malian authorities, unofficially complicit, took no
action against this group, who prospered and embedded
themselves in the region, trading with the nomads
and sometimes marrying into the local population.
Furthermore, drug trafficking – notably of South
American cocaine – found new routes across Africa, up
through the west of the Sahara, taking advantage of the
absence of the State and the lawlessness in the desert.
The Malian government, corrupted to the highest level
by the luscious benefits of this traffic, closed its eyes.
Some Tuareg made money by ferrying cargo but the
region, far from developing, sank amidst territorial
battles between heavily armed clans.

In 2011, exasperated by the situation, young Tuaregs
founded the *Mouvement national de l'Azawad* (MNA),

a name adopted by them to designate all of northern
Mali. Solely political at the start, it was however not
recognised by the government, which put some of its
leaders in prison. The MNA then moved onto a new
armed struggle, and renamed themselves the *Mouvement
national de libération de l'Azawad* (MNLA), or the National
Movement for the Liberation of Azawad. It developed
a military wing, soon considerably strengthened by
the return of Malian Tuareg who had been part of
Gaddafi's army and were now leaving after his fall (due
to the French and European intervention). Seizing
their moment in the political chaos - having plundered
the Libyan arsenal during the ensuing free-for-all -
returning Tuaregs were armed to the teeth, arriving in
armoured cars and pick-ups fitted with heavy machine
guns. This provided the firepower for a new rebellion
which began on 17th January 2012, led by an MNLA
leadership who now claimed to represent not just
the Tuareg but all the populations of Azawad, which
included Arabs, Peuls and Songhays as well as Tuaregs.
After a swift campaign in which the Malian army was
firmly routed, as well as a military coup in Bamako, in
March - which did not help the situation of the state -

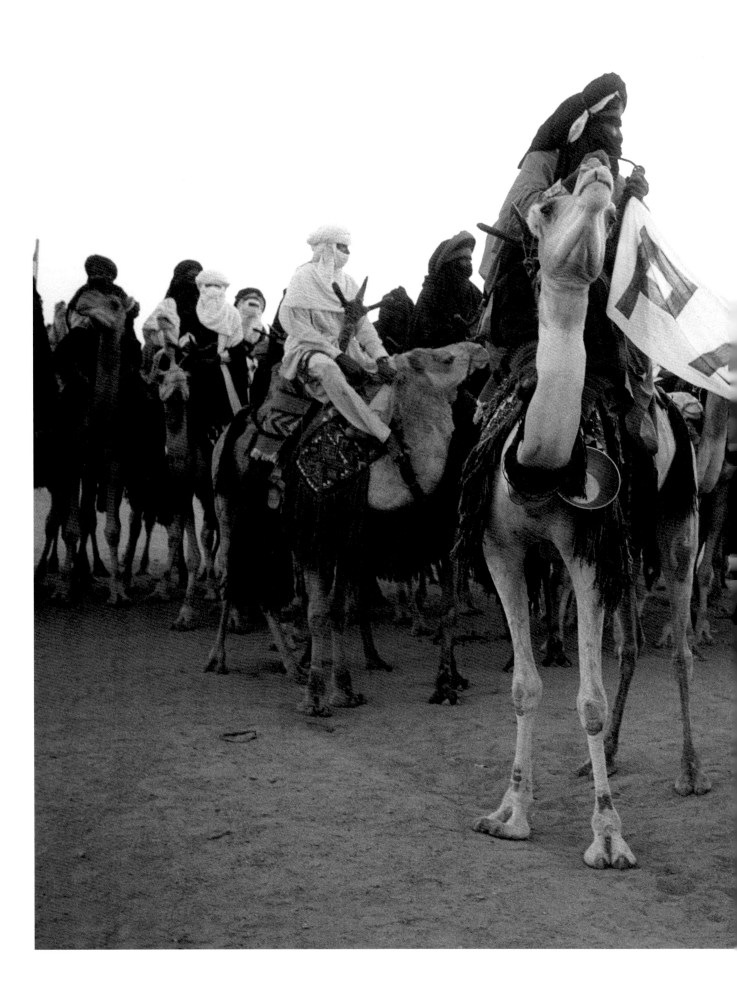

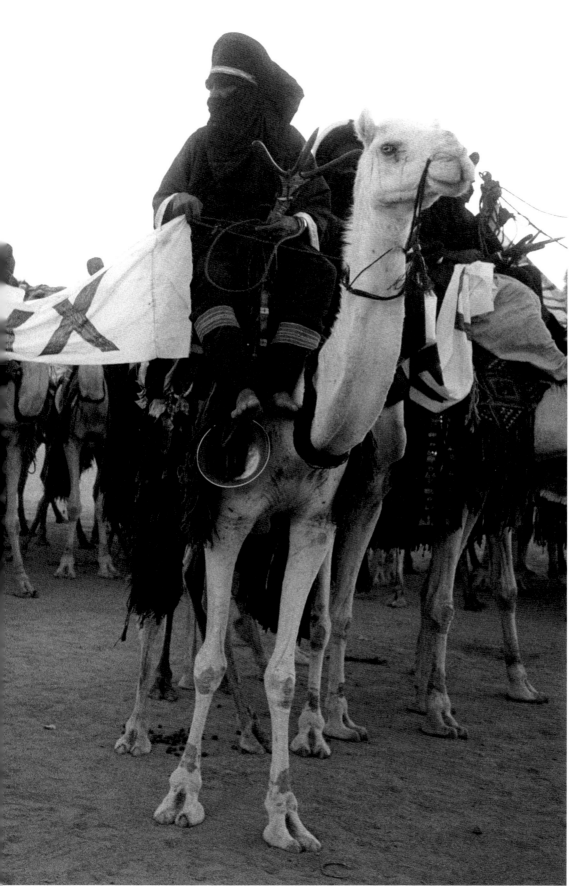

At the 1st Festival de l'Air in 2001 - inspired by the Malian Tuaregs' 1st Festival du Désert at the begining of 2001 - Tuaregs declare their wish for peace. In 1999, there had been a "Flame of Peace" ceremony when Tuareg rebels threw their weapons onto a massive fire in Agadez, as in 1996 in Timbuktu. As warriors however, Tuaregs will fight to the end for their rights - that is what they do - but in Niger (since their second rebellion, which was a disaster for them), they are striving to pursue change diplomatically. Tuaregs of Niger do have more rights than Tuaregs of Mali but there remain many social policies that do not cater correctly to Tuaregs

Below right:
Pierre Boilley, historian, professor at L'Université Paris-I Pantheon-Sorbonne, specialist of contemporary sub-Saharan Africa, Director of l'Institut des Mondes Africaines (IMAF)

the northern cities were occupied by the rebels. The last, Timbuctoo, fell on 1st April 2012. On 6th April, the independence of Azawad was proclaimed by the MNLA.

However, they had not reckoned on the Salafist movements... AQIM had allied itself with new factions: Ansar ed-Din, a majority-Tuareg group led by the former leader of the 1990 rebellion, Iyad ag Ghali, and MUJAO (*Mouvement pour l'unicité et le djihad en Afrique de l'ouest*), or MOJWA (*Movement for Oneness and Jihad in West Africa*), made up of Arabs and fighters from other regional populations. Taking the MNLA by surprise, the Salafists now took control of the cities, repelling the MNLA back into the northern scrublands, and establishing an Islamic justice system based on a particularly violent interpretation of Sharia law: of public floggings, cutting off thieves' hands and feet, and stoning adulterous couples. Music, football, cigarettes, and alcohol were all banned, they took over the tombs of the saints of the region, and spread terror among the entire population. After several months of this regime in Gao, Timbuctoo, and Kidal, the Salafist movements stormed brutally towards Mopti and southern Mali. Unable to remain unresponsive to the threat, on 11th January 2013 France launched Operation Serval against them, regaining control of the north in under a month, and then it sought to eradicate the Islamist presence in the mountains.

The MNLA, rid of the Salafists, regained strength and influence and helped the French military pursue the jihadists. In June 2013, preliminary agreements were signed in Ouagadougou between the rebel movements - the MNLA and the HCUA (*Haut conseil pour l'unité de l'Azawad*) - and the interim authority of Bamako. Captain Sanogo, the leader of the 2012 March putsch, was ousted and a new president, Ibrahim Boubacar Keita, was democratically elected and sworn in in September 2013 - on the condition that he quickly began negotiations with the rebels. Yet the months passed, and it became clear that the government wanted to re-take Kidal by military force rather than by dialogue. In May 2014, it attempted an attack on Kidal which ended in disaster in front of the defending rebel fighters. It was only after this failure that the Malian government, humiliated and condemned world-wide by global organisations, resolved to negotiate under the auspices of Algeria.

But now, with rounds of negotiation and renewed dialogue, it appears that there are two opposing concepts which are difficult to reconcile: a Malian government with decentralised control over the region on the one side, and that of autonomy or federalism for the *Coordination des mouvements armés* (CMA), on the other.

International players are well aware that a lasting peace can only come from good agreement which at least satisfies the minimum demands of all parties. This peace is just as essential for Malians as for neighbouring countries and Western interests - to finish the fight against the Salafists who, although beaten, maintain guerrilla forces in the region. However, such an agreement is difficult to achieve. The time spent negotiating only deepens the rifts between the populations, and impedes the action needed to draft a necessary development plan . . .

Toumast TV: the new Tuareg television channel

Akli Sh'kka
Founder Toumast TV

The word "Toumast" in Tamazight [Tamasheq] means "a Nation" or "a Culture". Toumast TV will be the first of its kind - a television channel about the Tuareg and for the Tuareg, with programs in Tamasheq, Arabic and French. It will teach the world at large about the long history of the Tuareg, Saharan inhabitants for over a thousand years, and address every facet of Tuareg life, including their 21st century dilemmas. Their dilemmas are numerous - thorny issues & political questions similar to those which many nomadic peoples confront and attempt to challenge.

The Tuareg have usually been ignored by the world when they have suffered grievous persecution, this being decade after decade. This neglect has mainly been due to bias or blindness on the part of countless media outlets. For us, many media outlets and/or their commentators are notoriously unfair. We will seek to correct these injustices, and to show the truth on the grave matters that affect the Tuareg, highlighting regional areas of difficulty that need attention, and both everyday and political issues that need resolution.

It is time to tell the truth about what is happening throughout the vast Sahara, along with the Tuareg's story, and to ask the difficult questions about what the answers may be to the Tuareg's wish for a greater role in the future of their regional, and now global affairs. The validity of Tuareg hopes for a modicum of the 'statehood' which other cultures enjoy, and value so much, should not be denied.

For over a hundred years the Tuareg have been harshly treated by former colonial powers and Pan-Arabists. This has resulted in their loss of the vast majority of traditional lands, and many ancient ways of life and important features of their unique, fascinating culture have suffered brutally.

Toumast TV takes on great responsibility in embarking on this enterprise: to inform the world of the reality of the much misunderstood issues in every corner of the Tuareg's historic territory of the Sahara Desert.

Our life was the most beautiful
A life of liberty and space
Now it is death, or half-death

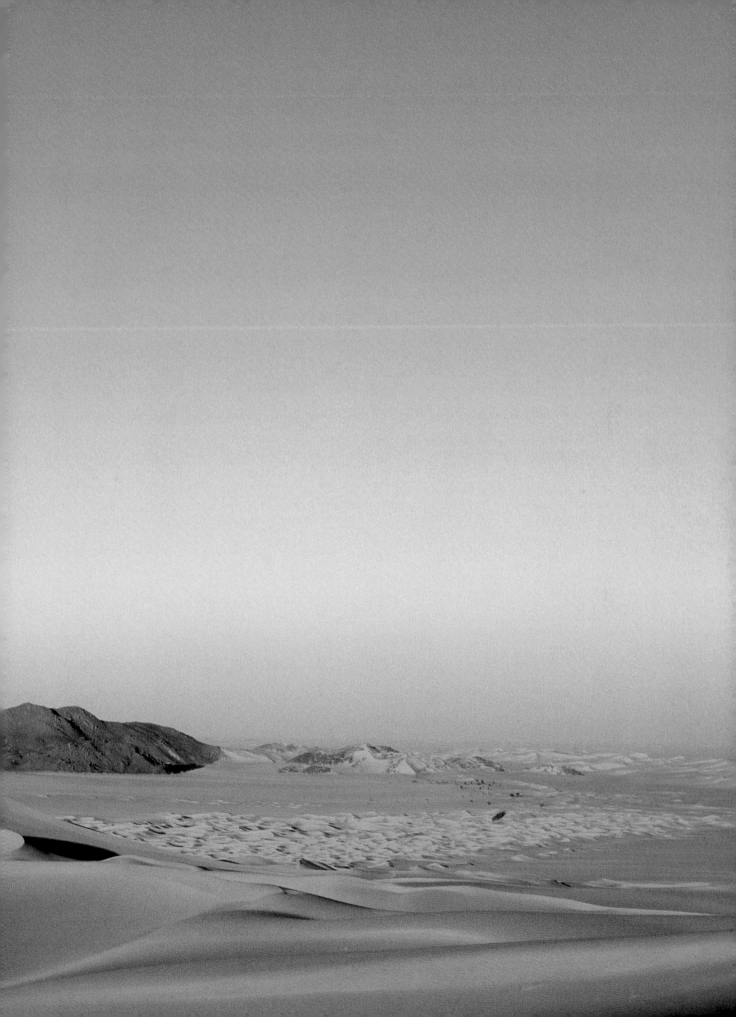

MOUSSA AG KEYNA OF TOUMAST
The child warrior-musician

Moussa ag Keyna, possibly the youngest rebel fighter to be wounded in the Tuareg's first rebellion in Niger in the early 1990s, met the musicians that would become the globally successful Tuareg band, Tinariwen, in Gaddafi's army training camps in Libya in the late 1980s. This was where all this generation of modern Tuareg musicians met. They all played and experimented musically together, inspiring each other with the new sounds that they heard on pop radio channels formerly unknown to them.

The musicians shared their new harmonies and lyrics, which had a new style but was still rooted in traditional poetic art. The electric guitar, for one, was now the instrument of choice, and they mimicked western musical heros of the time. They were of course the *Ichoumars* - the children of the 'lost generation' of Tuareg who came from all Tuareg groups or "confederations" from all over traditional Tuareg homelands - of Mali or Niger or Algeria. They were deprived of an education, cast out in a strange modern world that their parents had no knowledge of. They would soon take up the fight for Tuareg society with a new, more effective approach to battle, or war, which they would learn in the army camps.

Gaddafi was however using the young men as much as they were using him to acquire the new fighting techniques. Against their will, or sometimes even their knowledge, Tuareg bolstered his troops on the fronts of his Middle Eastern or African wars. They were sent to Chad and Uganda, and to Palestine and Lebanon. They boarded planes that they were told were going to Tripoli but which landed in Beirut, for instance; they had no papers or passports or money, and they knew no-one there. Some fought, some deserted. Gaddafi welcomed Tuareg in Libya but wouldn't give them any national status, they were still refugees - although many who weren't fighting did earn good money which they sent home to their impoverished families of Niger and Mali who were suffering the consequences of the severe African droughts of the early 1980s. This was a major reason why young Tuareg men first deserted Mali and Niger, in droves. Their families were starving and herds were dying; the young men were unemployed with no visible future. (The word *Ichoumar* comes from the French word *chômeur*, the name for an unemployed person).

Moussa was fifteen when he arrived in Libya, passionate to fight for his people, a wish of his own making. Before he left home he could think of little else while taking the family's herd to the well, near Menaka, where they lived, than when his mother might be able to cope with the news of his dream. Since the French left Mali and Niger - or the Sudan - at the end of colonisation, Menaka has been one of the most unsettled areas of eastern Mali. Tuareg of Menaka are also, as according to their class, warriors.

Moussa found his opportunity and finally got his mother's blessing, going to Libya with a relative. He now dreamt of helping secure a home, or independant territory for Tuareg, an autonimous region at least. He felt obliged to make war, not least to protect his family from the frequent brutal attacks by Malian governmental troops that didn't distinguish between Tuareg fighters and civilians, women and children even. And he wanted to fight for Tuareg culture and ideology at large too.

Moussa's dream is the same now as it was thirty years ago, for Tuareg autonomy in their traditional homelands. His personal dream is to then return home, buy some camels, and spend time living as he did as a boy - raising animals and being among his own people, not having to live as an exile in Paris, which he has done since first arriving there, gravely injured, as a seventeen year old victim of the first rebellion whose rescue was part of the Peace accords between the Tuareg and the Nigerien government.

Moussa first saw Paris and the western world through the windows of the ambulance taking him to hospital; his leg, he was advised, would have to be amputated. Fortunately, doctors managed to save the

leg, but he lost the luxury of being able to live in his home country, or homelands. He rarely goes back, he will never feel safe there until there is peace, "with a capital 'P'!", he says. A peace that will endure. There is always the possibility, he says, of a precarious, revenge attack on him at any time, his situation, having been rescued in such a way, is national knowledge. He was just one of three rebels saved in the peace agreements; the other two were older and more senior military figures. His dramatic survival, when barely more than a child, is too widely known.

Toumast's new album, which will come out later this year is inspired, as always, by traditional Tuareg poetry. It will talk of what is happening today for Tuareg. Moussa hopes that the voices of Toumast - which means nation in Tamasheq - will be heard by people who could re-assess any negative thoughts of Tuareg society, and instead help Tuareg find their feet again on what Moussa hopes will one day be safe home ground, free of terrorism and free of dispute.

Avant le commencement, était le rêve Avez-vous vu l'image image rêve miroir en mirage? En voici l'écho! Rêve vision rêve voix des paysages de l'âme brûlure carbonisée par la soif de l'agonie	Before the beginning, was the dream Have you seen the image the image of the dream mirror in mirage? Here is the echo! Dream dreamt vision voice of the landscapes of the soul burns charred by the thirst of agony

Mais face au désordre, seul lui reste le désordre de la danse rythme de la révolte et de sa transe qui donne à la dance le sens de désordre	Yet in the face of disorder, all that remains is the disorder of the dance rhythm of the revolt and of its trance which gives the dance its sense of disorder

Ahmed Boudane, 38, from a family of blacksmiths of the same region that Edmond Bernus researched, has lived in France since 2007. His abstract art transforms traditional Tuareg motifs and the Tifinagh alphabet into sometimes new, imaginary symbols. The paintings' backstories relate Tuareg issues - notably above, the Tuareg's musical rebellion - and Boudane's experiences as a nomad of the past and now of the world at large. They express the collision of his two opposing worlds. His striking calligraphy also defines his art: "When I work I go beyond the letter, the word and the phrase and I plunge into a calligraphic abstraction", he says of his oeuvre.

To make the colours, Boudane uses an array of natural dyes and pigments but most significantly, saffron, kohl and gum arabic (or acacia gum), ingredients which are indigenous to his homeland - and the revered indigo dye, which he boils and reduces for a couple of hours, as with the gum which he then mixes with the crushed kohl. The saffron is made into a watery paste.

Le corps humain
respire et boire la vie
par la voie de neuf trous noirs
L'oracle parle
par le fouet de neuf langues.
Et les neufs langues de l'oracle
ont dit:
- Ensuite les canons
du rouleau compresseur français
combleront les neuf trous
du cadavre touareg
Par neuf pavés atomiques,
la France va dérouler
une route nucléaire
sur les neuf sens
du crâne touareg

The human body
breathes and drinks life
through nine black holes
The oracle speaks
by the whip of nine languages.
And the nine tongues of the oracle
said:
- Then the canons
of the French steamroller
will fill the nine holes
of the Tuareg corpse
with nine atomic stones,
France will roll out
a nuclear road
over the nine senses
of the Tuareg skull

Three poems by Hawad, who is held in awe by Tuaregs for his fierce but just poetry. It tells the truth of the painful mistreatments Tuaregs have suffered. Hawad lives in France. The paintings are by Ahmed Boudane, who also lives in France. Boudane expresses Tuareg dilemmas with much the same force as Hawad. Hawad's poetry is as a cry from the souls of the nomads who are caught between tradition and modernity, and sometimes violence of a kind they do not understand. He talks for them

IN MEMORY OF TOURISM

"That's it, it's over. It's finished, that's all".

For once the Tuareg weren't talking about the loss of
their former life, their harsh and heroic existence in the
hot, unforgiving desert - they were mourning the death
of tourism.

Gliding through the desert in smart 4x4s with
wealthy tourists - often middle-aged Europeans or
Americans with a fascination for the pre-historic
rock-art or the Tuareg's poetical culture, in awe of
the beguiling land, potentially fierce and aggressive by
day, cool and seductive at night - this was the perfect
solution for the Tuareg in the last few decades, having
steadily watched their former world disappear since the
beginning of colonisation.

The tourism was highly personal. Travellers would
stay close to the guide's nomadic home, experiencing
the nomads' daily life. After a long day discovering the
desert at large: the rocks with Tifinagh or the ominous
jagged graveyards invisible to the ignorant eye; watching
the herds and people at the well, with the screeching
sounds of the pulley drawing water and the excited
yelps of the men heaving the huge sacs up from the
deep; finding a deserted pump to sneak a luxurious cool
shower; buying fresh cheese from a nomad haphazardly
appearing as if from nowhere; visiting other nomads far
into the desert's flat plains, the mutual joy of the novel
encounter. Small miscellaneous, unplanned surprises.

Then, returning to campsite as the sun falls on the
horizon, your body releases the tension of the day's heat,
and you hear the plaintive roars of the camels coming
back from the wells getting closer, their braying for
the foals they had left behind in the morning getting
louder until finally camels and foals are united. And
someone goes to milk the camels and brings you the
manna, delicious, rich creamy milk. You watch the fires
that make the evening meals light up one by one to be
finally dotted throughout the campsite of ten or twelve
tents, the flames casting flickering shadows of busy
activity here and there; you hear the distant chat and
laughter as people share the day's news, and you feel the
communal wave of relief of having got through another
day in the searing, oppressive heat, and you feel a faint
wisp of almost cool air. Dusk gives way to black night
and a magnificent display of all the stars in the world.
As elders chat eagerly, strains of the music of young
Tuareg at a distance in the bush who are singing around

a *tam-tam* float back. The exhausted traveller, content
after a perfect meal of fresh salad, fresh, beautifully
spiced meat and vegetables, and bread freshly baked in
the sand, drifts to sleep under *les belles etoiles*. It was high
romance.

Tourism was crucial to the Tuareg. The revenue
sustained the nomadic families of the tourist agencies'
employees, and much of the economy of local towns
- from the artisans with their shops bulging with silver-
and leatherware, all made locally, to restaurants and
hotels and the employment these offered. Salaries from
all jobs supported a wide community. But it's not just
the revenue that is lost, the desert itself is partly lost to
Tuareg, thanks to the increase of banditry in areas of
lawless wilderness. Areas are even unsafe for them.

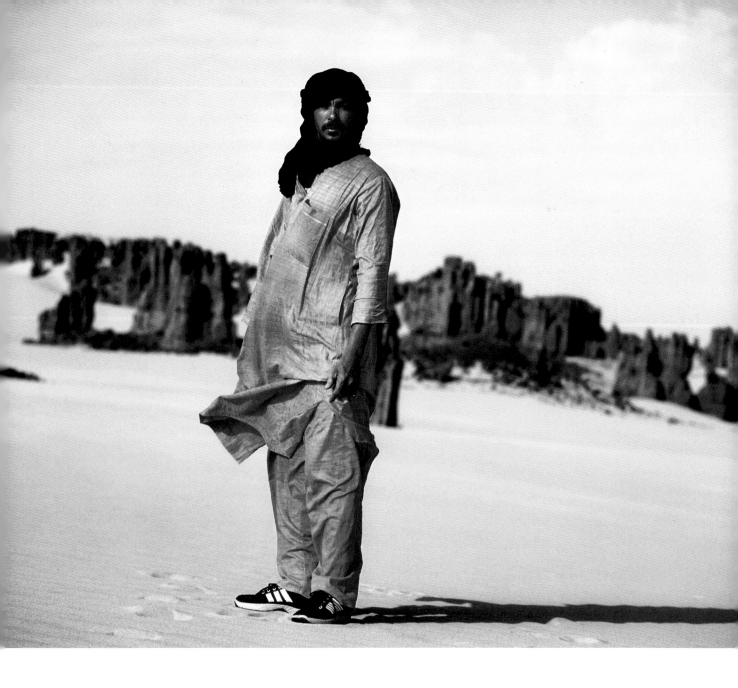

Above:
Tital, a tourist guide Ahaggar, 2004

Right:
Tuareg guides made extremely good money showing tourists their
roots. While tourism is firmly non-existant at the moment, it was
interesting to understand at the time (in 2004), that for these
Algerian Tuaregs – the vast majority of whom are more sedentarised
than those of Mali or Niger – they rarely visited the desert for
personal reasons
Ahaggar, 2004

THE TUAREG AND GADDAFI

As far as the nomads and Tuareg in ignorance knew
- uninformed of the political realities of Tuareg
connections with Gaddafi or that his public personna
was a sham - Gaddafi was the all-time hero, crucial as
the sole exterior or international supporter of Tuareg
during their civil conflicts, their saviour even. He also
funded many Tuareg causes or development projects
over the years, and was the primary intermediary
between Tuareg political leaders and leaders of
Malian and Nigerien governements at times of dispute.
Tuareg were caught in a bind during Libya's 2011 civil
war, somewhat forced to fight for or support Gaddafi,
despite knowing of and not condoning his duplicity.
They suffered from both angles here - trapped within
Gaddafi's regime and persecuted (soldiers and Tuareg
civilians alike), by anti-Gaddafi forces too. One of
Gaddafi's sons, Saadi, escaped Libya at the end of the
war going to Niamey in a Tuareg-led convoy driven
across the desert, and had to be protected there too,
until his final extradition back to Libya as late as
March 2014. For Tuareg in the bush however, for
whom Gaddafi was a hero up until and even after his
death, when at this time the truth filtered down to
Tuareg nomads it was much to their shame.

My friend, pass me some water
So I may rinse my mouth and God will not punish me.
I am going to talk of the great men,
Gaddafi and Tandja.
They compete for the country; they take the populations.
Gaddafi does not agree.
Gaddafi, your words are wise,
Tuareg women agree with you,
And until the end of machines.
Until the end of bics that write no more.
Gaddafi, I will come and meet you at the station of Libya,
or at the border with Algeria
For your honneur
I will bring seven letters.
They carry the same message, thanks

By Atano Handi.
Recorded in Agadez, Niger, 2012

Right, top:
The flamboyant Italian, Vittorio Gioni, owns several restaurants
or hotels in Air - in Agadez and Iferouane - and a restaurant in
Niamey, Niger's capital. All called 'Le Pilier', the restaurants in
Agadez and Niamey are the sole survivors of the Tuareg's second
rebellion of 2007-2009 and the death of tourism in Air. Initiated
by this rebellion, the collapse of tourism was then enforced
by the horrendous terrorist activity in the Sahara, at its peak
in 2013 but which still rumbles on. Le Pilier in Iferouane (the
original version), was a base for Tuareg rebels during the rebellion
and consequently got shot up such that just a couple of the
numerous pillars remain - the pillars being after which this first
hotel was named. Vittorio's creations are, or were, beautiful, cool
and tranquil "European" havens from the permanent oppressive
heat and amidst the bustle of sometimes chaotic daily life in
Africa for Europeans, the Le Pilier pictured here, near the mosque
of Agadez in the background is steadily crumbling, abandoned
and uncared for. Located opposite 'Kaocen's' famous Hotel de
l'Air, the once delightful Le Pilier with its constant stream of 4x4s
dropping off or picking up tourists to go for their week's foray
into the Sahara, is a sorry memory of better times in Agadez.
Everyone wonders and hopes for when these times may return

Right, middle:
Iferouane and its region is a day's slow drive from Agadez.
Navigating the brutal, crumpled tracks of spiky stones and
haphazard boulders is challenging for the best 4x4. Iferouane
is the Tuareg's primary stronghold in Air - a solely Tuareg
settlement to where Tuareg retreat in times of war or celebrate
in times of peace

Right, bottom:
Americans staying at Agadez' Auberge d'Azel on a business
trip need 24-hour around the clock military protection. It's a
mindless task for the soldiers but they deter anyone tempted
to kidnap the Americans who would have a high price on their
heads. The payment of ransoms to kidnappers has helped the
hostage-taking of foreigners business flourish. Dozens of people
have been kidnapped since the turn of the century, with fatal
ends for some - whether for reasons of non-payment or botched
rescue attempts

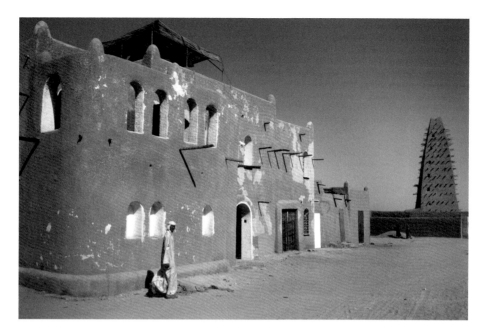

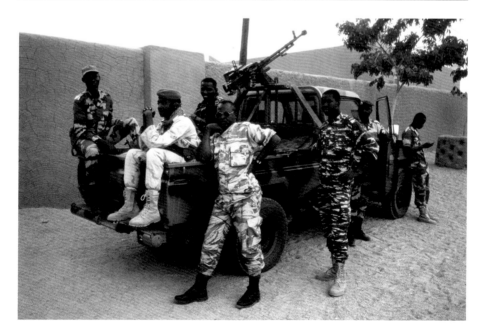

L¹Enfant De La Rue
The Street Child

By Moussa ag Aleko,
translated from Aleko's French
version, Agadez, Niger 2005

His look upsets me, deeply
His gaze confuses me to infinity.
His eyes could break marble,
Yet in this darkness, they fumble.
He has never known the real joy
That the world should give a young boy.
He has his thin little nickname,
And talks to himself of his misfortune.
His life is a secret, always,
His nights fall and turn back to days.
In his mediocre ignorance,
Suffering is his nourishment.
In my heart, so touched by his plight,
I make him a room, so that I may
Say that I haven't left him standing.
That's where we will soon be meeting.
Because in this world of forgetting,
This boy has no way of escaping.
Armed with all his charity,
He is looking for humanity,
With whom to share his destiny,
And his morning ordeal, daily.
In his look, so warm and friendly,
I can see that he is not happy.
What he remembers saddens him,
And will spoil what there is to come.
For every moment that goes past,
He is caught in another impasse:
The wars, the illnesses, the famines,
All could mean the end of him.
This poor child in all this agony
Needs nothing except a good family.
He wonders what will come to pass,
Yet his future is ours to grasp.
If we could rescue him from deathly illness,
We would have made earthly paradise.
Protecting this child's wellbeing
Is all that I can think of doing.
But few will fight for the lives of others,
If they are not their mothers or brothers.
Few people seem capable
Of something so honourable.

Left:
The little nomad boy
adores his primitive, home-
made car – it is most likely
the best toy he will ever
have

Pages 192–193:
Clockwise from top left:
i) The grand entrance to
seemingly nowhere leads
to the purpose-built
town of Arlit, near where
the world's third largest
uranium mine was built in
the 1960s;
ii) A roundabout indicates
four possible directions of
travel; tarmac covers two
options;
iii) The ground is hard,
mind-numbingly flat for
miles around. Arlit is
desolate and when the
wind blows the town takes
on an ominous appearance;
iv) Even camels are trapped
in the town's shanty
extensions

Pages 194–195:
New Tuareg refugees settle
a mile and a half from the
polluting waste of the
uranium mine – they had
nowhere else to go

LUCRATIVE, LONELY ARLIT

A small, luscious green field of ripe lettuces shone alluringly in the bleak and otherwise barren landscape. The farmer cut a dozen of the best and gave them proudly to his friend but Almoustapha Alhacen took them grudgingly, grateful but in a quandary. Ideally, he only ate vegetables grown a hundred miles away that relatives put on the daily bus for him. For, highly visible across the flat plain, was the world's third largest uranium mine, brazenly spewing out radioactive fumes.

If the fumes weren't harming the 80,000-odd population of Arlit town a mile away, particles from the 45,000 ton mountain of fine radioactive waste, staggeringly open to the skies, also blows towards the town. Some settle there: an invisible but sometimes fatal element of the Saharan dust that is everywhere. Only in 2004, after almost forty years of mining by the French company Cogema, a subsidy of Areva, was the water confirmed (by the European company CRIIAD), to be seriously polluted, as everyone concerned had guessed. The cocktail of polluted water and the radioactive fumes and dust was clearly to blame for decades of unusual, unexplained illnesses and early deaths.

Gaining notoriety in 2002 as the supposed source of Saddam Hussein's supposed uranium, Niger's mine at Arlit - in Niger's north-western wilderness, still home to nomadic Tuareg - has been operating since 1969 with blatant disregard for the health of either the local population or large numbers of their workers, or at least those on lower salaries. Senior, educated, staff know better - they drink bottled water, which they can afford.

Unbelievably, on top of the unintentional pollution, radioactive scrap metal was until recently dumped by Cogema in the centre of town for Arlit residents - as "gifts". The large yard is a rubbish tip of curious bits of metal and vehicles piled haphazardly on top of one another. Until known that the gifts were soaked in radioactivity - thanks to Almoustapha's educating the largely dreadfully poor population - people naïvely took the metal as building material for their homes. Walking around these homes with a geiger counter bleeping furiously here and there is depressing. Year after year Cogima was "in the process" of clearing the yard; this finally happened just a few years ago, thanks to Almoustapha.

In 1999 Almoustapha Alhacen, a worker at the mine for thirty five years, founded the NGO Aghirin'man to fight Cogema's blanket denials of criminal negligence.

Cogema persistently fights negative allegations. Only Aghirin'man informs the local population of Arlit's dangers; previously residents were kept firmly in the dark on the subject of radiation.

Niger's government and international foreign businesses (largely French or Chinese), are the mine's significant beneficiaries. The company doesn't even fill the potholes on the narrow road from Arlit to Agadez - which has almost more potholes than road. The worst road in the entire country, it is a laughing stock - considering that it ferries Cogema's numerous lorries of uranium for export world-wide. Apart from the odd hushed-up accident and radioactive spillage, transportation regulations are ridiculously slack - passengers have been reported as sitting on the uranium barrels. The absurdity of Cogema's neglectful operation of the mine would be comic if not fatal or harmful in so many ways.

The mine offers direct or indirect employment but only several thousand people work at the mine. Many residents are stuck in the town because of poverty. A reason for the growth of the 1960s built town is the movement of nomadic Tuareg off the land. Deprived of services to help them maintain feasible pastoralism (services that could be funded by some of the mine's revenue), bad years of drought deplete ever more families of livestock and, with personal belongings in sad plastic bags they walk the well-trodden path to the uranium town in the hope of a new livelihood - and there they are stuck.

Lack of benefit from the mine's income to groups living in northern Niger (the south of the country is better funded), was an underlying cause of the Tuareg's 2007-2009 rebellion. The MNJ (Movement for National Justice), purported to fight for the rights of all disadvantaged Nigériens but the government ignored their promises of the 1995 Peace Accords after the Tuareg's first rebellion. These would have given the Tuareg greater benefit from Arlit's revenue, within whose regions the mine operates, and whose land the radiation contaminates. Consideration for the few remaining nomads near Arlit might have enabled them to live slightly happier lives on the land as opposed to being forced into refugee status in unforgiving, dangerous urban environments.

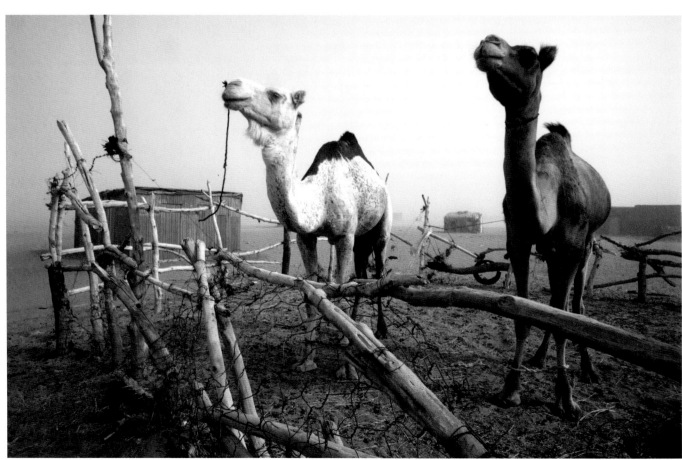

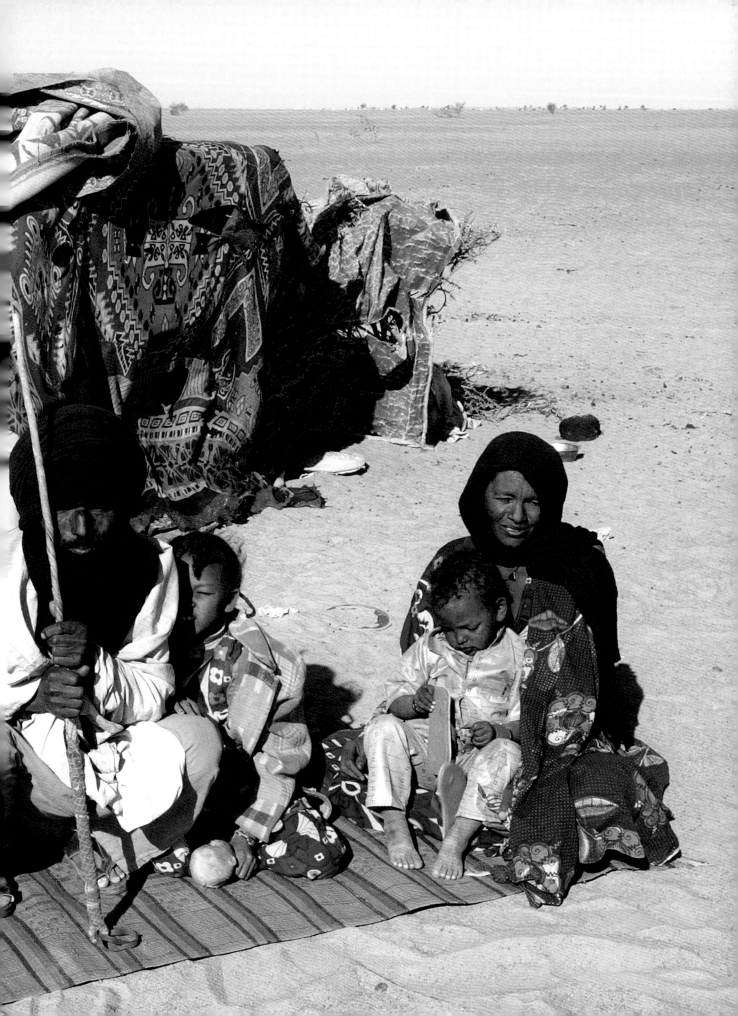

Right:
Ilaman and Assekrem as
seen by Georges Guinot

A SAHARAN UPBRINGING:
The Wisdom of Tuareg Science?
by Berny Sèbe

The Sahara has been an inescapable magnet for generations of Westerners, who have been fascinated since the nineteenth century by the dignified simplicity of its populations, and the calm outlook on the world which millennia of patient adaptation to a not-so-hospitable environment has turned into a frame of mind. This serene and characteristically un-envious appraisal of what lies beyond the desert was encapsulated when the Tuareg supremo, *amenokal* Moussa ag Amastan, reflected phlegmatically upon discovering Paris: 'true, you French people have the Eiffel Tower, but we have Ilaman'. In his eyes, the volcanic peak of Ilaman (just outside Tamanrasset in Algeria), which is endowed with near-human symbolic powers by the local Tuaregs, was clearly on a par with the engineering feat of the Eiffel Tower, which after all remained artificial and whose spiritual significance was nowhere near that of Ilaman. The desert gives a fresh perspective on beliefs commonly held elsewhere. Even today, Tuaregs enjoy reminding their hurried friends or visitors that 'Westerners have watches, but we have time'.

In spite of the many shortcuts which have made the world shrink since the middle of the last century (ranging from the telephone to aeroplanes), discovering the Sahara has remained up to this day an existential experience for many, often with life-changing consequences. Minds used to Western rationality, national boundaries and temperate climate find an entirely alien world as soon as they step south of the Atlas mountains, or north of the Niger river. Distances expand exponentially, the vegetation disappears, the bare geology of the earth surfaces, human settlements become smaller and spaced out, the sky widens, the light brightens. Clearly, life becomes scarcer too: just the odd camel or goat herd here or there, grazing what they can, occasionally under the watchful eye of a shepherd. There is probably no better mirror to the vanity of human life than these vast expanses where human beings are crushed between rocks and skies whilst, paradoxically, their horizon widens up to well beyond infinity.

The magnitude of these changes appears clearly to those who live on the edges of the desert: Algerians from the coastline north of the Atlas mountains, Egyptians from the Nile delta or Nigériens from the sub-Saharan zone dread the Sahara, which they perceive as a hostile,

treacherous and unglamorous dead end. The Arabic expression *bilad al khaf* (land of fear), often applied to these regions, is self-explanatory.

Yet, my own experience of the Sahara never went through any such phases of fear and apprehension. Neither was it an epiphanic discovery, because I never *discovered* it. This is because the Sahara forms part of my DNA: it flows in my veins. I was almost born there and, perhaps more importantly, I made my first steps a stone's throw from Temassinine (also known at various times as Fort Flatters and Bordj Omar Driss). My childhood revolved around annual stays in Southern Algeria or Libya, as did my schooling: distance learning allowed me to free myself between three to five months each winter right until the Baccalaureate, spending months of freedom crossing never-ending empty *regs* (gravel plains), exploring rocky *tassilis* (eroded plateaus), winding my way through *gassis* (corridors of pebble and clay interspersed between sand dunes), and also witnessing first hand the unstoppable evolution in the way of life of the Tuaregs, moulded by their nomadic life-style.

During these formative years, I learnt how to orientate myself in the desert, how to be self-sufficient (a matter of life and death under these extreme conditions), and also how to conform to customs that place respect, self-control and dignity at the heart of their value system. I also appreciated the determination of families who, against all odds, survived from herding and occasional hunting (usually without fire-arms), in the maze of wadis carved out of the sandstone massifs. Witnessing lives unfolding in a manner reminiscent of Biblical times, is a unique way of giving meaning to our understanding of mankind: distinguishing the essentially human from the historically contingent.

I owe this early exposure to the Sahara, its codes

and its teachings to my parents. Having escaped the trauma of the Algerian War, thanks to his three-year photographic training at the celebrated *Vevey School of Applied Arts* (1959-1961), my father discovered the Sahara with fresh eyes in 1966, at the invitation of the Algerian minister of Tourism (to whom he had been introduced by pro-independence French architect Fernand Pouillon, the brain behind almost all early post-colonial Algerian large-scale building projects). The encounter with the Sahara and its inhabitants was love at first sight, and my father has been extensively travelling the Sahara since then - discovering, in the process, some of its most hidden corners, and often sharing the life of populations who had rarely interacted with Westerners before. When a boy, I vividly remember alarming a boy of roughly my age merely by the colour of my skin!

My father's forty-nine years of Saharan travels have given birth to one of the largest archives of artistic photographs of the region, with enough material to produce more than twenty books (many of them award-winning), on the Sahara and its inhabitants. I was fortunate enough that my parents decided even before my birth that they would attempt a unique educational attempt: to take their child with them and raise him in the spirit of the desert. At nine months old, I was already on my way to the Ahaggar. When I could barely walk, I had already become used to coping with sandstorms, and sleeping out in the open, gazing at a bright Milky Way standing out in the deep, dark and undisturbed sky - the Milky Way makes Saharan nights unique. When I was learning to read and write the Latin alphabet, I was already aware of what the Tuareg script, *tifinagh*, was. Tamahaq and Arabic are languages my ears became familiar with well before English and Spanish. I spontaneously knew I had to look for my bearings even before I could read a map. Most importantly, I quickly learnt that it is safer to carry a bottle of water *at all times*, in case a journey takes longer or unexpected complications arise. Thanks to the elaborate teaching manuals and pedagogical programmes provided by the French national centre for distance learning, I was able to combine standard curricula with the life-changing experience of becoming intimate with the desert, and to strike friendships with people who had always lived there. As a result, for me the Sahara has never been a source of fear, but rather a motive of fulfilment: it is certainly not a *bilad al khaf*.

My life-long attachment to the Sahara and its populations has also informed my professional life in many ways. I started taking photographs at the age of nine, and ever since I have never ceased to find in deserts, and the populations that strive to survive in them, an inexhaustible source of inspiration. I have worked with my father on several photographic projects since the late-1990s, creating many co-authored books with him. As a student, my interest in history grew out of my attempts to understand the shortcomings of the present in Saharan regions, and to think about how to remedy these thanks to the teachings of the past. Why did the Tuaregs frequently feel uncomfortable with the states they lived in? (For instance). Why did borders divide their grazing territories? Why did armed rebellion break out repeatedly in Niger and Mali, but not in Algeria? How can we understand the geopolitics of the region? Perhaps less crucially, but important from my personal perspective, why are the Tuaregs so fascinating to the French but relatively unknown in the English-speaking world? What role did nineteenth century European explorers play in shaping an image of the Tuaregs? Why has this image both survived and been embellished in the twentieth century in some cases, whilst in others it has fallen into oblivion?

Indeed, history is a remarkably effective prism through which many of the region's current realities and, sadly, convulsions can be understood. The centuries-old trans-Saharan trade routes which linked West Africa to the Mediterranean anticipated the flourishing *trabendo* networks which criss-cross the desert today. Presented with new opportunities due to global market demands and the congenitally weak state apparatuses of the Sahel region, today's smugglers have clearly taken local business models into murky waters, but they have remained true to the chief economic tenet of populations surviving in harsh environments: given the shortage of opportunities, they seize them as they arise. The *modus operandi* of armed groups operating in the area also echoes earlier examples of resistance: the combination of kinship, shared interest (commercial or political), religious beliefs and the extreme fluidity of networks, disappearing somewhere to resurface a few hundred miles away, are reminiscent of earlier episodes of struggle against foreign colonisers. Evidently, there are also some differences. For instance, whereas past networks relied mostly on the power of Sufi *tariqas* (brotherhoods), the new spiritual networks inspired by Salafi ideology are ceaselessly fighting the influence of Sufism, which they see as incompatible with their vision of Islam. Beyond these differences, the extreme

Below:
Berny Sèbe, D.Phil (Oxon.),
FRHistS, FRGS, FHEA

mobility of the armed groups involved in the region's current turmoil is in keeping with the traditions of nomadic populations, for whom freedom of movement has been a vital asset over the centuries, allowing, as it does, access to resources and danger avoidance.

The modalities of colonial rule in the nineteenth and twentieth centuries explain to a large extent the recurring problems facing most of the countries of the Saharo-Sahelian areas today. The irruption of alien forms of sovereign statehood, which have tried to promote feelings of national unity since independence but have failed in most cases, has led to a long-lasting disappointment with the post-colonial political situation. Artificially drawn borders have not only created fragile heterogeneous countries which have frequently struggled to maintain their integrity, but they have also spliced through traditional patterns of nomadisation, at the very time when recurring droughts threatened livestock (i.e. the livelihood), of tens of thousands of nomads. These circumstances facilitated the settlement of the majority of Saharan populations, which was ardently desired by all regional states as a way of controlling their citizens more effectively. Sedentarisation was widely resented among populations who had been used to living freely in the open space of the desert, and its effect was made even more acute by the limited socio-economic development of new towns which offered very few socio-economic opportunities. This frustration, which has increased over the years, has been a fertile breeding ground for rebellion and for the ever-growing success of political Islam, in an area where before, religious practice had been characterized by its moderate character.

Yet historical records tell us that the post-colonial fragmentation of Saharan territories was not inevitable. Although it ultimately failed because of its clear neo-colonial undertones, the attempt to create a Common Organisation of Saharan regions (or COSR, 1957-1962), could have offered Saharan populations an alternative path to autonomy, and then independence. Vehemently fought by the Algerian nationalists, for one, who were adamant that the Sahara and its resources were a vital element of their future state, it lost its currency when trans-national projects (such as Panarabism or Panafricanism), failed and the framework which COSR offered was discarded. Tuareg populations ended up depending on capital cities which were well beyond their territories, condemned to being minorities in all the countries where they lived, and facing the risk of

being misunderstood by rulers who either ignored their world view or openly disliked them. This disjunction between states and populations in the Sahara have had long-lasting effects, up to the present day.

What can the 'Tuareg science' of the title of this essay do to make the twenty-first century better for Saharan populations? Such science differs from what is commonly understood in the West. It is not practised in labs or in the loneliness of an archive. Rather, it is a subtle science of life, in the etymological sense of the term: made of wisdom, respect and patient determination. This philosophy of life places the emphasis on *knowledge* (which is *sciere* in Latin). This acute consciousness of where they come from and how they want to live would be is the best antidote to the Tuaregs' loss of cultural references which is undermining their society, often leading to violent disintegration of their social fabric. As far as I am concerned, it has been a stepping stone for my own philosophy of life, which focuses on the patient construction of knowledge, simplicity in human relations and resilience in front of adverse conditions. Above all, it values the authenticity of human feelings well above the superficial satisfaction of material benefits. I see in these values one of the most significant rewards which my 'Saharan upbringing' has bestowed on me.

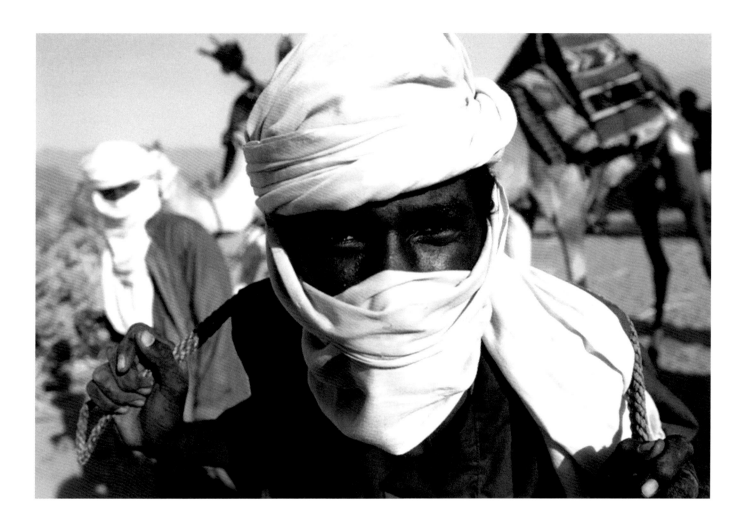

Above:
Nomads head home after the 5th Festival de l'Air at Iferouane, Niger 2006

Pages 200-201:
A mural by a mobile phone shop in Agadez, now painted over.

Pages 202-203:
Arriving at the 8th Festival de l' Air in mid-January 2012, which was held near Arlit, for security reasons. This festival was as much a political as a cultural event with a two-day "Forum for Peace" in Arlit town. All parties, from the Prime Minister and ministers to rebel leaders and rebels spoke, in an impressive show of democracy. The quest for peace was heard from all sides. After a military coup in Niger in 2010, after the end in 2009 of the Tuaregs of Niger's second rebellion, a new government wasn't sworn in until 2012. This was the first opportunity for the rebels' issues to be addressed. The Malian Prime Minister was also present, the Tuaregs of the two countries being closely linked: what happens in one country might be duplicated in another, there will certainly be repurcussions. The atmosphere at the end was positive. Two weeks later however, Tuaregs of Mali seized the Malian town of Gao – marking the start of the most grave crisis of recent times for Tuaregs of both countries. The Malian government fell and fundamental Islamists most significantly took over Timbuktu and Gao, practising an horrific version of sharia law. Thanks to the French, the Islamists, members of AQIM (Al-Qaida in the Maghreb), were ousted from the towns. But, although it has been discussed and analysed globally, whether by the press or during official negotiations, the crisis staggers on today - with less world attention but with almost equal misery to everyday Tuaregs. A true resolution to ensure equal rights for these ancient historic peoples and their valuable culture is, in the words of Pierre Boilley, "hard to find"

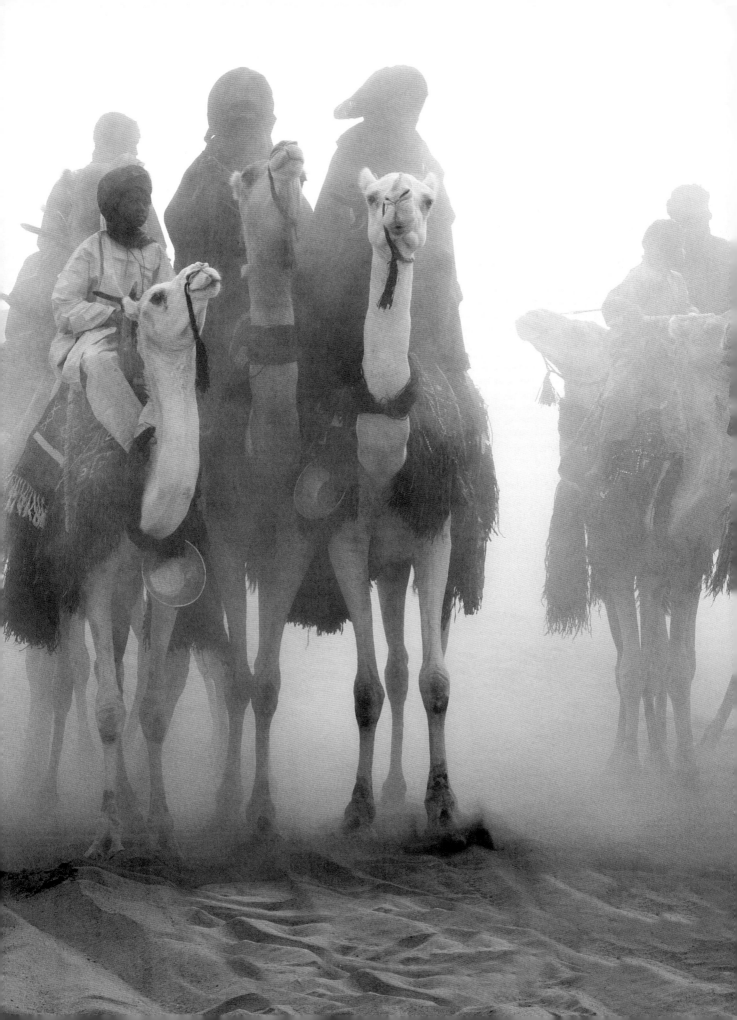

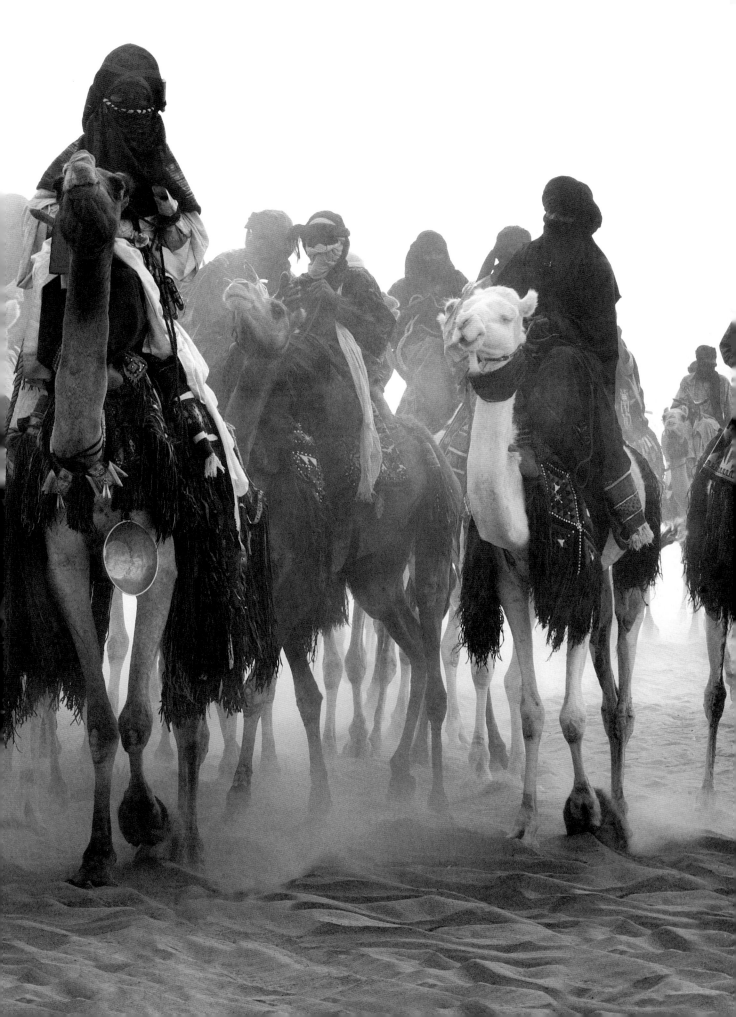

Footnotes

Pages 64-73: The Work of Edmond Bernus by Caroline Bernus

1. Formerly ORSTROM – Office for Overseas Research in Science and Technology, now IRD, Marseille
2. The French National Scientific Research Centre
3. *Aperçu sur les migrations de population en Basse Côte d'Ivoire*, s.n., s.l., 1957, 32p.
4. The French translation of a Tamasheq term, these people were prehistoric, and possibly the first Berbers in the region
5. "Kobané : un village malinké du Haut-Niger". *Autrepart*, 2005, 34, 121-150, (reprint) and "Kobané ou le temps arrêté", *Autrepart*, 2005, 34, 151-172.
6. *Les Illabakan (Niger) : une tribu touarègue sahélienne et son aire de nomadisation*. Paris, Mouton/ORSTOM, 1974, 10, 116p. (Atlas des structures agraires au sud du Sahara).
7. This is now nationally celebrated as the "Cure Salée"; it has been politicised. It helps unify Niger, with the southern people of the country coming to experience life in the north.
8. *Tagrest*, 1967, CNRS, colour film, optical sound,18mn.
9. *Touaregs nigériens, unité culturelle et diversité régionale d'un peuple pasteur*. Paris, ORSTOM, 1981, 508p. reprint, Paris, L'Harmattan, 1993, 508p.
10. With Ekhya ag Albostan ag Sidiyene, "L'amour en vert (en vers?)". *J. Africanistes*, 1987, 57, 109-115
11. 1906, a year rich in *alwat*, a wild cabbage which helps camels lactate, *Schouwia purpurea*.
12. "The source of the *tageyt*", the doum palm, *Hyphaene thebaica*.
13. "The place of the *tamat*", one of the numerous acacias in the region, *Acacia ehrenbergiana*.
14. "L'arbre et le nomade", *J.Agriculture Traditionnelle et Botanique Appliquée*, 1979, 26, 103-128.
15. *Eguéréou : Niger, d'une rive l'autre 1953-1977*. Paris, Marval, 1995, 107p.
16. CRP Nord-Pas de Calais, Place des Nations, F-59282 Douchy-les-Mines
17. Tamasheq word derived from the French word "chômeur" i.e. unemployed
18. Base Indigo de l'IRD : *www.indigo.ird.fr*
19. *Touaregs du Niger, le regard d'Edmond Bernus*. Brinon/Paris, Editions Grandvaux/IRD, 2007, 96p.
20. *Mondes touaregs*, exhibition catalogue, Cahors, Musée Henri Martin, 2014, 128p.
21. *Touaregs, chronique de l'Azawak*. Paris, Éditions Plume, 1991, 176p.

Picture credits

Any picture not listed below is the copyright of Henrietta Butler, with the exception of illustrations out of copyright which are also unlisted

Right:
A leather pouch or *Inafad*,
worn by men to hold
money, a pen or paper and
often a mirror

Bibliography

Agg-Ālāwjeli, Ghubāyd, *Histoire des Kel-Denneg*, Akademisk Forlag, 1975

Aghali-Zakara, Mohamed., *Inscriptions Rupestres de l'Ahaggar Site de Tit*, Rilb, No. 17, 2011, pp. 5-8

 -, *Tifinagh de la Grotte d'Aligurran et de Tafadak (Air nigérien)*, Rilb, No. 18-19, 2012-2013, pp. 5-9

Ag Keyna, Moussa, & Vautier, Maguy, *Toumast parcours d'un combatant*, Sahira, 2010

Ag Solimane, Alhassane, *Bons et Mauvais Présages*, l'Harmattan, 1999

 -, Les gens de la Parole disent, Kephalonia, 1996

Albaka, Moussa, & Casajus, Dominique, *Poésies et chants Touaregs de l'Ayr,* AWAL-L'Harmattan, 1992

Barth, H. *Travels and Discoveries in North and Central Africa,* 5 Vols., Macmillan, 1857-8

Bernus, Edmond, Éguéréou, Marval, 1995

 -, *Touaregs Nigériens,* L'Harmattan, Orstom, 1981, L'Harmattan, 1993 (second edition)

 -, *Touaregs Chronique de l'Azawak*, Plume, 1991

 -, *Touaregs de Niger, le regard D'Edmond Bernus*, Grandvaux, 2007

 -, *Germaine Dieterlen et les Bijoux Touaregs,* Journal des Africanistes, tome 71, 2001, pp. 63-68.

Bernus, Edmond, & Agg-Albostan, Ekhya, *L'Amour en vert (en vers ?),* Journal des africanistes, tome 57, 1987, pp. 109-115

Bernus, Edmond, & Durou, Jean-Marc, *Touaregs,* Robert Laffont S.A., Paris, 1996

Bernus, S. *Henri Barth chez les Touaregs de l'Air*, Etudes Nigeriennes, No. 28, Niamey, 1972

Boissonnade, Euloge, *Conrad Killian*, Éditions France-Empire, 1971

Casajus, Dominique, *Charles de Foucauld*, CNRS Editions, 2009

 -, *Gens de Parole*, La Découverte, 2000

 -, *Henri Duveyrier, Un Saint-Simonien au Désert*, Ibis Presse, Paris, 2007

 -, *Poésies et chants Touaregs de l'Ayr*, AWAL/L'Harmattan, 1992

Castelli Gattinara, G. C., *I Tuareg attraverso la loro poesia orale,* Consiglio Nazionale delle Ricerche, 1992

Claudot-Hawad, Hélène, *Touaregs*, Gallimard, 2002

Claudot-Hawad, Hélène, et Hawad, Mahmoudan, *Tourne-tête, le pays déchiqueté*, Amara, 1996

Dayak, Mano, *Touareg, la tragédie*, Lattès, 1992

 -, *Je suis né avec du sable dans les yeux*, Fixot, 1996

Durou, Jean-Marc, *L'Exploration du Sahara*, Actes Sud, 2004

 -, *Sahara, The Forbidding Sands,* Éditions de la Martiniére, Paris, 1995, Harry N. Abrams Inc, New York, 2000 (second edition)

Duveyrier, Henri, *Les Touareg de Nord*, Paris, 1864

Fleming, Fergus, *The Sword and the Cross*, Granta Books, 2003

Foucauld, Charles de, *Poésies touaregues*, vol. I-II, Paris, 1930

 -, *Chants Touaregs*, Albin Michel, 1997

Galand, Lionel ed., *Lettres au Marabout,* Berlin, 1999

Gast, Marceau, *Tikatoûtîn*, Éditions de La Boussole, 2004

Genthon, Anouck. *Musique Touarègue*, L'Harmattan, 2012

Guinot, George, & Bernus, Suzanne et Edmond, *Mondes Touaregs,* Ville de Cahors et les auteurs, 2014

Hawad, Mahmoudan, *Sahara Visions atomiques*, Paris-Méditerranée, 2003

Keenan, Jeremy, *The Tuareg*, Penguin Books, 1977, Sickle Moon Books, 2002 (second edition)

Kemper, Steve, *A Labyrinth of Kingdoms*, Norton, 2012

Khun de Prorok, Byron, *Mysterious Sahara,* The Narrative Press, 2004

Lhote, Henri, *Les Touaregs*, Armand Colin, 1984

Lyon, G. F., *A Narrative of Travels in Northern Africa in the Years 1818, 1819 and 1820,* London, 1821

Mézières de, Bonnel, *Major Gordon Laing, and the Circumstances Attending His Death,*
 The Geographical Journal, Vol. 39, No. 1 (Jan., 1912), pp. 54-57

Monod, Théodore, *De Tripoli A Tombouctou; Le Dernier Voyage de Laing 1825-1826*, Société Française d'Histoire d'Outre-Mer,
 Librairie Orientaliste Paul Geuthner S.A., 1977

Pandolfi, P., *Conqerants et autochones dans les recits d'origine des Touaregs Kel-Ahaggar*, Carnets de la MAE, January 2014

Prasse, Karl-G., *The Tuaregs - The Blue People*, Musuem Tusculanum Press, University of Copenhagen, 1995

Rennell, James, *On the Rate of Travelling, as Performed by Camels;* Philosophical Transactions of the Royal Society of London,
 Vol. 81, 1791, pp. 129-145

Rodd, Francis Rennell, *The Origin of the Tuareg*, Geographical Journal, 67, 1926, pp. 27-52

 -, *People of the Veil*, London, 1926

 -, *Major James Rennell,* The Geographical Journal, Vol, 75, No. 4 (Apr, 1930), pp. 289-299

Sattin, Anthony, *The Gates of Africa*, Harper Perennial, 2004

Sèbe & Sèbe, Alain & Berny, *Sahara, The Atlantic to the Nile,* Hachette Illustrated UK, 2001

A complete list of Edmond Bernus' works was compiled by Caroline Bernus, appearing in *Acta geographica*, 1526, h.s. 40-55, 2007.
In particular, references are available to all articles which appeared in scientific reviews, as well as work published posthumously

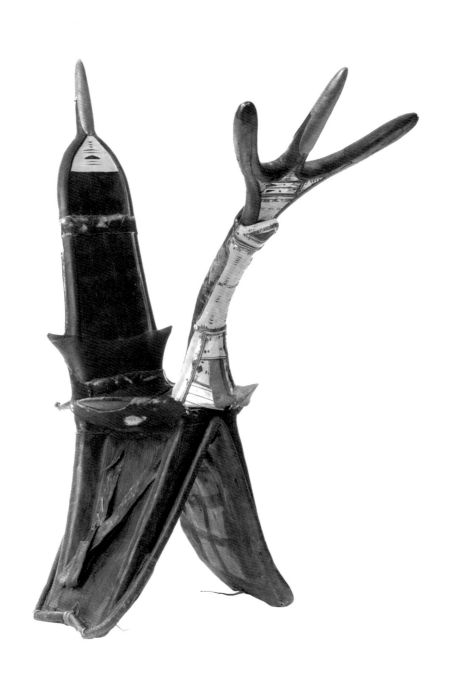

First published in 2015 by Unicorn Press,
60 Bracondale, Norwich NRI 2BE

Published to coincide with the exhibition
'The Tuareg or Kel Tamasheq and a history of the Sahara'
at the Royal Geographical Society, London, June 2015

ISBN 978 1 906509 30 9
A Catalogue record of this book is available from the British Library

Designed by Jesse Holborn, Design Holborn
Printed by Graphius Group, Gent, Belgium

Right: An arm dagger or *nam takopa*
Front cover: Morning on the edge of the Ténéré desert, Niger 2003